The Art Festival Handbook

Marc Duke

Park Drive Publishing

Published by Park Drive Publishing.

www.theartffestivalhandbook.com

Printed in the United States of America.

ISBN 978-0-615-19813-2 (hardcover)
978-0-615-19814-9 (softcover)

Library of Congress Control Number: 2008925600

First Edition April, 2008

10 9 8 7 6 5 4 3 2 1

For Max, Dianne, Wendy, Jason, Aaron, Lauren
and, of course,
Linda.

TABLE OF CONTENTS

INTRODUCTION

NOT EVERYONE IS PICASSO. Or Brancusi. Or Monet, Manet, Van Gogh, Hopper, Pollock.

Not everyone can, or should, attempt to make a living as an outdoor art festival artist. Why? Simply, because talent, if you are fortunate enough to have it, and the years of hard work required to attain a professional artist's skills are not enough. You will also need a substantial amount of intestinal fortitude, the kind that survives disappointment, discouragement, cold and rain, heat and smog, dirt and dust, backaches, headaches, slow sales and, above all, self-doubt.

Of these, self-doubt is the most challenging obstacle to success as an artist at outdoor art festivals...and in marketing your art through any other means. For every buyer who leaves the coin of the realm in your hand in exchange for your artwork, thousands will pass by your booth with barely a glance. Hundreds will compliment your talent and skill, and yet not buy. Dozens will ask myriad questions, evince sincere interest, and still not buy.

Outdoor art festivals are not for the faint of heart. Or the faint of art. This Handbook explores both areas and offers suggestions and answers to the practical and emotional difficulties—and opportunities—art festival artists face.

Is there enough money spent at art festivals to go around?

The best-selling outdoor festival in the country, held each Labor Day weekend in Sausalito, California, annually averages about $15,000 per artist, or, with 250 artists in the show, about $3.75 million in artists' sales. A more typical high-quality festival, with 200 artists each selling about $5,000 of their art, adds up to $1,000,000, more than enough for all the artists to leave happy with their sales. Outdoor art festivals, of which 30,000 are staged each year, are a multi-billion dollar business.

Can you earn enough at outdoor art festivals to make a reasonable living?

According to one directory of shows that includes reviews and artists' income, in 2005 the average artist's revenue in the country's top three hundred shows was just under $5,000. If your work sells at that level and you participate in 10 shows each year, 10 times $5,000 equals $50,000. Exhibit at 20 shows per year with a $5,000 average each and you will bring in $100,000. Increase your show sales average to $10,000. You will boost your earnings to $200,000 annually. More than a few art festival artists bring in $100,000—and better—year after year. Quite a few sell twice that much.

You *can* earn a living wage—even a great income—at outdoor festivals. The keys are where you exhibit, how you exhibit, and the hundreds of nuances that add up to success in the art festival business. Even more important are the exhibition, marketing and sales strategies you employ. The Art Festival Handbook will help you accomplish this.

Art festival artists come from all walks of life. I have known former doctors, lawyers, architects, dentists, chiropractors, realtors, housing developers, shoe salesmen and women, factory owners, truck drivers, carpet cleaners and dog trainers who leave the nine-to-five to explore the art festival artist's life. I have also known artists, lifelong, 100%-of-their-careers artists who embrace the

outdoor festival circuit as the best and most fulfilling way to market their work. And I have known retirees looking for a second career or to enhance their pensions, part-time artists—often art teachers—who want to exhibit their work and add to their incomes, and young art school graduates who believe the outdoor festival circuit will propel them into the artistic stratosphere.

One and all, they love the outdoor art festival lifestyle. They cherish the freedom it offers, the ability to display their artwork to tens or hundreds of thousands of people every year, the potential for excellent earnings and the very democratic nature of the art festival system: everyone who exhibits can compete for the buyer's dollars, with no dealer, gallery or other middleman in the way.

These thousands of artists arrive at outdoor festivals as a way (or partial way, if they have other jobs or pensions or partners who earn money) of life for one or more of three reasons: the independence it offers; frustration with not being able to sell their artwork in other ways; or to finally fulfill their secret desires to create after years or decades in other careers. I can think of hundreds of ways to earn a living—with the attendant company health plans, 401k's, paid vacations and sick days, maternity and paternity leaves and other benefits—that are easier than the outdoor art festival route. I can think of none that offer a better, swifter, more compelling expression of our personal selves.

Some artists start down the art festival path and soon discover it is not for them, for any number of reasons. Others remain with art festivals as their chosen marketing path for decades; one lady, a painter in her 90's who recently passed away, exhibited at outdoor festivals for at least 53 years—at the same show each year! For the last ten years, her son set up her booth and helped her to her chair, where she greeted visitors with

a knowing sweetness. She painted extremely well, and sold most of her paintings at every show.

We who choose the outdoor art festival life comprise an independent, diverse and at times cantankerous lot. We often work seven days a week, creating our art, traveling to shows, exhibiting. We brave the elements, the highways and uncertainty. We hear the accolades of the people who visit our booths and we enjoy the fruits of our sales. We are—and should be—insistent about our status as artists, not merely street vendors. We bring to the public literally thousands of works of art by hundreds of artists in a single weekend at one location, to be seen and appreciated and, hopefully, bought.

I have never known a successful art festival artist who believed that selling was more important than creating. And I have never known a successful art festival artist who failed to understand that the purpose of exhibiting at outdoor shows is, simply, to sell.

Over the years, I have made hundreds of acquaintances among art festival artists, and quite a few good friends. One and all, they consider what we do to earn a living at our art not merely commerce, but, in large measure due to the special nature of outdoor art festivals, a lifelong adventure. In the conversations with them that take place at every art festival, after discussions about where we've been, what shows are working and which are not, our families and news of our colleagues, we look into each other's eyes with a special and rare interaction: we know.

If you can meet and overcome the challenges of a successful career at outdoor art festivals, if you choose to make the sacrifices that you must and live the lifestyle that outdoor art festivals require, I invite you to join us in that adventure. You will be rewarded in many ways.

The Art Festival Handbook, along with its sibling on the World Wide Web, www.theartfestivalhandbook.com,

where you will find much more information, is intended as a guide to that adventure, to the financial and personal rewards to be found along the way, to the clearest and most direct path, for both new and experienced art festival artists. Enjoy it, add to it, let me know what you think of it and how you would make it better. You are about to embark on a journey that not only allows you to smell the flowers, but also to paint, sculpt, photograph, draw, weave and carve them.

Travel safely, create beautifully, sell well.

CHAPTER ONE

What It Takes to Make It On the Art Show Circuit

ART, IT HAS BEEN said, results from extraordinary people doing extraordinary things.

Perhaps. Or, perhaps art results from ordinary people doing extraordinary things. It does not matter which definition you prefer. Both encompass the prime directive: *doing.*

This Handbook is about just that: doing. Not doing your laundry, day job, child raising, partying, television watching or emailing, not even about doing your art. It is all about entering and succeeding in the outdoor art and craft festival market, where every weekend of every month of every year, millions of dollars changes hands— from the art-buying public to the art-making minority. This exchange of value, money for creative output, represents a large fraction of the artwork sold in the United States. And it allows tens of thousands of artists to sell, and therefore share, their creative endeavors with many millions of people.

First, and foremost, if you are reading this book, you are or want to be an artist. You yearn to create, with paint or clay or metal or a camera or silver or gold—or wood, paper, fabric, thread, any of a hundred or a thousand materials. You want to spend hours and days, perhaps all the days of your life, translating your personal

and private vision into visual work someone else will see, enjoy—and buy.

What of art for art's sake? If art were created only for art's sake, it would be priceless—not in the sense of immense value, but completely without price. In the dim ages of prehistory, art on cave walls may indeed have existed for its own sake, but more likely it was used to record events, give direction, describe places and living beings. Artists do not create their work only to sell it; at times the notion of selling the product of our creative efforts is and should be very distant from the act of creation. But not to sell, or try to sell, our artwork leads to, well, a room full of paintings or etchings or sculptures very few, if any, people will see or enjoy. This is not to say that artists should—or even can—produce artwork for the sole purpose of selling it. In, of and for itself, the creation of art provides the creator with incalculable rewards. The process of marketing and selling our creative product adds to those rewards and allows us the income to pursue, enhance and broaden our creative output.

The notion that we artists work to sell has a certain unclean aspect to it; am I not the starving artist, for whom ideas and images and the immense satisfaction of *doing* are the sole reward I seek? If that is you, and satisfies your creative urges, so be it. You are blessed, and in the minority, and probably independently wealthy, or a teacher of art to others, in itself a noble endeavor.

Art, for the artist, has been described as the process of making meaning. This is not a new thought; making meaning, transmitting ideas or simply beauty, informs and sustains artists of every ilk. We transform what is within us, our ideas, visions, emotions and viewpoints, into something outside us, using talent, skill and technique. Paint or clay or metal or wood become invested with our hearts and souls. We change these raw materials, personalize and connect them to human thoughts

and feelings. We interpret our objective and subjective surroundings and reveal our very personal perspectives. Above all, we seek to communicate meaning.

For the viewer of art, the objective is to find meaning, to experience art created by you and me in a way that enhances life—through the talent and skills and intelligence of the artist who says, "I will make and communicate meaning." Making meaning is the *doing* of the artist. Finding meaning is the *doing* of the viewer. While this happens in museums and art galleries, it happens much more often in the venue of art and craft festivals held in cities and towns throughout the USA, to the tune of 30,000 different festivals each year, attended by many, many millions of people.

And when, at an art festival, a customer buys and an artist sells, the act of making meaning and finding meaning becomes a single, wonderful expression of completion for both: the artist has given someone, who has paid for the transmittal of it, his or her creative output and, it may be argued, transferred a piece of his or her self to the buyer.

Philosophically, that's terrific. Pragmatically, if you want to spend your days creating art, it is necessary. While creating art is truly its own reward, selling it allows you to continue receiving that reward.

Let me coin a phrase: transactional art. That is art which, either on purpose or by accident, is created and thereafter, by a monetary or value exchange, winds up in the possession of someone other than the artist. Only so many avenues exist for transactional art: from artist to buyer directly, from artist to buyer through an intermediary (be it a gallery, dealer or auction), from artist to buyer at an art festival. Unless the artist has an extraordinary number of friends and acquaintances, direct selling will not pay the bills. Intermediaries, including dealers, galleries, auctions, eBay and others, are rela-

tively few and fraught with many problems. That leaves art festivals.

Let's play a numbers game for a moment. If 30,000 art festivals, each year, have an average of 150 booths, that yields 4.5 million annual booths at which art is offered for sale. Assume, and it's a pretty good assumption, that the average artist exhibits at five festivals per year. That's 900,000 artists offering their art for sale. Let's estimate sales at an average of $2,000 per booth, for every booth in every show. It's a conservative estimate, as we shall see in later chapters. Multiply 4.5 million by $2,000 and, yep, it comes out to 9 Billion Dollars! Divide that by the 900,000 artists, and you have an average of $10,000 per artist, per year. Doesn't sound like much? It isn't, as later chapters will show, but it is a pretty safe average. This book is about, well, *doing* better.

Question: would you exhibit at an art festival knowing that you would earn $2,000 from the sales of your art at the show? Many, unfortunately, most, artists will say yes, that sounds good. They are the artists who do not need, or want, to make a living at art festivals. They may have other jobs, own businesses, bring in retirement income, have spouses who work and support them. A few will say yes, that sounds great! They are the true amateurs of the art industry, whose goal is to gain the title "artist" and wow their friends and families with a paint-soaked studio coat, tales of the little old lady who just had to have this or that watercolor painting, or a ribbon attesting to winning an "Award of Merit" at one or another show. Others will shrug and say, it's better than not selling at all. True, but insufficient.

Then there are those, the minority of art festival artists, who will laugh at the $2,000 per show sales number and suggest, for the time and effort and investment an art festival requires of the artist, they would rather lay

brick or paint houses or sell jeans or go on unemployment. To them—hopefully you—the business of selling their art represents the most important, if not sole, source of income for themselves and their families. To them, if the transactional art sold at outdoor festivals results in billions of dollars changing hands, they want more than a lamb's share of the proceeds; they want their sales to roar!

Not everyone is cut out for the art festival business. It is important to decide, first and foremost, if you are.

Well-thought out answers to a few questions will help you decide:

1. Do you create art on a continuing basis?

If you do, then you may have enough work to show and sell at outdoor festivals. If not, then you need to consider keeping your work, giving it to cousin Maude at Christmas, or simply stowing it in the attic. Success at outdoor art festivals—especially financial success— requires that you create artwork on a continuing, disciplined basis. The art festival business does not reward the so-called "Sunday" painter, or potter or sculptor. The business requires that you plan your festival exhibition schedule in advance, at times a year in advance, and apply to the shows you want to exhibit at months before they take place.

In a seeming anomaly that happens to all businesses, the price of success is the need to make more saleable products. So, as your art festival business grows, meaning you sell more work at more festivals, you will need to create more work to sell. This may sound like accepting a treadmill way of life and in some ways that does happen. You can control it, with self-discipline and a high regard for your goals, by careful planning and even more careful husbanding of your time and efforts. Most successful art festival artists I know complain often and deeply about the lack of time they

have to create. Yet they manage—by excellent application of their resources—to pursue both creating and selling their work.

2. Is your artwork transportable and showable at outdoor art festivals?

I am reminded of the metal sculptor whose steel monuments soared thirty feet into the air and weighed in the tons. He wanted to exhibit at art shows. Good luck.

Everything you display at an art show must be transported there, set up so visitors can see it, carried back to your studio or home and, no small point, taken by the buyer to his or her car and thence home. You can deliver large pieces to buyers, but only within certain boundaries, such as the size of your truck and the width of the buyer's driveway. Most artwork created by most artists can be taken to and displayed at outdoor art festivals. If you visit art festivals, you will be amazed at the range of work shown.

3. Is your artwork saleable?

At outdoor festivals, I have seen people selling painted, rhinestone studded toilet seats with Art Deco motifs, to a crowd that lined up all day to pay $200 or more for one. I have also seen bronze sculptors sell life-size human and animal figures for upward of $50,000, each. I have seen dozens of painters selling oil paintings for $5,000 and way, way up (I think the record, for me at least, was a painter who sold a large oil of Venice for over $100,000 at a show in Colorado.) I have seen photographers regularly sell $500 prints, unframed, and jewelers with average sales of $5,000 per day, and basketmakers whose creations started at $2,000 and who sold several at every show. Your artwork can find an audience at outdoor art festivals and enter the realm of transactional art.

Among the 30,000 art and craft festivals held each year in the United States, you can find more than enough shows where your work, created by you, presented by you and sold by you directly to the public will generate a profit. Whether your work sells for $10 or $100,000, shows exist that provide a buying public for it. Your task, after creating your work, is to find, apply to, be accepted in and exhibit at those festivals. Customers exist at all economic levels all over the United States, in sufficient numbers to make your sales high enough to participate in the art festival business.

Sadly, however, many artists who begin doing festivals give up after only a few shows. Their reasons for quitting are many, ranging from the physical difficulties encountered in doing art festivals, to the time requirements that make weekends off a dim memory, to a lack of sales. When this comes from exhibiting work that is not saleable—which the public ultimately decides—the artist is well advised to reevaluate the work he or she creates and, perhaps, to continue doing it for personal satisfaction alone. Other reasons for low sales, such as entering the wrong festivals, poor presentation or improper pricing, can be addressed and improved.

4. Can I replace my income from my full-time job with sales of my work at art festivals?

Yes. I did. Many others have. Is it easy to do? No. But it can be done, and with just a bit more effort than it takes to *not* make a living participating in art festivals. We'll get to the how down the road. One cautionary note: most jobs and professions require a single-minded commitment to them, if the worker is to succeed. A bad accountant will likely not make much of a living, no more than a poor autoworker will retain his or her job. Artists who choose to make a living by their art must also be good at what they do. Unlike the straight world, what-

ever that really is, artists have few outside ways to judge
the quality of what they create. This makes the market-
place—art festivals—all the more important to them,
since, by accepting the notion of transactional art, sales
come to equal, in the mind and actions of the buying
public, a qualitative acceptance of the artist's work.

As I write this, I can hear the sniffing of metropoli-
tan art critics, museum curators and the like, for I am
saying that what sells determines what is good. It is a
very democratic notion, allowing the people to decide
first, what is art and second, what is—at least to them—
good art. It is also the only way most artists will ever
have to look in the proverbial mirror and say to them-
selves, I Make Good Art. Does this truly matter? To
some artists, yes; to others, no. The simple truth is that
the more of your artwork you sell, the more you can af-
ford to create and, as in most endeavors, over time you
might just get good at it! In the interim, you will cer-
tainly enjoy eating regularly and sleeping indoors.

What of the people who come into your booth at an
art show and love your work and do not purchase it?
Well, they are great for the ego, and they may be buyers
in the future. They can also add a dimension to your life
that goes beyond selling your work.

Once, a very, very elderly lady, a senior among sen-
ior citizens, entered my booth and fell in love with my
photographs. She spent an hour or more looking at
them. She looked up at me before she left and said she
wished she could afford to buy one. The next day, she re-
turned with her daughter, and could not stop smiling
over the photographs. Her daughter was sweet and sup-
portive. After another hour, I told the lady to pick out a
print; it was my gift to her. She started to cry, which un-
settled me. I explained that she had given me more than
money; she had obviously found something in my work

that held deep meaning for her. No money changed hands, but I was enriched by the transaction.

Outdoor art festivals offer some of the feedback that other art sales and exhibition channels do, beyond even emotional fulfillment. Many shows offer prizes for excellent work, using judges from the art world—gallery owners, curators, artists, art educators—to evaluate and award both ribbons and cash. These become ego-boosting moments for the winners and motivation to create better work for the rest of us—and the extra income is always welcome. Artists may be mentioned in press coverage of a festival, with pictures of their work. Architects, gallery owners, even museum curators visit festivals looking for artwork that they may be interested in buying or exhibiting.

But unlike galleries and even museum shows, outdoor art festivals bring us closer to the public, in fact into direct contact with the people who will or will not think enough of our artwork to purchase it for their homes or offices or business locations. If you participate in ten outdoor festivals in a year, and these are attended by 10,000 people each, you have the opportunity not only to display your work to 100,000 in twelve months or less, but also to interact with them—not all of them, of course, but many thousands. Few, if any, galleries or even museums offer either that exposure or opportunity.

The art world is a large, complex, ever-changing part of our society and culture. It is an amorphous world, without strict hierarchies—at least for the most part—and with few clear paths to success, however the artist defines that term. Every city, and most towns, have art associations you can join and local, small art shows you can use to display your work. These are not part of the outdoor art festival industry, but they do offer the casual artist a way to display his or her creative product. You can approach galleries and dealers to handle your work,

as many artists do. These are limited venues, difficult to enter and even more difficult to use in maintaining an ongoing income. You can find so-called "cooperative" galleries, where you trade time and work for space on the co-op walls. You can even pay for wall space in some galleries; many artists follow this path. And you can approach museums and universities—there are many across the country and world—with your portfolio, asking for a review and possibly a place in their collections or a showing of your work. A more traditional segment of the art world, where art students become art educators and, over the course of an academic career, create and exhibit their work, appeals to certain artists, whose immersion through a career path brings them satisfaction.

These, and more, are all valid segments of the art world. You may decide to limit your exhibition and sales effort to this sort of environment or, as many art festival artists do, add one or more of them to your outdoor festival business.

The outdoor art festival industry is a large, multi-billion dollar part of the art world. Art festivals offer both challenges and rewards that other avenues to sales and display do not. Learning the pathway to success in the outdoor art festival business requires time and perseverance. If you have what it takes to succeed in outdoor art festivals, it is worth the effort.

Where does this lead us? To this Handbook. Its reason for being is to provide you, the artist, with a clear, practical path to the buyer of art, while keeping intact your vision, talent, skill, commitment and artistic integrity. One way this can be done, perhaps the *only* way it can be done for a majority of artists, is through outdoor art festivals. Once you have looked at the requirements of the art festival business, arrived at the conclusion that it suits you and you it, and made the decision to

embark upon the journey, the Art Festival Handbook will assist you at each turn along the way.

Go and do, and above all, enjoy!

CHAPTER TWO

What Sells—and Doesn't—at Art Festivals

WILL YOUR WORK, YOUR outpouring of creativity, sell at outdoor art festivals?

At which outdoor art festivals will it sell? How do you determine the festivals that are right for you?

These, of course, are the first, most important and most difficult questions in the art festival industry. A metal sculptor I know spent years making stylized insects from copper and brass and glass (this last for the eyes of his dragonflies), participated in up to forty shows a year and barely squeaked out a living. When his spouse, who worked alongside him, reached the end of her credit card rope, they split. He, being a fine and generous fellow, acquiesced to her desire that she keep the bug business.

Looking for another outlet for his creative juices, he settled on large abstract wall pieces fashioned of metal. Immediately, they succeeded at the shows. He regularly sells all of the ten or so wall sculptures his booth accommodates and takes orders for one or two more—at prices from $500 to $2000. Wifeless and bugless, he is nevertheless smiling all the way to his annual vacation in the Colorado Rockies. His wife, by the way, has made the bug business a buzzing success.

Another artist, like myself a photographer, produced quite beautiful landscape and nature studies and did just okay. His wife, a painter, began painting extensions

of each photograph on frames they make out of wood. This "mixed media" approach caused the couple to triple their prices—and they can't keep up with demand.

And then we all envy the bronze sculptor whose average—average—show receipts exceed fifty thousand dollars. At twenty shows a year, that's. yes, a million dollars. It's true, and you can close your mouth now.

Or the oil painter, of large-scale fruits and vegetables, paintings five feet by six feet and larger, for whom the sale of three or four $10,000 paintings represents an average show.

And finally, the photographer—me—whose average year exceeds—no, that's between me, my accountant and the IRS. I'll just say it is a good living.

But for every winner, there are a hundred who do not do well in the outdoor festival business, quality artists who barely pay their rent or mortgage, who regularly take day jobs between show seasons, who sell insurance, or cars, to get by. They are painters and sculptors and lithographers and photographers and weavers and basketmakers and jewelers and practitioners in every medium permitted to exhibit in shows. Many are talented, skilled and personable. Often they are experienced in both art and commerce. Usually, they come from two-income households—the spouse providing the bread and butter, the artist bringing home the gravy. Lately, many are retired from boring mainstream jobs of all descriptions (my personal favorite being the ex-chiropractor who trades me back treatments for hints on how to photograph his jewelry. Wonder why I like him so much?). Add in baby boomers seeking the exhilaration of his or her hippie youth, the newly minted art school graduates who can only count to ten by leaving out the numbers nine to five and the wealthy-by-inheritance for whom a beret is a badge of courage, and you have the art show business: a minority of professionals, a majority of

amateurs; ten percent who make a good, sometimes great, living, ninety percent who eke out a minimally acceptable sustenance, or who exhibit at shows for added income, ego boosts or just to pass the time on weekends.

What makes the difference between these two groups?

It is, first of all, about the art. The work you exhibit should be excellent in artistic quality, a very subjective judgment. It should be beautifully presented in a show booth that mimics a fine art gallery. It should be priced high enough to seem, by its price alone, high quality art, and low enough not to exceed the average showgoer's means—or the price range of comparable work (much more on this later). It should appeal to a broad sector of the public, since the public is whom you must sell to and it cannot, ever, be created and presented solely for its shock value. In a word, it should be mainstream.

So what about "artistic integrity"? Let's define the term. If by artistic integrity we mean the right to smear dog caca on a canvas and coat it with varnish and call it art, simply because the artist believes it is art, that's fine, but no one will buy it at an outdoor show. If by artistic integrity we mean excellent skills applied with a developed, sensitive talent to a subject that creates emotional responses in many viewers and, thus, earns a place in their homes—and along the way creates in the viewer a new appreciation for the subject and medium—the work will undoubtedly find an audience, all other factors being equal.

One other note: I once bemoaned to an art expert all the people who visited my booth looking for something to match their sofas or bedspreads or wallpaper. I said I was tired of selling wall decor and wanted to sell fine art. She laughed at me and said, "The Sistine Chapel is wall decor."

The lesson: leave your "artistic integrity" in the studio. Nobody cares, and it doesn't sell anything. Bring, instead, your best work, geared to the people who attend the shows you participate in, and you will make a living. Price it and present it well, and you will make much more than a living.

But enough about "what sells" in the abstract. Let's look at it in the particular. What sells at outdoor art festivals ranges from the good to the bad to the ugly. Some rules apply. Show attendees expect prices to be lower than in galleries or stores. Why? They are dealing directly with the artist, no middle-person involved, and thus believe they are entitled to a better price. This may not be a realistic expectation, since artists do not want to lower their prices when their work is sold in any retail environment. From art galleries' perspectives—many artists sell both at outdoor shows and in galleries—artists whose price on the street is lower than in the gallery will soon find themselves without gallery representation. Undercutting your galleries is, at the very least, a no-no.

Festival visitors expect the work to be of the highest quality, since, according to the show organizer, this is Art they are viewing. They want the work they see in any one booth to be of a family, that is, thematically related and exhibiting the artist's unique vision. They want it to rise in value—even though little that we buy in life outside the financial markets has any chance of being worth more tomorrow than today. Some festival artists respond to this concern by raising their prices each year, so that repeat visitors to their booths will think their earlier purchases have increased in value. They want the creator to be a true "artist" and like to believe artists do indeed starve (if we did there would not be many of us, would there?) for the joy of their creative lives, or at least struggle. And, above all, they want a re-

inforcement of their chosen purchase as special, preferably unique (even though the painter has a dozen similar pieces in boxes behind his or her booth). We will revisit these principles later and in detail, but for now, to answer our question of what sells: what sells is what convinces the buyer is art, not junk, no matter the price, medium or subject matter of the piece.

Artwork sold at outdoor shows falls into categories the show promoter or organizer uses to easily define which work will be accepted into the show for exhibit and sale. The usual categories are: painting (oil and acrylic); watercolors; mixed media (two-dimensional); mixed media (three dimensional); sculpture; drawing; photography; printing; graphics; paper; baskets; clay; fiber (decorative); fiber (functional or wearable); glass; jewelry; leather; metal; wood; furniture; toys; and "other". Not all shows will have all these categories included and there is usually some overlap of definitions, For example, "graphics" may include drawing and "sculpture" may include metal. Most shows define the categories they accept in their show applications, and those that do not invite inquiry if the artist has a question. You will on occasion see an unusual category, such as in the application for the highly regarded Boston Mills Art Festivals, held at a ski resort outside Cleveland, Ohio. This show has a category entitled "Multiple Images" that includes photography, lithographs, etchings and other limited edition but not one-of-a-kind images. Craft shows may have even more categories.

Another way to look at what sells: work sells in all the above categories, or no artist would apply in them.

But what sells best, or to make it clearer, which categories draw the most money from the showgoing crowds? This is really a three-part question,

Part I: Which categories sell best at which shows? Certain festivals are known as "painters'" shows, for ex-

ample. Others regularly include a fabulous selection of sculpture or ceramics. Some shows emphasize what are called "Fine Craft", such as ceramics, over "Fine Art" such as oil painting. Jewelers thrive in many shows, but do dismally in others. "Contemporary Craft", at times with no "Fine Art" included, can refer to modern craft categories—glassmaking—while "Traditional Craft" encompasses older skills, such as hand-weaving or wood-carving. Again, there can be much crossover among these definitions. Applications to festivals usually define what fits into their application categories.

How, if you are a watercolorist, do you determine which shows sell best for your fellow watercolor artists? A few clues exist. *The Art Fair Sourcebook*, which lists and rates the top 600 outdoor shows in the nation, distinguishes between fine art and fine craft festivals, and lists the percentage of each in all the shows it rates. The AFSB also divulges how many artists in each media display in each show. A festival that is 70 percent fine craft, and includes only two or three watercolorists, will not likely favor sales for a watercolor artist (or a painter, photographer or sculptor, for that matter). You, as a watercolorist, would do well not to apply to such shows.

The best determinant of a show in which you can expect to sell well is experience: do a show once, or twice, and you will know how well it produces sales for you. Second best—and a close second depending on your sources—are the opinions of artists in your medium about shows they have done. A caveat here: not all artists will tell other artists how they truly fared at particular shows. Competition out there is high, and some artists would rather not divulge that a show produced twice their usual sales. In fact, the most successful outdoor festival artists have simple, usually one-word responses to the question "how was the show?" Over time, you will find, as I have, that certain artists with whom you de-

velop personal friendships will share their experiences, in return for equal openness from you. Successful artists form a rather small, tight community, and one of their goals—we'll discuss why further on—is to have only the best and most successful artists in the shows they do.

You may also consider visiting shows you want to exhibit in before applying. This can be difficult if the festivals are far from home, but valuable whenever the opportunity exists. You can also contact the show director, committee members or promoter and ask what media seem to flourish in their festivals. Often they will be forthright and do their best to answer your questions.

Part II: Will my work, its style and price and subject matter, sell well at a particular show?

Again, experience teaches here. But certain assumptions can be made. The first is regionality, and it stems from common sense. Paintings of palm trees rarely do well in New York City (or any northern city, for that matter). Abstract sculptures rarely succeed in places known for historically imperative figurative work, such as the cowboy bronzes of the Southwest. The second is price. A show in a small, rather isolated city will not usually include many painters with pieces selling for five or ten thousand dollars; too few people able or willing to spend that much attend the show. The third is crowd quality. This tends to be a bit difficult to define. For example, in Fort Worth, Texas, the annual national art festival held downtown draws upward of 250,000 people. The show is very high in quality, easily among the top ten percent nationwide. But the crowds come mostly for the excellent free music, which plays on three stages for eight to ten hours each of the four days of the festival. They enjoy the beer, hot dogs, regional food, and a host of other attractions. The festival is an "event" more than an art show. Perhaps one in ten visitors even looks at the art.

Thus, the real buying crowd is perhaps 25,000, equal to or less than many top shows with far smaller attendance than Fort Worth's. So the 250 or so artists vie for the dollars of 25,000 potential buyers. As a strong Southwest show, certain styles and levels sell best: realist, conservative, mid-priced. The crowd is remarkably knowledgeable about art. Back to our watercolorist: in Fort Worth, watercolor is considered a secondary form of painting (not for any good reason). The people who buy prefer to have oils on their walls, even if the painting is inferior to a watercolor sold in the next booth. It's a Texas thing, I believe; regional character influences the purchase of art, of course. I would advise our hypothetical watercolorist to think carefully before exhibiting in Fort Worth. It is long (four days, three of them ten hours); hot (often in the 90's), expensive (high booth fees, upscale hotels and restaurants); difficult (booth spaces are sub-optimal in size and have no storage). Anyone who has participated in the show knows these elements and returns only if their sales are extremely high. A good friend in the business will pass these points along.

Part III: Does the show attract people who will buy my work?

This represents the crux of choosing at which shows to exhibit. The answer is part economics, part demographics and part show character.

Economics dominate the question. If you sell fifty-dollar drawings, your market is larger than for five thousand dollar paintings, of course. More people have fifty dollars to spend than five thousand. Few shows are good for both ends of the market, although there are exceptions, usually the larger events that draw big crowds. I exhibit at a show in northern Florida that attracts only well-heeled customers, and not many of them—perhaps two thousand on a good weekend. I also do very well at the show consistently. My buyers are there, for photo-

graphs priced up to $2000. Jewelers with $2,000 neck-
laces and $1,000 gold rings do very well. Why? Everyone
in attendance has money to spare.

For a few years I exhibited at a show on the East
Coast of Florida in a middle class town, with good new
housing development and lots of people in attendance.
Couldn't make the show work. The public simply did not
have the money—or the desire—for high-end photogra-
phy. Artists with beach scenes priced at the low end of
the painting scale consistently sell well at the show.
Most others waste their time and booth fees. Many art-
ists participate year after year because the festival offers
awards totaling nearly $50,000, with several prizes for
each medium. Although about 30 awards are given out;
most of the 200 other artists must rely on their sales
alone.

The practice of presenting awards to artists chosen
by one or more judges is controversial. Certainly, awards
add a bit of excitement for the exhibiting artists and
many shows "grandfather" award winners for one or
more future festivals. However, artists often complain
that the same people seem to win awards at the same
shows, year after year. While this may be a bit of sour
grapes from those who do not win ribbons, cash and a
guaranteed acceptance into future shows, you will also
find artists who enter festivals only for the award com-
petition. Their work may be far too expensive, or edgy,
for the buying public. It may also stand head and shoul-
ders above much of the other work on display. Awards
can distract you from evaluating a festival on its other
merits, such as sales and crowd demographics that, in
the end, are more important.

The economic makeup of a show's attendees, which
usually means the population in the immediate area,
creates the base of buyers for a show in that area. A
wealthy population generally means sales of expensive

artwork. A working class population usually indicates that only lower-end art will sell. A middle-class population is more difficult to analyze. If the people are mostly blue-collar, such as in manufacturing, low to middle price work will probably sell best. White-collar middle-management populations often indicate a propensity toward mid- to upper-level priced sales. You can choose shows appropriate to your work by analyzing the income characteristics of location. It's worth doing. The internet offers many sites, including those run by governments or chambers of commerce, that offer in-depth information about a particular place. Also, take into account the economic vitality of the location. Cities hit hard by economic downturns—Reston, Virginia when the dotcoms failed, for example—can mean low or even no sales until the economy rebounds, even in very upscale locations.

Demographics follow closely on economic indicators for show analysis. For example, places with high incomes but a large proportion of senior citizens who have owned their homes for many years will likely not be fertile ground for sales; the walls are filled. Northern cities tend to be good examples of stable populations whose art needs have been for the most part fulfilled, but not always, because some northern cities are noteworthy art markets. Washington, D.C. is perhaps the best example. People there simply love art and purchase what they want, wall space be damned. In Pittsburgh, art is usually a tough sell, except in neighborhoods such as Shadyside, where an upscale Yuppie urban renaissance is taking place and young professionals abound, most of them renovating old houses and apartment buildings.

Demographics also encompass education levels, for our purposes a factor which I call art sensitivity. In the last few years, photography has become the art to watch and collect, the rising star among the media. In some places, this is well known and followed by art buyers and

photographers are doing well there. In others, the popu-
lace doesn't follow art trends and could not care less. Be-
thesda, Maryland, a Washington suburb, is a hot pho-
tography market; a few miles away, in Frederick, Mary-
land, buyers think of photography as a secondary art
form; unless an image reminds them of their trip to Tus-
cany, it isn't worth owning. So, in Frederick, which has a
wonderful annual community festival, the wealthiest
residents—and many there are indeed well off—opt for
traditional oil and acrylic paintings. Of course, things
change over time. Frederick has become a haven for ex-
urbanite Washingtonians who want a simpler, quieter
lifestyle, within commuting distance—albeit a long
commute—of the nation's capitol.

Let's draw a conclusion up to this point: if your work
matches the economic level of a show's community, and
the demographics seem likely to respond to your me-
dium, style and price level, include the show in your list
of "possibles." If either factor falls outside the positive,
put the festival in a "maybe later" category, if at all.

The last denominator, show character, is a more
slippery concept.

Every art festival has a character of its own. Defin-
ing that character takes a bit of thought and selective
application of characteristics. Outdoor shows fall into
two primary categories: promoter owned and operated
and community owned and operated. The first category
includes show promoters such as Howard Alan Events,
Amdur Productions, Thunderbird Artists and others who
run several shows. We can accurately call these "for
profit" art shows. Community shows are created by one
of several types of organizations, including local arts
groups, museums, civic clubs such as Rotary, town gov-
ernments, parks departments, business associations,
and many others. They are generally not-for-profit, but
most use the shows to fund other programs, such as the

highly regarded Longs Park Art Festival in Lancaster, Pennsylvania, which exists to benefit the park's orchestral concert series.

In general, the two types of show operators—and shows—will have very different styles. The promoter-owned shows, in essence, rent you a booth space for the duration of the show, spend part of your booth fee on advertising, some on show operating costs, and keep the rest as profit. The community festivals usually offer cash awards for artists in various categories, provide an artists' dinner or brunch, send people around with snacks and beverages, offer booth sitters so the artists can take breaks and work to provide a comfortable and helpful environment for the artists. These shows will often have volunteers from the community doing most tasks, and spend most of their booth fee income on prizes, operating costs (including salaries for show directors) and advertising, keeping the rest for their non-profit causes. On occasion, you will find a promoter, such as Amdur Productions, who does offer some of these amenities.

Which is better? Neither, and both.

Promoter shows offer little in the way of frills for the artist, but are run by highly experienced, organized people who have a profit motive: if the shows don't do well for the artists, the artists won't return and the promoter's revenues will fall. Promoters therefore benefit by bringing in hordes of potential customers. At the same time, however, promoters will cancel shows that don't offer acceptable profits to them, even if the shows are good for some or most of the artists who exhibit. It's the way of all commerce: profit comes first, or you go out of business.

Festivals run by promoters can also suffer in the quality of art displayed. While most promoters screen artists' work for quality and suitability, and some even have independent juries do the choosing, the level of art

can be spotty, since the promoter must fill as many booths as possible. In the end, the promoter's profit motive can override show quality. The best promoters do understand that shows with low or diminishing quality will at some point fail; they work hard to keep the quality of art high.

Also on the positive side, promoter shows usually are consistently operated, with few surprises for the artists. Staffs are for the most part professionals. The rules at the shows are clear, enforced, and generally equitable. And being able to deal with a single organization for several shows means less time spent on paperwork, applications and telephone calls. Exhibiting costs at promoter shows run about equal to those at community shows although, of late, booth fees at promoter shows have risen faster than at community events.

Many promoter shows are high-selling events, such as Amdur Productions' Port Clinton Art Festival, a perennial top ten show, and Howard Alan Events Alexandria, Virginia show, which, in its first year, ranked fifteenth in the nation in *Sunshine Artist* magazine's annual poll. An important consideration is that the larger promoters produce many shows in series, allowing artists to plan for whole or partial seasons in advance with some certainty about their schedules.

Community shows vary widely in almost all aspects of their operation. They may be one, two, three or more days long. They occur in cities, towns, and the countryside. They are usually well supported by their communities, take excellent care of participating artists, work hard to maintain a high level of quality and truly support the arts. Press coverage will often be extensive, even including remote broadcasts on local and cable television stations.

But, and it's a big but, community shows are also capable of losing focus, allowing in sub-par artwork, grow-

ing too large or shrinking too much, failing to promote adequately to attract buyers, favoring local artists without regard for show quality, having parochial attitudes toward acceptability of work (no nudes, for example), scheduling hours of operation that make no sense (such as the show in Tampa, Florida, that has the unbelievable practice of offering the artist dinner during show setup, leading to either eating or preparing your booth, but not both. Most artists don't eat).

Strange things do happen at community shows. Once, in Michigan City, Indiana, rain began to fall Sunday afternoon, the second day of a two day show. I waited for an hour to hear from the show staff whether we would close early, since all the attendees had left. Eventually, I went looking for the show director, who was packing up her paperwork at the front of the show. When I asked what the policy toward closing early was, she said, literally, "do what you want" and hurried to her car. Over one hundred artists were left without instructions.

Yet community shows dominate the list of best-selling events. Most have long histories, often over a quarter-century, with ties to important arts and media organizations. Show coverage in the media tends to be excellent and broad. The best of the community shows can earn artists huge sales, year after year. These, of course, are the most difficult shows to jury into, meaning your work has been reviewed and accepted by independent, often paid, arts professionals. The flip side of this principle is that community shows can go downhill fast, losing their audience and thus your sales, in only a year or two. The prestigious and excellent Austin Art Festival, one of the nation's best for many years, moved from a lovely park next to an art museum to a dusty, rather ugly and construction-filled downtown area a few years ago. Some people—high-ticket buyers especially—

stopped coming. Artists' sales fell quickly to a fraction of their peak and top artists stopped exhibiting. The organizers filled booths with local artists, whose earnest work unfortunately didn't measure up. More people stopped attending. In three or four years, the show took a steep dive, one difficult to reverse. Austin worked diligently to regain its status and to some extent has—only to change the show location again.

This first indicator of a show's character—promoter or community—offers the artist two large groups of shows to choose from and to which other characteristics can be applied.

The second characteristic is attendance, itself a slippery eel of a subject and one that shows are extremely loath to discuss at length. Festivals vary in attendance from a few hundred to a few hundred thousand. At the lower end are local art organization shows (but not always; the Mount Dora Art festival in Florida attracts a quarter-million visitors and is operated by a small arts council). Smaller attendance usually means fewer artists. This generally is bad for sales, but also means fewer competitors for the buying dollar and prize money. Community shows may charge admission, from two to twenty dollars. This often lowers attendance, but increases the quality of attendees when it comes to buying. In 2004, the nationally prestigious Coconut Grove Art Festival began charging admission, cutting attendance at least in half. But sales went up for almost all artists; the crowd quality soared.

Nevertheless, it is axiomatic that more people mean more sales, yet not for everyone. If your work doesn't appeal to the crowd, a bigger crowd won't help. The quality level of a given show is much more important to sales than the size of the crowd. The public has expectations for every art festival, meaning that the people expect the art displayed to be of a certain level of quality and price.

If your work doesn't fit that expectation, on either the high or low side, you simply won't find a buying audience. Here's a parallel. Let's say you open a low-end shoe store in an upscale mall. The people who visit the mall will be predisposed toward seeing and buying high-priced merchandise, including shoes. Your shoes won't sell; there is no ready buyer for them. The same holds true for outdoor art festivals. While selling good artwork at lower prices might sound correct, you simply can't do it when the people coming to the show expect to find only high-priced art. And the converse is also true. High priced art offered among $25 dollar prints will not find many buyers, even if a portion of the public can afford your high-priced work.

Thus we add another piece of the show character puzzle. There are more. Is the show in an urban, suburban or rural setting? The excellent Boston Mills art festivals are held miles from the city of Cleveland at a ski resort. Customers must travel to the show on purpose, thus ensuring that anyone who attends really wants to be there.

Is there an admission charge? Most people won't pay to see an art show unless they are really interested.

Is the show attended by a single age group, or several? A broad age spectrum indicates interest in many styles of art.

Are the show hours acceptable for people coming to the show? Hours that are too short cut off the supply of potential buyers. Hours that are too long may indicate a lower than optimal attendance, with the show organizers trying to make up for the problem with long days.

How many days is the show? Shows that run too many days allow customers to walk away saying they can always come back. Sometimes they do, often they don't.

Is advertising optimal and is the local media suppor-
tive on its news programs? You must let the public know
if you want them to attend.

Does the quality level of the show indicate that your
work will fit in and therefore become attractive to the
customer? Being a fish out of water means dying of
thirst—sales thirst in this case.

Finally, does the show center around the art or are
there other elements that influence audience size, demo-
graphics, buying desire and quality of art? Few aspects
of outdoor art festivals rankle as much as setting up
your booth and display and finding out you are ten feet
from a stage featuring loud rock music, or a food court
with fifty vendors. Just about every show includes non-
art booths and areas. These may include: a children's art
area, where youngsters can create simple crafts and par-
ents can get a break from listening to their offspring
complain about being bored; sellers of show-related mer-
chandise, from cookbooks to t-shirts to festival posters;
lemonade stands, popcorn stands, arepa stands, hot dog
stands, ice cream stands and vendors of every other
foodstuff known to humankind; musicians in booths
mixed in with the artists who sell CDs of their songs;
show sponsors, including but not limited to car dealers,
window and storm door dealers; cellular phone compa-
nies, insurance companies, banks, hospitals, newspapers
and magazines and picture framers.

Two schools of thought exist about this wide-spread
practice. One, sponsors and other vendors support the
show, lowering artists' booth fees and increasing traffic.
Two, they are no more than a distraction, attract the
wrong crowd and serve to take space from worthwhile
artists. I believe both viewpoints have validity. Art show
visitors certainly need food and drink and may stay
longer when these are provided in abundance. Yet cellu-
lar phone companies seem to merely take up valuable

space and distract showgoers, as do car dealers and window installers. Media sponsors, such as television stations, provide valuable and otherwise unaffordable publicity. Kids' art areas engage and involve children, making it easier for parents to attend festivals. But the large and prestigious national festival that always includes booths selling orchids, bonsai trees and exotic plants may have gone too far. You must judge for yourself whether a particular festival has exceeded an acceptable level of non-artist participation; your sales experience will be the best guide.

All these questions need to be answered for every show you look into doing. You will find other show character indicators as you investigate shows and talk to other artists. The important point is to delete from your potential show schedule those festivals that clearly do not have a character in which your work will fit.

Once you have delved into the character of a show, it's time to look at some of the more practical matters: distance, cost, logistics and the show's environment. These have a real relationship to what will sell at a show, and to what you can expect from your own sales efforts.

Travel is a wonderful way to see the world, explore new and exotic places, recharge your personal batteries and build fond memories with your companions. Traveling to exhibit in art festivals can be long, tiresome, boring, dangerous and expensive.

Do the twain meet? Sometimes, when your journey and your destination fulfill the first set of travel goals and you earn enough money to make the second set of goals worthwhile. Many artists, it is true, travel for pleasure as well as for profit. I am one of these. Every summer, my wife and I book shows in the Rocky Mountain states and marvel at nature's wonders, both en route and when we arrive.

Yet, even the best destinations become tiresome, when the distances are vast and the costs astronomical. In Aspen, Colorado, for example, $250 per night hotel rooms are the norm. From my home to Aspen is a four-day drive, going really fast, on interstates. The scenery leaves much to be desired until we reach Denver. Restaurants and hotels en route tend to be pricey and dreary and you can actually find rest stops where the bathrooms are no more than a series of outhouses. The show we participate in there can be a logistical nightmare, as it is in a park and all our display components, as well as our art, must be dollied in over thick grass or simply carried. The price of a single booth space approaches $500 and I am certain will cross that line in the near future. Artist amenities are, to be blunt, nonexistent. Weather, which can be fine, can also turn violent in a few minutes; afternoon storms come with a swift fierceness.

On the flip side, the work in the show is excellent. The public is wealthy and buyers are abundant. My record of sales at the festival ranks in the top five, year after year, of all my shows.

Then there is the painter friend of mine, from Arizona, who comes a lesser distance, stays in a relatively inexpensive, if older, condominium hotel and tries not to partake of restaurants where a hamburger (with fries) can run $30. Yes, Thirty dollars! All this notwithstanding, in 2007, this artist's sales at the show totaled less than $500.

Thus the two sides of looking at practical matters when you choose shows. For me, this show would be wonderful whether close to home or nearly a continent away. For my painter friend, the clean Colorado air and a nice suntan are about all he gets from exhibiting. Might I have a bad show in Aspen one year? Certainly. Might my friend have a good show there? Quite possibly.

But if I have one bad year out of, say, six, I will return and my friend, if his lights are all on when he considers where to apply, would be better off staying home and painting.

The Aspen show has all the earmarks of a fine selling event for my painter friend, but the practical side of matters indicates the risk is unlikely to equal the reward, in any year. He cannot be blamed for applying to the Aspen show and, once accepted, going there to exhibit. To mitigate his travel costs somewhat, but not enough, he books three or more shows in a row, using the time between weekends for painting and sightseeing.

The point is this: after all is considered, your own history exhibiting at festivals will be the best and possibly the only barometer of which shows to do. Using the yardsticks in this chapter and later in the Handbook, and adding in others you may find, will only tell you what *might* be a good show, not what *will* be. As in so much of life, experience is the best teacher.

CHAPTER THREE

Understanding How Art Festival Finances Work

ART IS ART AND business is business, and never the twain shall meet, correct?

Wrong! Yes, art is art, or better yet, Art is Art, but to succeed in the outdoor art festival business, you must commit the seemingly unpardonable sin of thinking and acting like a businessperson. You may decide, in order to escape the potential ridicule of artists who believe the word business has only four letters in it, to keep your business-like thinking to yourself. However, I will wager an MBA in accounting (which, thankfully, I do not possess) that, were they willing to admit it, all successful art festival artists conduct their activities as serious, if small, businesses.

Most successful business people develop and carry out a business plan; properly finance their enterprises; keep good business records; understand profit and loss; learn to construct and read a balance sheet and income statement; comprehend all the other terms, principles and practices that make a business run. In a perfect melding of the artist and the businessperson, those tasks would be easily accomplished. We do not live in a perfect world, fortunately, for if we did, many of us would not toil ceaselessly to bring beauty to others through our art. In this imperfect world, many of the aspects of business can be left to the accountants and bookkeepers and bankers. What we must do is comprehend how to oper-

ate and expand our little art empires using a bit of business-like thinking, translated into the way we approach, and execute, our art festival businesses.

For example, this truism of the business world: a business survives on cash flow, but grows on profits. What does that mean? Simply that if the money that comes in adds up to less than the money that goes out, you will be out of business or in debt soon, unable to pay this month's bills. That is cash flow. If the sales of your art exceed all your expenses, your little art company will thrive; if not, well, find a day job. That is profitability.

Basic business principles are not difficult to understand, even if you are an artist. The best approach to the everyday business requirements of exhibiting at outdoor shows is, first, find a qualified accountant to take care of the more arcane aspects of business—taxes and the like—and, second, follow a strict record-keeping regimen that will keep you out of money trouble. Finding an accountant is a task you must undertake on your own. Business records can be kept by you, your significant other or a bookkeeper. In our computerized world, software equal to the task can easily be found and used. What we will tackle here and what is most important to your success as a festival artist, is an understanding of how money works in the art festival industry—as a business—and what you can do to fit into that system and prosper. Indeed, to put your mind at ease, we need not even tackle the vocabulary of business theory beyond a few important items; we can work from the viewpoint of the art festival business and let the theory reside inside our day-to-day methods of running our art festival businesses.

When you exhibit at an outdoor art show, except for a very few notable exceptions, the money from your sales comes directly to you, not to the show's organizer. The exceptions, which I personally do not recommend par-

ticipating in, are shows that charge a percentage of your sales, rather than a flat booth fee, and may collect the money from sales at a central location in the show, paying you your percentage. These few shows, instead of organizing and running the show and leaving the rest to you, become partners with you. Few artists I know want partners; I certainly do not. The show takes between ten and forty percent of your sales. That is simply too much to sacrifice.

The vast majority of shows charge a flat fee for your booth space. The fee can vary from about $100 to over $2000. Why the large difference? Shows at which artists can expect—if they are successful—to sell many thousands of dollars worth of their work can charge high booth fees; a large pool of artists is willing to pay the price. Shows that sell less well cannot command high booth fees. Is this a key to shows worth your consideration? Perhaps. While it is logical that a show charging high booth fees has many high-selling artists exhibiting, this does not mean that the show, the area, or the company of artists will work for you. It also does not mean that the level of the art is a good mix with your work.

Booth fees have been climbing in the last few years, as have other costs, and now average approximately $400 per show, for a single 10' by 10' booth, the basic standard. Corner exposure booths can add $100 to the fee; double booths another $400.

Your largest expense at an outdoor show will not be the booth fee, at least not unless you can stay free at the show, with friends, or at home, and pay nothing for meals. Travel costs, when they involve shows more than a day's drive from your home, consume far more dollars than booth fees, at nearly all festivals. In 2007, a fairly conservative average of travel costs was $200 per day, with an added $50 per day for a second person. Skyrock-

eting gasoline prices may soon add significantly to that number.

Experience has taught me, painfully, to budget for extraordinary expenses, too. These may include emergency vehicle repairs, replacement of torn clothes, patent or prescription medications and any number of other needs or desires. Every expense reduces your take-home pay. Sounds simple and obvious. The trouble is, many art show expenses are not all that easy to see, or remember, or keep a record of for show analysis or tax reasons.

Okay, now to the stuff that, while boring to most people and to all artists, can make the difference between a nice wad of cash in the bank and a huge balance on your credit cards.

First, the income: sales of your artwork. Nothing more, and nothing else. If you sell related items that are made based on your art at festivals—note cards, for example—the income from these should be included (some shows permit sales of derivative merchandise; the majority do not). If you bring in money by selling your work in other ways, such as through galleries or over the internet, these, too, are income; however—an important point—these sources of income are not part of your art festival proceeds, and should be excluded when you evaluate the shows in which you participate.

Next, the expenses. You will incur the majority of them at every show:

1. Booth fee, which is really the rental cost of the ground beneath your booth for setup, teardown and the duration of the festival.
2. Show application, or as it is often called, "jury", fee.
3. Lodging cost. If you drive an RV, substitute RV park fee.
4. Meals, on the road and at the show.

5. Snacks, on the road and at the show.
6. Parking, at some shows.
7. Gas or diesel fuel for the car, van, truck or RV.
8. Setup and teardown assistants fee. Some artists hire helpers, others do the work themselves.
9. Show booth supplies. This can include wire cable ties (always useful), ground cover in rainy weather (weed cloth works great and it's very inexpensive), nails, screws, wood for shimming booth legs on uneven ground,
10. Credit card transaction fees. Arrange to take credit cards. Your sales will increase. Credit card transaction fees vary from processor to processor (the company that turns your credit card slips into money in your bank). You can compare these costs from different processors to find the lowest price for the most services.
11. Check processing fees. Your bank likely charges them. If not, you pay a monthly fee. Or your uncle owns the bank. It's a small thing, but it is there.
12. During-the-show-extras. What are these? A bag of ice on a hot day. An ace bandage for your sprained ankle. I could have termed this miscellaneous, but that's too, well, miscellaneous. These happen, at almost every show.
13. Now, the other set of costs, what accountants call "Cost of Goods Sold". First come art materials. Paint, canvas, turpentine, clay, wood; all the materials you use to create your work. If you purchase some services, such as casting from a bronze factory or picture frames, these, too, are a part of your Cost of Goods Sold. Not included here are the costs of your equipment and tools, whether a clay oven, brushes, photo-

graphic printers or easels. These are looked at as assets and semi-permanent, not part of the cost of each work of art you create. Nor do we include here the rental on your studio, or the portion of your mortgage you may be able to deduct from your income taxes as a business expense; this is a complex subject for discussion with our accountant. Your Cost of Goods Sold for any festival should be limited to those directly related to the artwork you sell at that festival and deducted from your sales only of those pieces.

14. Next, packaging. Got to protect all that great work. Buyers don't usually like paintings with gouges in them from metal that seems to protrude inside all vehicles artists use.

15. Shipping. You will ship to some customers and many will want you to include the cost in your price. Not all, but many. You can choose to lose the sale or eat the UPS charges. My practice is to include shipping. The buyer feels as though the price is the price, with no hidden charges.

16. Sales tax. Artists are required to collect and rebate to the state the applicable tax on their sales. Not to do so is to court disaster, as in breaking the law and taking the consequences. Unfortunately, some artists flaunt the law, but it is not in any way smart. And even if you don't charge and collect the sales tax, you are still required to pay it. My experience is that nearly all buyers understand this. If not, well, you make the decision. Mine is to stand my ground. I prefer breathing the air outside state prisons.

17. Use taxes, which may not be taxes, in name, but amount to the same thing: highway tolls,

for example. Local and state vendor fees, which some festivals include in the price of your booth space, while others do not, may need to be paid to the festival or to the municipality where the show is located.

Regular old day-by-day costs may impact your profits, but we do not include them in the cost of doing art festivals, at least not here. These encompass studio rent, or a portion of your housing cost for your in-home studio. Same with electric, gas, water, sewer, trash removal, telephone, computer hookup fees, magazine subscriptions, show guidebooks, and dozens of other little, but incrementally important, ways your wallet gets emptied. They are matters for you and your accountant to discuss and, while important to your ability to make a profit, should not be assigned to the shows themselves.

Now, you may say, some of the above are not directly related to exhibiting at art festivals. Oh but they are, my budding Leonardo. At the end of the year, your take-home pay will be diminished by all the above, and probably some others. Only after taking them into consideration will you put a penny into your bank account for such things as mortgage payments, medical insurance and vacations.

A different area of cost for the art festival artist is the purchase, and payment for, his or her tools of the trade. For some artists, such as painters, this may be limited to brushes and an easel, plus a few relatively inexpensive tools and fixtures. To a studio photographer, it can add up to many thousands of dollars in cameras, studio equipment, darkroom equipment, computers and printers. Bronze sculptors rarely do their own castings, since a professional foundry can cost hundreds of thousands of dollars. Potters use kilns; weavers need looms. No medium is without some cost for items necessary to the production of that medium's artwork. And art festi-

val artists need, in addition, their booths and displays, a vehicle for transportation and sundry other items that can add up to several thousand dollars. In 2008 dollars, a high-quality booth, display system and related items you will use in every festival may cost between $3,000—a fairly low estimate—and $10,000, which would buy the best of the best, custom display construction included. Every artist will arrive at a different number, of course. Remember that you will need either the cash or credit to buy these things, and you will likely not earn enough to completely pay for them—out of profits—for a few shows or a few years. Large, expensive purchases in certain categories, such as vehicles, may be treated differently than, say, brushes, by your accountant, with a portion of the cost deducted annually.

Another area of financial importance can be a bit more difficult to grasp: working capital. This is the money you must have to operate your business, especially when you begin participating in art festivals. You will need some of this money before you do a particular festival, for booth and jury fees, artwork you must create to sell and miscellaneous costs. Some of the money will be spent traveling and exhibiting and thus not needed until a festival takes place or, if you travel on credit cards, until the bill comes in. Your individual situation will determine how much working capital you need. It is important to recognize that, until your shows become highly profitable or you do enough shows to cover these costs easily from profits, working capital is a permanent requirement: the money you put into your business will remain there.

All that said, how do you quantify what makes a successful art festival appearance?

The answer depends on how you view your art festival business: by the show or by the year. Perhaps the best way to answer the question is to consider your an-

nual goal and determine whether a particular show contributes to meeting it.

In dollar terms, it is rather simple: more money in sales than in all expenses combined and you have succeeded at the art festival business. Income less costs equals profit. That is a simplification of what, for tax purposes, can be frustratingly complicated; for our purposes, it will suffice.

Apply this to art festivals. If you do ten shows a year, and average $5,000 per show, not a bad average for many of us, you'll bring in $50,000. Assume your booth and application fees average $400 per show. That's $4,000. Peg your travel and related costs at $1,000 per show for meals, lodging, fuel, tolls, parking and other fees (easy to get there when all the expenses are added up). That adds another $10,000 in cost. Tack on a 20 percent of sales cost for materials, supplies, framing and other art-related costs; chalk up another $10,000. So far, we have $24,000 in costs against your $50,000 income. If your studio, utility and other expenses total $2000 per month, you need $24,000 to pay them. Add the show costs and studio-related costs together and you have $48,000, against $50,000 in income. You have made a profit, but not a very large one. You have sold enough art to support your art-making, but will not pay many personal bills from your earnings.

But this Handbook is about how to earn a living, or at least part of one, from sales of your artwork. True. Let's explore how to do just that.

Start by considering the First Commandment of the Art Festival Business:

Price your work for profit. Pricing your art is perhaps the single most difficult challenge art festival artists face. So, being brave, we'll face it first.

Over the hundreds of shows I've participated in, one stark fact has stood out: the higher priced my work, the easier it has been to make a profit that pays my bills.

Let's say you are a clay artist, doing non-functional sculpture. People who attend the shows you exhibit at buy your work consistently for $150 on average. You sell thirty or so pieces per show, averaging $4,500 across the ten shows you do. Now, close your eyes and double your prices. Sales drop, by number of pieces, from thirty to twenty per show, since fewer people are willing to pay the higher price for your work. Multiply 20 times $300 and—WOW—that's $6,000 per show. Okay, you say, what if the number of pieces sold drops even more, to let's say 15 per show. That's still $4,500, for half the work.

We need not be puritanical about this. Instead of raising all your prices to $300, raise half of them to $300 and leave the others at $150. Now what happens? Well, if you sell 15 pieces at $150, and 10 at $300, you come away with, yep, $5,250. Up $750 from before you raised some of your prices.

Price for profit. Not per piece, but for your show. And your life. To do otherwise is to court disappointment, at least, and financial disaster, at worst.

How do you go about pricing for the art show circuit? Should your work be priced higher or lower than in galleries, person-to-person or on the internet?

I'll give you my answer, which you may or may not accept. The price of your creative endeavors should remain the same, no matter how you sell it. That does not mean you cannot vary the price of your work, or even change it—up or down—as you see fit. It's your work. However, consistent pricing for similar work—in size or scope or difficulty—will enhance your reputation as an artist who charges a fair price, over all sales channels. Even though an art gallery or dealer takes a 40- or 50-

percent cut of your sales, you need to keep gallery prices in line with art festival prices. Some artists price their paintings, for example, by the square inch. To me, that's like buying a restaurant hamburger by the pound, regardless of how it tastes or the quality of the restaurant. Other artists charge what they believe the market will bear. One painter I know prices his work solely based on what he believes the potential buyer will pay. He even names them as they walk into his booth, as in "that guy's a five hundred." Often he is correct, but he has been at the art festival game for over thirty years and should know what he is doing by now. Certain media, artists claim, bring less money than others. True, watercolors rarely equal oil paintings in price, nor do ceramics approach the price of bronzes. Yet, a Chagall watercolor will outsell, in price, an oil painting by an unknown artist any day.

Call that The Quality Conundrum, straight out of a Robert Ludlum novel. Old Bob knew how to name his books, but he didn't price them. In fact, they sold for about as much as other books of the same genre, length and manufacture. But a handmade book set in moveable type, printed on a letterpress machine operated by footpower, well, that's a book of a different color, so to speak. To relate this to our artist needs: if you are selling photographs well at $100 for an 8x10 open edition print, how about going to a 16x20 print, in a limited edition, on fine art paper, nicely matted. My 16x20 inch limited edition prints sell for $450. About 100 of these leave my booth in buyers' hands, their money in mine, every year. And I offer the same prints, all limited editions, in five sizes. Lucky me, being a photographer, but the logic works for all media: rarify your offerings, by editions, or unique-ness, or...we'll get into that later.

So, Price for Profit.

Here's where to start. If your costs are $49,000 per year and you want to do ten shows, then aim at $98,000 in sales at those shows. Your goal is to double your costs with sales. Can it be done? Sure, I do it every year. So can you.

I'm going to round off the number to $100,000, for convenience. If you average $5,000 per show, you will need to exhibit in 20 festivals to reach that sales figure. But as the number of shows you exhibit in increases, so do your costs, at least those directly related to the festivals.

You can also reach that $100,000 by increasing your show average to $10,000.

That is about twice the average reported by the *Art Fair Source Book* for the top 300 shows for all artists in all media. Yet a significant number of artists do average $10,000 per festival. They do it with talent, brains, experience and hard work. The artists who average a fraction of that also have talent, brains, experience and work very hard.

Then what makes the difference?

At first glance, it would appear that only three avenues exist for you to increase your sales at art festivals: sell more pieces, increase your prices or exhibit at more festivals. These are all workable answers to increasing your festival income, and we will examine them in detail. But these ways to increase your sales relate to *what* you do, not *how* you do it.

The artists with the highest festival incomes work most diligently at how they exhibit at festivals. They not only bring wonderful art to festivals, but they market, package, display and serve their buying public extremely well. In the art festival environment, each of those four areas carries principles and practices different than in other segments of the art sales world. They are crucial to your art festival success.

Each of the four areas will receive a chapter of its own in this not-created-by-hand and thus relatively inexpensive volume! For now, we will return to the question of pricing.

Typical business practice suggests that in order to sell more pieces at each show, you should lower your prices, not raise them. It is the quintessential discount store strategy. At art festivals, this may not be the case. If the public at a festival is made up of lower-income visitors, lower-priced items will sell better than higher-priced art—in number of items sold. Our objective is more dollars, whether by selling more pieces or selling higher priced items.

Art festivals are different than typical retail environments. The public is, usually, buying one-of-a-kind, or in the case of multiples, one-of-a-few pieces of original art, and they do not expect, or necessarily want, discounted prices. Customer psychology is a large subject, to which we will devote an entire chapter further on. For now, think of pricing this way: you are attempting to sell one piece of art (even though multiple-piece sales do occur, thankfully) to one buyer (or a couple, as is often the case, but they still make up one sale) at the highest price you can command. I will provide a basic strategy on how to arrive at that price later on.

So, you increase your prices to comply with the First Commandment. Yet, you may sell fewer, not more pieces, than when your prices were lower. That is not the place to start comparing how many pieces you sell. Instead, whatever your prices are, create a booth display that shows off more of your best-selling designs—cat pictures rather than camel pictures, for example—and obey the Second Commandment of the Art Festival Business: Build on Your Successes.

This takes many forms. If for years you have sold paintings of domesticated animals and yearn to display

and sell paintings of wild animals, you risk losing your position in the art festival business. Position, in this context, is a fairly rigid marketing term, as in how you "position" your "product" to the marketplace. If you are known as a painter of dogs and cats and suddenly display mostly camels and yaks, the public, who may see you year after year or weekend after weekend at art shows, will no longer associate you with your cute puppy and kitty paintings. Unless the public also yearns for images of wildebeest and water buffalo, you risk losing your customer base, many of whom may not yet have purchased from you, but have planned on doing so, once they repaint their dens or build a new bedroom wing or buy a new house. In classic marketing terms, you will have "positioned" yourself differently. Assuming you have succeeded in selling many paintings of Fido and Fluffy, at numerous festivals over a reasonably long time, you will likely have to start all over educating the public to your particular art.

We all become weary of creating the same sort of images, in 2-D or 3-D, year after year; it is only human to want a change. However, this is a classic example of trying to follow the market, not lead it. Your work at an art festival needs variety, development and fresh viewpoints, but not for the sake of sales. It will rarely work.

When you find a subject matter or style that appeals to both your artistic instincts and the public's buying desires, you have hit upon a winning combination—a success. As your work progresses, you can and should raise your prices. The public will understand that, as time goes on, the value of quality art—or at least its purchase price—must increase. This is abiding by the Second Commandment at its best: build on the success of your good-selling, artist-identifiable, subject-consistent work by creating and displaying more of it and refreshing it through your personal artistic development. In the proc-

ess, increase your prices to reflect the new work. You will sell more pieces of art at higher prices.

Thus, price and what I will call product strategies contribute to your income. What of the number, and variety, of festivals in which you participate?

This leads to the Third Commandment of The Art Festival Business: Expand Your Horizons.

No, I am not referring to mind altering drugs, but rather to the number, location and type of art festivals you do. If you are an experienced art festival artist and have kept good business records, you know exactly which festivals in what locations, with what characteristics bring in the most money for you. Artists new to the festival business can use the techniques described in the Handbook to start building a profile for the festivals you want to try. In either case, a certain potential or actual sales-limiting trap lurks: doing the same festivals, year after year after year.

While it may seem prudent to return to festivals where you have sold well and made an acceptable, or better, profit, this is not always true. In fact, most festival artists experience a downward trend in festivals after they have participated for a few years. This is due to two factors: public attendance, for the most part, by the same people at the same shows every year; and the unfortunate belief by the public that, once they see your work, they will only see more of the same by you. We have addressed the second item with changes in your work and pricing. Let's look at the first dynamic: the returning public.

People who enjoy art festivals go to them regularly and often. Many people who winter in warm climates, such as Florida and Arizona, make visiting outdoor art festivals a major part of their winter activities. Nearly all art buyers have limits on the space they have for art in their homes, the money they are willing to spend, and,

most certainly, the number of pieces they will buy from a single artist. When these criteria have been satisfied, they may come into your booth to say hello and tell you how much they love the piece or pieces of yours they own, but they will no longer buy. They may even bring along friends or relatives, who might become customers, but this, oddly, happens less than you might expect; people like discovering their own artists.

Art festivals do attract new potential customers every year, especially in areas of high population growth, such as Florida in most years. Most artists will tell you stories about customers who looked at their work for years before deciding to buy, but these are a small minority of your potential customers. In the main, after a few years, even the best of your shows will begin decaying in sales. That is the time to follow the Third Commandment and Expand Your Horizons.

For a moment, return to our $5,000 average show, for 10 shows per year. Since this is an average, some will be better, others worse. If three of your shows return just $3,000 each, you should look, after a year or two, at potential replacements for them. If you believe that the show's location represents a good demographic for your work, find a comparable show in the same or nearby geographic area. If you think you have run out of buyers in the area, try another geography, and perhaps a different demographic makeup.

Look at the numbers: three shows at $3,000 equals $9,000, not even the total of just two of your $5,000 average festivals. So, you need only two shows, if they return your average sales each, to make more money—both in sales and profits. But just think: what if one show you replace turns out to bring in, say, $8,000 and the other new show's sales total $7,000. You have now replaced three sub-average shows with two above average shows and increased your sales by $3,000!

Now take a look at your three best shows, those that bring in, for the sake of example, an average of $7,000 each (this balances your three $3,000 shows). Analyze, for a moment, what each of them represents, not just in cash flow, but also in profit. If it costs you $3,000 to exhibit in a show that brings in $7,000, you will have a profit of $4,000. Not bad at all. But if your cost for that show is $6,000, which can happen depending on the art you sell and the extent of your travel, space and other expenses, you might want to look again at the worth of that festival. I have found myself in this situation and, while it can be difficult emotionally, I have sought to replace the high-sales, low-profit festival with another of equal or near equal sales but higher profit.

Expand Your Horizons. Do not become complacent, just because you have reached an average show sales number you can live with, or because of familiarity, ease of acceptance, distance from home, nice people on the show committee, pleasant restaurants near the show site—or any reason other than sales. Judge each show separately. Many artists, myself included, will continue to participate in shows they know instinctively have stopped performing as they should. Try not to form the habit; it can be difficult to break.

There is another element to expanding your horizons: participate in more festivals. Once you have learned how to best plan, travel to, set up, exhibit and teardown at festivals, even though you will make changes as long as you do art festivals, you will be able to add shows with relatively little extra effort. Many of your business costs, those that are ongoing no matter how many festivals are on your schedule, will not go up; studio rent, utilities, vehicle payments are just a few. More shows will spread these costs out and increase your profits at every show where you succeed. This is an important point: every show's costs go down as you add

shows to your schedule. If your non-show related business expenses total $24,000 per year and you do ten shows, your per-show cost is $2,400. Increase that to 20 shows and the per-show cost nosedives to $1,200. This can make the difference between a very successful year and a not very successful year.

Plus, the more shows you do a year, the lower your chances of a bad show affecting your overall show average. The successful festival artists I know keep careful track of their show averages. It is more than a number; it is an indication of how well you are managing your entire business.

A final way to Expand Your Horizons. Rather than looking at sales from a single viewpoint, that the people who come to the show need to buy your work for you to make money, see the show in context of an active plan to both bring customers to your work—from booth selection to display design to presentation of your art—and to maximize selling to them by understanding how sales at art festivals work, and the many psychological elements that result in sales.

These are both large topics. Each receives its own chapter, and more, starting with the next one.

CHAPTER FOUR

The Psychology of Art Festivals

BEFORE READING THIS CHAPTER, I strongly advise you to brew a cup of herbal tea, nestle comfortably in your favorite chair and put a soothing musical piece, perhaps Mozart, on your stereo or MP3 player.

Either that, or mix a strong drink. Or, if all else fails, raid your brother-in-law's stash of prescription tranquilizers (you know you've done it before!).

Why? This chapter is solely and wholly about the psychological factors that impact the sale of your art at outdoor festivals. It is the most divisive, confusing, contentious and arcane element of making a good living at art shows.

It is also the most important. A later chapter discusses the customer in detail; here, we are concerned with the show itself. Many factors influence a show's psychology, by which I mean the overall "aura" that seems to prevail at a particular festival.

First, let's draw a picture of a typical outdoor art festival. I'll use two by name. We start with what many nationally touring artists would consider the premier festival in the nation: The Sausalito Art Festival. Held every Labor Day weekend in one of the nation's prettiest and richest communities, Sausalito, California, acceptance into the festival ranks, to most outdoor show exhibiters, up there with what a nomination to win the Pulitzer means to reporters. I agree, and I have exhibited there

more than once. The show has been both my best-selling festival, and one of my worst.

It's true, frustrating and completely understandable.

The Sausalito festival takes place in a park with a magnificent view of the Golden Gate Bridge, Marin County and Alcatraz. The show is three days long, Saturday, Sunday and Monday, plus a Friday night party—no, make that soiree—during which artists and patrons eat, drink, dance and even transact business. So you're open three and a half days. Long hours, but well worth it.

First, checking into the show. You arrive at an appointed time—which you select upon receiving your acceptance. You are met by workers in electric carts who transport your art and booth to your space. Sausalito would not dream of making you carry your own art! Your booth is inside a large tent, with walls erected to your specifications. Should you need more, a crew of carpenters, electricians, and painters awaits your instructions.

Need a bathroom break after all that hard carrying? Private facilities, clean, air conditioned and also with a view of San Francisco Bay, await you. Thirsty? Beverages are available, no charge. Food? Every day, meals are served in a private, artists-only tent, complete with artists-only entertainment. You may wish to eat on the lawn overlooking the bay where chairs and tables await you. Your choice.

So you set up your booth, with all the help you need, plug into the included electrical outlets, and look around for a way to secure your booth from potential vandals or thieves. Not to worry, Sausalito is completely enclosed by tall fences, guarded by uniformed and undercover security officers and tighter than Alcatraz itself; no one has ever escaped—without buying!

The Friday night party starts at six p.m., a civilized hour. Guests attired in ball gowns, tuxedos and, I saw

this, top hats and white gloves, leave their limousines and enter the main gate. They've paid $150 each to hob-nob with us artists, eat a bit and listen to music.

First, the eating: groaning tables with caviar, lob-ster, shrimp, rare cheeses, fine wines (in glass goblets engraved with that year's date and the show logo.) Then, the music. Chamber music with the above vittles, which are only appetizers. The guests wander through the aisles, visit some of the booths, talk with artists, make a purchase here and there.

Dusk arrives. The artists are getting hungry. So, they leave their booths and partake of the appetizers, not a little embarassed at their clothing, which tends to be jeans and pullovers (the night air can get chilly, after all). What of the booths? Artists simply leave them.

Darkness falls. At the side of the show, a circus-size tent opens. Uniformed servers greet guests who stream toward tables piled with filet mignon, salmon steaks, gourmet veggies and side dishes, towering chocolate fountains with mountains of strawberries just yearning to be dipped.

On the stage at the end of the tent, one year I was there, a 26-piece salsa band played for five or six hours. Artists mingle, eat, drink and, this is difficult for me to believe even now, are taken by the arm to guests' tables to discuss their work.

Without a doubt, it is the single most extravagant, enjoyable and productive—most of the guests will return over the weekend to buy art—artists' party in the na-tion. With one drawback.

You have to be in your booth about nine a.m. Satur-day morning, no slack granted for hangovers!

And it is on Saturday at ten that the show really be-gins, with thousands on line to pay $20 for the privilege of seeing your art, buying your art, and listening to some great music. One year, Grace Slick and Jefferson Star-

ship headlined. On the main stage. Other stages displayed the musical expertise of smaller, but wonderful, acts. Of course, food is available—expensive gourmet offerings—at the show; one would not want those who have paid to enter going hungry!

And amid all this, art, much art, is sold.

If not already apparent, the psychology of this show should be obvious: soften up the customer, ply him and her with victuals and libations. Lead them to their pocketbooks through their comfort food sensors. Put them in a beautiful location. Make them feel like they are a part of something grand. The artist needs do nothing but show up, right?

Wrong. If anything, selling at Sausalito is more difficult than at many other top shows. The guests are used to being coddled, used to being tempted and used to turning their noses up at us mere mortals. They appreciate art, maybe Art, or even ART, but they do not appreciate it enough to buy it for no reason. After all, they didn't get rich by, well, spending. Their purchase comfort zone rests on buying what they believe will fit into their lifestyles—and what they consider to be good art. And what is that, you ask? Their mansions have many walls, most already covered with art. Their garages are larger than most homes. And their kitchens cost more than most college educations.

So why do they buy?

Prestige, for one reason. Well-heeled art collectors collect—art. To do so is part of their way of life and, in Sausalito or nearby, the Sausalito Art Festival is, outside of galleries and private dealers, the best place to pursue the art of collecting

The erudition of the collector, for another. Sausalito showgoers are remarkably knowledgeable about art. They connect the dots in various styles, genres, media and techniques.

Because it is the Sausalito show, for a third. Art festivals, it would seem to the Sausalito patron, are just enough outside the establishment gallery-dealer system to be a bit *adventurous*. But of the art festivals, Sausalito *is* the establishment.

Because they are knowledgeable about art, look for great work at fair or even lower than fair prices, connect with an artist's work emotionally, don't want to find the artist's work priced twice as high in a gallery and, above all, love what they see and choose to own, Sausalito buyers rank among the nation's best.

The folks who pay $20 just to walk in the gate at the show are guilty of all three of the above. The art festival artist must feed that guilt, with subtle aplomb (look it up; it's really a word). Okay, so Sausalito is not your typical art festival. But it exists, and the type of customer who buys there goes to other festivals, as well.

Let's look at another festival, a much younger and smaller one: Art on the Square in Belleville, Illinois.

Belleville is a small, somewhat down-at-the-heels community on the outskirts of St. Louis, about 15 miles to the east. The show hosts only about 125 artists, some of them local (from Illinois, that is). It is run magnificently by a small volunteer staff. The artists are treated every bit as well as at Sausalito, but without gourmet food—during setup, you will be delivered a really great meal from KFC. The show site is the central town circle (yes, they call it a square, but it is definitely a traffic circle). Setup is easy on Friday before a party for the local high-steppers. Don't like your booth location? They will find you another. Need help? They will call out the volunteers. One artist hurt himself in 2007 unloading his truck. The staff rushed him to a hospital, where a doctor they knew cared for him beautifully. The volunteers then secured his work, got his booth ready, did every-

thing but—no wait, they did indeed staff his booth with him over the weekend.

And that's the norm at Art on the Square. Now to the potential buyers. Definitely not the tuxedo crowd seen (and there to be seen) at Sausalito. But the wine and food served is excellent and the artists are respected and well cared for in every important way. Still, the crowd is not Sausalito. Truthfully, not even close—and it does not matter.

Yet, many an artist, including me, will tell you that they sell as well in Belleville as in Sausalito. Why? The Belleville buyer loves having a signature show to call his or her own, appreciates that the artists travel from thousands of miles away (the show has an international section for foreign artists) and cherishes what he or she buys as a true masterpiece to be loved for a lifetime. At Sausalito the psychology is one of exclusion: the masses are excluded from the show, by default of location and social status; at Belleville the masses are included, framed with belonging to something, touched with a relationship to the show that becomes an attachment to the art and artists who are on display. Be a part of Belleville and you will sell to them. Care about them, ask about them, enjoy their own enjoyment of life in Belleville, and Art on the Square's part of it, and you can open the door to excellent sales. Above all, be genuine.

Neither is a bad show for the artist. They are simply different, as are the psychological characteristics of customers at most shows, but they fall into categories that can be recognized. How? Analyze the demographics of the market, check out the area for levels of housing, ask other artists who their buyers are at a given show and, last but not least, when you do the show, keep careful mental notes about what the customers say and how they approach your work.

Let's expand on that: the psychology of selling, certain would-be gurus who write selling self help books will tell you, runs across all industries and professions. That's true. That's how they themselves cast a wide net, trolling for as many fish as will bite on their books. Not a bad strategy, but, for us art festival artists, a difficult one. We need a keener eye, since we don't line up seminars with thousands in the audiences, nor do we use printing presses to make thousands of copies of our work (well, most of us don't).

So we must learn from our customers. Do most of them, at a certain show, ask the price before they commit to buy? Lower end crowd. Do they take out their platinum Amex cards before they even know the price? You're in Sausalito. Do they seem ready to buy, but suddenly ask about where you are from? Looking for a connection to you as a "regular guy". If you're in the Midwest, be cautious about a hard-sell approach. Expect the customer to visit your booth three or four times before buying. Never pressure them. In New York, prepare to bargain; in fact, you might open a conversation with "if you like the piece, I'll work on the price with you." And at Sausalito, seem disinterested, as though the sale is a foregone conclusion, just as you would expect them to be nonchalant about the Mercedes they drove to the show (the blue one; the red's in the shop and junior has the convertible).

Now, does this mean you become an art show chameleon? No. You simply build your presentation to appeal across the Grand Canyon of customers at the shows you do, and tailor your personal communications to the market. The selling self-help guru would, no doubt, agree.

And, most of all, choose to participate in shows that attract a public that fits with your work and your personality.

Let's dwell a bit on the personality of the artist. We are too numerous for most generalizations, but a few of our differences shed light on how to evaluate the shows in which we choose to participate.

Visual artists, for the most part, work alone. A few of us have partners, a few more employ assistants or work in media, such as bronze sculpture or large glass, that require others to participate. When all is considered, we are generally an independent lot and like it that way—or we would pursue other careers. We have friends and relatives, of course, and are not likely to be recluses, simply at home and happy in our solitary pursuits.

An art festival such as Main Street Fort Worth draws upward of 200,000 visitors over four days. The onslaught of sound, images and boisterousness becomes a cacophony for most artists' brains. People arrive in your booth holding turkey legs dripping with juice and beer in plastic cups that spill onto your display. Four days of this and I, for one, need a long vacation on a desert island. But sales at the festival are uniformly above average.

What is the typical rather shy, introverted artist to do? You can take the Zen path and Become The Show, melding your self with the energy of the crowd. Or, you can retreat into a shell, find a small place to sit, and simply survive. We will explore the emotional impact of participating in festivals at length in a later chapter.

You can also choose not to participate, instead looking for a festival that better suits your personality. They exist. They may not be as remunerative as Main Street, but they will be much better for your spirit and sanity. As it concerns this particular show, that was my decision a few years ago, and I have never regretted it.

Other aspects of our personalities also come into play. Festivals can be ultra-structured, with little room for individuality, when it comes to rules and regulations.

If you do not like to adhere to boundaries, you might avoid these shows. Shows may be tightly laid out, with little space beyond your 10x10 footprint, or they may be loosely set up, with lots of room between exhibitors. You may like one or the other style. You can ask the show director and other artists about this type of characteristic and make your choice from there.

And, of course, some shows draw huge crowds while others do not. You may be happier one way or the other.

I stress matching your personality to the shows you do for an important reason: you will deal directly with the public at every festival and the public is very good at sensing whether an artist is happy to be there, comfortable discussing and selling his or her work and truly engaged with the show's visitors. Sales often are made or broken by how a potential buyer feels about the artist. A festival that does not match your personality will likely turn out to be a poor generator of sales for your work.

Factors outside your control will impact your sales, too. Local, regional and national economic situations create either pain or pleasure in masses of people. For retirees in Florida, who often rely on investments to pay their daily expenses, a stock market in decline can turn them sour on art purchases—and any other expenses they see as unnecessary. The financial markets, recently, have trended toward instability, up or down hundreds of points in a week or even a day. This breeds uncertainty in many people's psyches. Uncertainty leads to indecision toward major purchases, not just in people heavily invested in the stock market, but also for average folks who lose confidence in their knowledge of what the future may hold.

In an industrial city that has experienced job loss in one or two industries, such as the automobile and steel businesses, people whose jobs have nothing to do with those sectors may feel tentative about their own careers.

In communities that rely heavily on tourism, increasing fuel costs that make travel more expensive and lower the number of tourists who visit may well create trepidation at buying art; they worry that the economic hardships of tourists will affect them, even if their incomes have little or nothing to do with the tourist dollar.

Can you counter these elements in your booth? You can, although it is not always easy to do. You can, for example, offer discounts when you believe outside factors, not just affordability, affect your customers' decisions, You can also ask what you can do to help the customer make his or her decision, and if you hear that he or she or they are worried about the economy, openly discuss it with them. They are buying a work of art for a lifetime of enjoyment, perhaps even as a respite from the world's impact on their lives. Try to take their minds off the stock market and onto the rewards of buying your artwork.

Public affairs also affects art buyers' psychology. Wars, terrorism, disease, natural disasters, crimes, accidents—the entire gamut of what they see on the news. Politics can become a sharp and largely immutable distraction. One election year at the St. James Court Art Festival in Louisville, KY, which is held on the first weekend of October every year and for which the schools actually close on Friday so children can attend the show, every fifty or so visitors held a political poster on a stick as they walked. Pollsters interviewed showgoers; politicos signed up potential voters. The festival came to resemble a political rally more than an art festival. Sales plummeted for many artists.

Weather impacts crowd psychology, of course, but not always in negative ways. Very hot days tend to make visitors move out of overheated booths very quickly and if the forecast is for an inferno of a day or weekend, many people simply won't come. But mildly inclement

weather, such as an overcast sky with a few light show-ers or a bit of a chill to the air, can motivate the public to forsake other activities for a visit to an art festival.

Seasonality can impact art show psychology as well. Too early in the Florida snowbird season may suggest waiting to visit more festivals before buying. Too late in that same season might create a negative impact; buyers want to have ample time to enjoy the art they buy before returning to the North.

For makers of lower-priced art and crafts, Christmas psychology usually means increased sales; not so for art-ists with high-priced work, unless it is early in the fall and the buyer wants to redecorate before inviting friends and relatives over for some holiday cheer. Otherwise, holidays don't seem to impact sales, except when people would rather be out boating on July 4th weekend, but mom insists on walking the weekend's art festival first. You won't find many cooperative spouses or offspring on those days.

Art festival layout impacts buying psychology in strong ways. Layouts of art festivals vary as much as the festivals themselves. Some are on streets, with few op-tions but in-line booths and a few corner booths at inter-sections. Usually, the festival will try to maximize the number of booths that fit into the shortest distance by placing booths immediately next to each other. A few festivals recognize the artists' hunger for display room by placing aisles between each booth, or between pairs of booths.

If the booths in a street layout are set up back-to-back down the street's center line, storage or sitting space behind the spaces may be minimal. The festivals themselves are only partially responsible for this; mu-nicipalities mandate certain widths for emergency vehi-cles, even when a street is closed.

You may also find that booths are set up on opposite sides of a street, facing inward, with a wide lane for the public to walk. This design will often lead to more storage or seating space behind your booth, but will leave room for pedestrians to walk behind booths.

Artists debate which street layout is preferable. The center line means the public will have only one booth to look at as they walk; the center aisle layout offers more space, but means the public can be distracted by booths across from each other.

Either street layout, when it extends down side streets off the main show avenue, can leave some booths at dead ends. This creates a visual barrier to the public: if no one is walking down the dead-end, people may think there is little to see; if there are crowds, people may not want to become entangled.

Shows on streets often exist to aide retailers' traffic flow. The businesses give up their customers' parking on the street in return for the extra foot traffic art festivals draw. The businesses may run sales days to coincide with the festival, or even set out racks of merchandise at lowered prices to clean out inventory. Many promoter shows are held on streets—and in parking lots, which we will discuss later. Some community shows, those sponsored by business organizations, do the same.

Few highly rated shows take place on streets in front of stores, although there are notable exceptions. The psychology of buying art does not really mix with the psychology of buying shoes or electronics. Artists watch with dismay as strolling visitors carry bags with the logos of local retailers, knowing that most of these folks have no real interest in their artwork. For the well-healed potential buyer, the street show may seem a bit too much like a flea market and disruptive of their downtown rather than supportive of the arts. When a street festival alters driving and parking patterns, the

public may become annoyed and unwilling to see the show in a good light. Street shows that succeed usually do so because the festival is an event in its own right, the location has long been associated with the festival and community support runs high.

Many shows have no-pet policies, but these are difficult to enforce at street locations, where the public is used to walking their dogs without interference. Artists rarely welcome canines to shows; they can scare the public, interfere with traffic inside and in front of booths and deposit various bodily fluids and solids in unwanted places. Dogs sniffing each other do not really add to the ambiance of an art festival.

Other shows may be in parks, lovely, green, shady and meandering. Booths can be set up in a grid pattern, on broad grassy fields, if space permits, with walking aisles set to be as wide as desired. Storage and artist seating space will be more flexible. Aisles between booths are easier to build into the layout. Booths can be placed along walkways through a park's leafier areas, with excellent space for display on the booths' sides. Visitors will tend to linger at booths longer in parks and parking can often be set aside near the show site.

For the artists, park settings can be ideal, but a few difficulties do crop up. You may find driving to your space less than easy and at times impossible. A few shows mandate that the park's grass not be dug up by heavy vans or trailers. Excessive rain may force show directors to require that artists dolly or carry in and out their booths and work. If rain comes during a show, the ground will soften into a muddy mess or soggy and thick morass of grass. All but the most intrepid showgoers will run for their cars, not having stores to pop into until the deluge passes. This tends to break up the rhythm of the festival for the public. Even when clouds clear, the out-

look of the public can change and the day, for sales, will
be over.

A few shows combine streets with park-like grassy
and tree-lined areas between the streets, notably the
Uptown Art Festival in Minneapolis and the Boca Mu-
seum Show in Boca Raton, Florida. The layout may also
include booths both on the street and in a large park—
something the excellent Naples National Art Festival
does every year. Visitors enjoy the different areas in
these shows; the layouts seem to extend the festival,
making it both larger and easier to digest for the show-
goer.

A potential drawback—in any layout—occurs when
the festival is so large that just walking through the en-
tire show resembles a long mountain hike. If the size of a
festival interferes with the public's enjoyment of it, sales
suffer. Showgoers may not walk the entire show. Dis-
tance becomes a psychological barrier to purchase, in-
cluding the difficulty of carrying large or heavy artwork
to the buyer's car. This last factor can be overcome, if
you are willing and able to leave your booth long enough
to take a customer's purchase to his or her vehicle. At a
few shows, this can entail walking a mile—or more—
carrying or dollying your work. Sometimes, you can find
spots closer to your booth than where the buyer parked
that will allow the buyer to drive up for a few minutes
while loading. At a very, very few festivals, the show
provides transportation by cart of customer purchases to
distant parking lots.

Another difficulty in shows with a long or broad lay-
out is the customer's ability to return after deciding to
buy your work. Some shows' layouts can also be confus-
ing. One answer is to find a landmark near your booth—
a particular store, a street corner, even a certain grove of
trees—and provide the potential customer with a refer-
ence point. The best shows provide maps in show pro-

grams with booth numbers and even artist's names printed on them. You can mark this for a potential buyer. I often write my booth number on my business card and give it to the customer; this is always appreciated.

Festival layouts don't end with park, street or combination venues. You will find shows staged in mall parking lots, or other parking facilities (my least favorite is a festival in Tampa, Florida, where a few booths are set up on a slanted ramp into a multi-level parking facility).

Parking lots can offer flexible and spacious layouts, but they are inevitably asphalt, which becomes extremely hot in warm weather, both underfoot and by radiating heat into artist's booths. Mall parking lots are convenient for show visitors, but do tend to draw people to the show who just happen to be shopping in the mall. Newer "lifestyle" centers, the next generation after enclosed malls, resemble street festivals in public perception, traffic flow, distractions and amenities. They will have inside restrooms and a respite from hot or cold weather. The public's psychological response to mall shows varies with the type and economic character of the mall. Upscale venues will tend to draw upscale visitors; discount stores and big-box stores do the opposite. The public will expect the artwork displayed to coincide with the mall's economic level.

At times, it may seem that street and mall venues do not please the retailers nearby. Merchants at street shows will often express their displeasure by putting up signs barring all but their customers from using their rest rooms. When this happens, it is not a far stretch for the artist to believe that the public will react negatively, carrying that reaction over to the festival itself.

Location influences layout, which in turn affects the public's viewpoint toward an outdoor festival. I have

heard show visitors say they will never return to a festi-
val because it is too crowded, too long to walk, too low-
end or high-end, not open late enough in the evening, too
far from restaurants, too close to stores and, unfortu-
nately, has too few bathroom facilities. Many shows have
no choice but to offer porta-potties to show visitors and
artists alike. The festivals may or may not rent the bet-
ter portable rest rooms, those with wash stations and
adequate soap and paper towels, and pay to have them
properly cleaned during the day and overnight.

An interesting answer to this has been developed in
Harrisburg, Pennsylvania, home of a highly popular
Memorial Day weekend festival every year. Somehow,
the show has found people to clean the portable toilets
after every use and offer the public hand sanitizing
spray. The cleaners work for tips, which I imagine are
plentiful, since the experience is much better than at
unattended outdoor facilities. In addition to creating a
much healthier environment, the psychological impact
on the public is important—including possibly keeping
people at the show far longer than they would otherwise
stay.

With all these factors to consider, is it possible, then,
to construct a show schedule that takes into account,
evaluates and responds to psychological influences at
festivals?

The answer is a qualified yes. You can match your
work, personality and display needs to festivals, by visit-
ing them, asking about them and exhibiting in them.
You can sharpen your ability to apply to the best match-
ing shows by experience and keen observation. You can-
not account for all the factors that comprise a show's
psychological profile—for the public and for yourself—
since too many random factors, from weather to world
events, influence the public's mindset and thus purchase
decisions.

That randomness is the way of the art festival business—and fortunately for those of us who would not trade a modicum of uncertain excitement for a boring sameness at each and every show—the way of the world.

CHAPTER FIVE

A Brief Course in Art Festival Applications

IF YOU BUILD IT, they will come. Not a bad tag line for a movie. Not a bad start for a tag line for an art festival committee looking to attract artists. Better would be: if you build it, they will apply.

The top art festivals in the United States attract literally thousands of applicants, each paying from $15 (rare these days) to $60 (in the case of a few top shows) to see if their egos can stand the pain of rejection—again. The sad truth is that of the tens of thousands of us who apply to art festivals each year, no more than a few hundred will be accepted into the top festivals. Shows that do not screen artists through a jury system or by the show's oversight committee or, in the case of some promoters, the company's owners, tend to have lower-quality art. These festivals simply accept artists based on the number of spaces available on a first-come, first-serve basis. Except for very low priced, or non-artist made work (this is called buy-sell in the industry) few of these festivals will earn artists much in the way of income.

Between these extremes rest the 30,000 or so festivals where most of us can find more than enough shows we can jury into and where our sales can add up to an excellent living. Here is how the festival application system works, and what you can do to increase your

chances of acceptance into the festivals at which you want to exhibit. Two basic areas require consideration.

First, the show. Established or brand new, it needs to provide detail to aspiring entrants: when, where, what media, application or jury fee, booth space fee, setup and teardown particulars, acceptable and unacceptable types of work. Some show rules and regulations, such as payment terms, will be included. Application deadline dates, artist notification dates, show dates and other pertinent timetables are usually listed. You may find some history of the show and even a few words on the location and why a show in that city or town makes sense. Then, either on paper or electronically through ZAPP (more on this later) or JAS (again, read on), an application must be published and provided to the artist community. Festivals use email, snail mail, ads in industry publications and other methods to inform artists about their shows.

Unless you are familiar with the festival, the information in the prospectus and application will rarely be enough to inform your decision on whether or not to apply. You will want to talk with other artists who have done the festival, investigate the demographics of the festival's local population, reach out on the world wide web for more data and even talk with or email the festival's director or staff.

Second, the application itself. It will offer space for information about the artist and, sometimes, particulars about his or her work. Slides, electronic files or, rarely, printed pictures of the artist's work will be required. This, with your application fee (often called a "jury" fee) is forwarded by the artist to the show, once more either by snail mail or electronically. If all the requirements of the application are met—all the blanks filled in, images sent as required, money forwarded as requested—the application joins the pool of artists to be considered for acceptance. A few weeks or months later, letters or

emails are sent out to the applicants, indicating acceptance, rejection (couched in nice phrases, usually) or limbo. Limbo? That is the notorious "waitlist" where some artists who didn't make the grade for the show, but might have if so many great artists had not applied, are placed. Festivals with juries that choose artists assign those applicants whose scores fall just below the acceptance level to the waitlist. This provides the festival with a pool of artists to choose from in case of cancellations, which can happen for any number of reasons.

Acceptances make your day, maybe even your week. The letter begins with "Congratulations...". Rejection sends you into paroxysms of self-doubt. The letter starts with "This year's pool of applicants was extremely large and talented...please don't take it personally, but you ain't good enough". Well, not those exact words, but you will get the message. Waitlist letters offer hope, as in "should a space open up in your category, we'll let you know immediately". If that happens two days before a show a thousand miles away, you may decide not to participate. If you are notified earlier, you may have been accepted into another festival scheduled for the same weekend and, again, decide to decline the invitation. When you think about it, this means you were accepted and turned the festival down!

Okay, let's take a closer look at this process, and what it means to you.

The application process itself can become onerous, but it is necessary. ZAPP, which may be explored at www.zapplication.org, represents dozens of festivals, small and large, prestigious and not so hot, and acts as a clearinghouse for applications. Juried Art Services, JAS, whose web address is www.juriedartservices.com, operates in the same way, although on a smaller scale, but with festivals that are broader, at times, in reach. Both require you to be computer literate to a certain extent.

You must have internet communication capability, email, and a way to turn images of your work into electronic files. You can do this latter task yourself, using the instructions given on the ZAPP and JAS websites, or you can pay someone to do if for you. A few shows, for an extra fee, will convert your slides into electronic files, configured to meet ZAPP or JAS requirements. It's a fairly expensive way to go, but workable. Another few shows, probably no more than ten nationwide, still solicit or accept photographs on paper of your work. These are small, local and usually run by arts organizations whose volunteers have the time to plough through hundreds or thousands of photographs.

Applying electronically, of course, is a rather new process, but can take a large burden off you, time- and money-wise, once you begin to use it. When images of your artwork have been uploaded to either service, you simply fill in the blanks in an application for a given show, choose which images to attach, pay the application or jury fee via credit card, and click. The application is done. I estimate that within five years, half of all shows will require electronic applications, and in a decade, the paper application will be a dinosaur.

When the electronic application sites first came online, many artists saw them as a major and not welcome change to the art festival application system. The electronic systems were sold to art festivals as an answer to the problem of handling hundreds or thousands of slides from artists, managing them through the jury process and streamlining the artist notification procedure. These are all true, given the computer's ability to hold and organize information. But some artists believed the electronic systems would lead to potential abuses of the application process. They worried that computer imaging software would permit alteration of the images of artists' work, allowing what slides would reveal to be in-

ferior artwork to look as good as did superior creations. This, too, is true. And many artists wondered how they would bridge the gap between slides and electronic image files. This largely has not been a problem.

What the electronic application systems have done is make the artist's life easier—and harder. The ease of applying through ZAPP and JAS has increased the number of applications to many festivals by significant percentages; some shows report up to a 40 percent growth in applications they receive. More applications create more competition. A rather unfortunate side effect of this is artists applying to multiple shows held on the same dates who will, of course, exhibit at only one show on a given weekend. If these artists are accepted and others who would attend the show are rejected, the festival may be forced to work through its waitlist or, worse, invite artists who have been rejected to exhibit! This has happened several times at highly rated national festivals. The fact that, at the time of application, only the jury fee needs to be paid on ZAPP or JAS adds to this situation and the uncertainty many artists feel.

Overall, however, electronic applications work for most artists. They have no doubt increased the number of artists applying to festivals—and the festivals' income from jury fees, a sore point among many artists who believe this to be the main reason festivals use the electronic services. As of the end of 2007, no major company any longer manufactured slide projectors; even the venerable Kodak organization has left the business. Electronic application systems are a reality and will not disappear. A few festivals and promoters, however, have resisted switching to them, at least for now.

Paper applications come in all shapes and sizes. Some arrive by mail, others can be downloaded from the internet. You fill in the spaces with a pen (yes, you actually have to write!) and enclose other required material:

slides, an artist's statement; a biography (the last two only for some shows). Paper applications vary in their completeness. Many offer needed information about the festival, but some give you little more than a few sentences on requirements for slides, categories of artwork and space to fill in with your information. Usually, festivals refer to this information as the "prospectus" for the show, considering the "application" portion separate. Shows try to spend as little as possible on their paper applications; postage is expensive.

When you send in your application, you will be asked to include a self-addressed envelope (or two) already stamped, for return of your show notice and your slides, in case you are rejected. Imagine paying to mail a letter that excludes you from a festival, adding the proverbial insult to injury! That is, as they say, the way it is.

And, my poor artist friends, you attach a check for the application or jury fee, plus, more often than not, another check for the booth fee. If you are accepted, the show will usually cash the booth fee right away; if you are rejected, they return your check. If you are wait-listed, they hold on to your check pending rewarding your patience with a place in the show. Now, if the application deadline and the notification deadline are far apart, say two months, your booth fee is, yes, at risk. ZAPP and JAS don't ask for the booth fee until after you are accepted, and you can say no at that point. Paper applications can play havoc with your cash flow, since you may or may not have the money you think you have in your checking account. Electronic applications make sense for artists that way, and in another; you need not have slides made of your work. Slides are costly, require proper handling and storage and management of a physical inventory adequate to meet the needs of festival application deadlines. Different shows require your slides to be labeled in varying ways, with your name,

medium, name of the artwork shown or size. Thus, you often must remount your slides for different festivals. Electronic applications, on the other hand, still require photography of your work (unless you are a photographer who shoots digital only or a digital artist whose work is already on your computer). But once you have the image, you need not duplicate it as with slides and the image requirements remain the same for all an electronic service's shows.

So which is better? Neither and both, in their own ways. Look at the application process from a different perspective: the shows you have chosen to apply to should not be discarded just because of the application process they require. To do so guarantees you won't participate. My advice: apply to the shows you want to attend. One day soon, all of them will be electronic. Until then, bite the slide bullet, manage your cash flow for the uncertainties involved in writing booth fee checks at the time of application, and, if needed, find a good photographer versed in taking pictures of artwork for art festival applications. Normally, the photographer will be able to provide both slides and electronic files for you to use. And, yes, this is one of those hidden costs of the art festival business, one that may diminish but will not entirely evaporate.

All that said, what about the more challenging aspects of art festival application—specifically, what are your chances of acceptance and how can you increase them?

We begin looking into this with the festivals themselves. A few of the top national shows receive upward of two thousand applications every year. That's 2 with three zeroes. They have, ostensibly, perhaps 250 spaces to award. So, by the numbers alone, you seem to have a statistical chance of a bit more than one in ten of getting the "Congratulations..." letter.

That is not the way it works. If you are a jeweler or photographer, your competition will be many times higher than if you are a sculptor. Why? Nearly a third of all applications to art festivals come from photographers, another quarter or so from jewelers. Only a handful of sculptors apply. The number of applications from painters falls somewhere in between.

For the sake of example, I'll construct a hypothetical show: call it the Offshore Art Festival, or OAF, for short. OAF includes 12 media, from painting to fiber arts, has 250 available booth spaces and is held in July in Maine on an island, so the weather is generally okay. The show attracts 1000 applicants. OAF annually awards three prizes in each category, thirty-six in all, plus Best in Show and two memorial awards honoring local bigwigs (happens in a lot of festivals). That adds up to 39, all of whom receive a pass on the application process for the year after they win the award, thus being, as artists say "grandfathered" into the show.

Unfortunately, 39 spaces of the 250 are now spoken for. Subtract 39 from 250, and you have 211 spaces left. Now we are at 211 acceptance possibilities out of 1000 apps. Okay, that's not too bad. Almost one in five.

But if you are a painter, and the show permits 10 percent of its booths to go to painters, of 20 available spaces, at least 3 are for prize winners from the previous year. If 20 percent of the OAF applications come from painters, that's 200 artists seeking 17 spaces. Your chances went down to below one in ten. Ouch!

There's more. If one of the top three awards was given to a painter, you now are one of 200 artists seeking one of 16 booth spaces

Yet more. Many festivals—I would venture to say 75 percent—allow the show directors or committees to accept artists they believe will enhance their show. These may be for the sake of "balance", which the application

may specifically say, or because the artists are well connected or well known. Sometimes it is who you know, and how closely. This may occur more in promoter-run shows than in community festivals, but it happens everywhere. Ask any artist who has applied to a particular show for years and years; he or she will tell you that this form of "grandfathering" runs rampant.

Is this a bad practice? Depends on your perspective. If you exhibit year after year in a festival, have developed a strong buying base there, and wish to continue selling to it, grandfathering works in your favor. If you are new to the business, or the area of the country, you may find yourself with a long wait.

Is this a fair practice? Probably not, since artists are often led to believe that the published number of booth spaces are available to everyone who applies. If it is disclosed by the festival, it is at least understood. However, grandfathering is rarely acknowledged by an art show. I believe it should be, and I highly respect those festivals that do mention the practice in their applications or other literature.

And there is still more. Some shows use a technique called a "street jury" to select artists at their festivals to invite back without having to jury into the show. The director, or a committee, walks the show and decides whom to invite back. Once again, if this is disclosed, so be it. The festivals use street juries to build what they consider a high-quality level in their shows, especially if, on their chosen weekends, other high quality shows are scheduled. They believe pre-acceptance will motivate the artists they jury in during the festivals to choose their show over another. This often works for the festival and in a way, by inhibiting an artist from applying to other festivals held on the same dates from applying to them, opens booth spaces for other artists in those shows.

So let's return to OAF. Sixteen spaces were left for painters, of 25 to be assigned. Now, six more are chosen to return, by dint of the street jury or connections. Only ten spots remain. As you will recall, OAF drew 200 applications from painters. Your chances went down to one in twenty, or five percent.

Those are the numbers. They are painful. They are also typical of most, I would say 80 percent, of shows, especially highly rated national festivals. Certainly, prestigious national festivals will have more applicants and a higher potential for rejection than smaller local shows which offer smaller crowds of buyers to fewer, local or regional artist applicants. On balance, the local show will not produce the sales for an artist that the national show commands, but it will be easier to jury into.

The words "jury" fee and "application" fee are not interchangeable. Some festivals, including most promoter-run shows, do not employ juries to vote on which artists are accepted. The promoters, or their employees, decide. You pay them an application fee, and they like getting your money. A promoter-run show that attracts 500 applications at $25 each will realize $12,500 in revenue before any booth fees come in. This is not, however, pure profit. Promoters have costs, overhead they must pay since few use volunteers. And they play an important part in the art festival business as a whole, since without them hundreds of festivals would not exist. They also tend to be loyal to artists who participate regularly and often in the shows they stage. Promoter-run festivals can be easier to jury into and, depending on your goals and travel desires, easier to do.

True juried festivals hire, or at least pay expenses for, professionals in the arts to view and choose what they believe are the best artists for a given festival. The jury members view the art either electronically on screens or in slide shows, rate the artists on a number

scale and the festival collates the scores. Higher scores rate an acceptance; lower scores invoke rejection; somewhere in between the waitlist evolves. The move to electronic applications has made certain changes in the application process inevitable. In both types of applications, your task is to send out images that portray your work in its best light. You can either hire a professional photographer to take pictures of your artwork, or do it yourself.

Taking pictures of art is in itself an art, one few of us will ever, or would want to master. You can, however, learn to take credible images of your artwork and use them in applications. You will need some fairly basic lights, a camera and lens capable of rendering your work's color and detail and a simple backdrop, small staging area and a lot of patience for mistakes and reshoots. Photographing 2-D work is simpler than photographing 3-D work. Many jewelers would never attempt to make images of their rings and necklaces and bracelets, since doing so is particularly difficult.

I want to posit another hypothetical show, called the Louisiana Outdoor Art Festival, or LOAF. LOAF is different than OAF, but on the same weekend. It attracts perhaps 100 applications for 150 available spaces on the town square in a small, off the beaten path, barely electrified rural community. It is a juried festival, with the jury consisting of the local high school's art teacher (the one and only) and the owner of Mamie's Feed and Gift Shoppe. The local DAR sponsors, and the town's used car dealer contributes $250 in prize money.

The application for LOAF is paper, of course. They ask that you send in one slide of your work. The jury fee is $25. The booth fee is $100, rather than the $4-500 now common at larger festivals.

Should you apply? If you live nearby, have nothing else to do that weekend, want to chew the fat with town

friends for a couple of days and don't mind going home with negligible sales, yes. And more importantly, if you wish to try out a new booth configuration, see how a new style of work looks at a show, take photos of your new booth setup, sure. You will support the local art effort and have a nice time. The show is not expensive to do, and you may just make a few dollars in profit. Even if you get called from the waitlist at OAF and must cancel LOAF, you have also given yourself the option of doing a show rather than sitting home wishing you were doing a show.

Unless, of course, you would rather be painting, or sculpting, or mowing the lawn. The choice is yours.

In the OAF example, I've given you accurate information about a single medium. OAF, by the way, is a thinly disguised real event. So is LOAF. The art festival business includes every possible level in between. But your medium will vary from the numbers I used, as will every show and even the same festival from year to year.

So, numbers aside, how do you successfully apply to important festivals?

Let's slide on in to that topic (pardon the pun). After applying to and exhibiting in hundreds of festivals, I have not discovered a magic formula that guarantees acceptance; no such formula exists. There are, however, a few principles, what I call the Laws of Application to Art Festivals, that will help.

The First Law of Application to Art Festivals: it is all about your work. The better your art, the higher your chances of acceptance into the art festivals you desire. I did once hear of a festival that purposely downgraded the work they accepted, believing the public needed a more "working class" level of art to view. If true, it is an amazing insult to all of us who work as artists and to all who see our work. Other than that instance, festivals

want the best work they can draw and are, in the main, fairly good at choosing it.

Festivals also want art that fits into their concept of what the festival should, in artistic terms, be about. A festival that consists of modern, abstract art (in most, if not all, the booths) won't respond well to old-masters style figurative painting. Western shows are unlikely to accept artists who paint Maine lighthouses. Your own visits to festivals, research into the work of other artists who exhibit in them (the internet is a wonderful way to accomplish this, since many festivals post images of exhibiting artists' work) and discussions with other artists and festival staffs can provide a good deal of insight into a festival's style. Festivals can even be biased toward certain media over others, containing many more painters than sculptors, for example.

The Second Law of Application to Art Festivals: pay attention to the show's prospectus. It may say "No reproductions allowed" or "Limited to Colorado (or Illinois, or Connecticut) artists" or "All work must be less than two years old". Follow the directions, don't try to sneak past the rules. If you succeed in being accepted and break the show's rules, it may be the last time you exhibit at that festival, and your reputation may suffer in important ways. Meet the deadlines, mark your slides as requested, send the required monies.

The Third Law of Application to Art Festivals: stifle the urge to do anything not requested in the applications. Don't call show directors to tell them how much you want to exhibit. There is one exception: if you are waitlisted, do call or email to express your interest, unless you are explicitly asked not to in your limbo letter. Don't send packages or press releases with your application—but consider putting the show on your news release mailing list. Refrain from drawing happy faces on the application or envelope or slide borders (this

really does occur). Common sense, and a realization that the First Law governs most selections of artists, should prevail.

The Fourth Law of Application to Art Festivals: apply early. Many shows display applications to juries in the order received. A jury looking at five hundred or even a thousand sets of slides or digital images over one or two days can easily become bored and dazed. Your only defense is to be among the first artists' work seen. Most shows set up their jury sessions by category—painting, then photography, etc. You have no control over this, but if your slides are seen early in the process, even if your category comes last, your acceptance chances increase. Whether electronic—on individual computers or on computer projection screens—or manual, from 35mm slides, an artist's submissions are viewed together, that is, all his or her images at once.

Festivals ask for differing numbers of images of the artists' work, generally between three and five, and most of the time, one of the images must be of the artist's booth, completely set up and ready to sell. Some shows lend great weight to how your booth looks in that image, up to 25% of your total jury score; others simply want to know that you are using a standardized, good looking display. A few shows will allow you to substitute a picture of a grouping of your work, in case you are new to the business or for some other reason do not have a booth image. You should not do this; instead, borrow or rent a tent, walls and display materials, if necessary, and make your booth picture look as professional as you can. Optimally, photograph or have your booth photographed looking great, during a festival. Morning light benefits these images and you can shoot your photographs of your booth before the show opens. Late afternoon light is not as photogenic, since as the sun wanes the color of its rays actually changes. (Some photogra-

phers might disagree with this, since late day sunlight is called "sweet light" for landscape or architectural photography; for your booth slide purposes, try to avoid it).

In these days of computer manipulation of photographic images, you can have your booth slide retouched to eliminate unwanted elements, change the pictures on your display walls and even change the color of the sunlight. I believe this is an important investment in time and money, since your booth image will be presented alongside the images of your artwork and can make or break your acceptance chances.

The Fifth Law of Application to Art Festivals: make certain your slides or electronic images are the best they can be.

This may sound obvious, and it mostly is, yet a few details should be considered at length. Taking your own photographs of your own art sounds like a good idea and, if you follow the suggestions above, will result in usable images. Notice the word "usable'. It does not encompass "perfect". The choice of whether to do your own slides or hire a professional photographer comes down to time and money. If you can afford a professional's work, I urge you to hire one. The results will be worth the cost, as long as the pro's experience includes photographing art. Some professional photographers with long careers and terrific recommendations from clients have never taken a picture of a painting, sculpture, necklace or basket. They may know a lot about photography, but little about how artwork should be photographed. Go with the experienced art shooter, and pay his or her price.

Typically, a photographer will charge you either a day rate or a price per finished picture. For top quality work, in 2008 dollars, you can expect to pay between $150 and $500 per finished image. So plan on budgeting between $750 and $2,500 for five top-notch slides—with electronic files included. It is a lot of money, true, but

anything that will increase your chances of acceptance into the best festivals is worth doing, so different is the potential revenue from the best shows.

Adhering to the Five Laws above will not guarantee your acceptance into all the festivals to which you apply. Nothing offers that sort of certainty, but they will make your application professional and allow you to meet the standards used by the most successful artists.

Another vital area of thinking goes into applying to art festivals: choosing the right ones. This topic consumes artists, since the right choices produce excellent sales and the wrong choices may lead to employment applications for nine-to-five jobs. I cannot say enough times that your experience will be your best guide, but if you are considering applying to a festival you have never entered, or are new to the business, you will not have the experience you can rely upon to inform your choices.

The industry supports a few sources of information about outdoor festivals, two of which are the most prominent and often consulted by artists. These are the *Art Fair Source Book* and *Sunshine Artist* Magazine.

The Art Fair Source Book, or AFSB as it is usually called, is a festival information and rating service operated by Greg Lawler, himself a photographer with a long and successful history as an artist. AFSB publishes, in printed form and on the internet, a listing of what they consider the top 600 shows in the United States. The information provided for each show is copious, containing every item you need to consider the festival, at least those that constitute facts. Dates, locations, setup and teardown regulations, telephone numbers, number of applicants and participants, number of participants by medium, awards, security—the information seems endless.

The listings include ratings, from 1 to 10, that Lawler assigns, and a ranking of the show that he de-

termines. Actual dollar numbers of sales per artist are also shown. The sales figures come from reports sent to AFSB by artists who participate in the festival. Here the system has a flaw: not all artists are included, since only those who send in the postcard sales reports are included in the sales numbers. The individual show listings do not reveal how many artists from each category have forwarded their postcards, so sales in a high-dollar medium, such as sculpture, can affect the average, as can a large number of low-dollar artists' information.

This aside, the information provided by AFSB is unparalleled in the industry, at least for the top-ranked festivals. It is always possible that a show where you will sell well does not make it into the AFSB; the system relies on the festivals to distribute the comment postcards, and some choose not to participate. One of the more valuable portions of each show's listing is a comment area, where the publisher offers insight from personal observation of the festival.

The 600 festivals are divided into two spiral-bound volumes, with a third volume of "early deadline" festivals that comes out in autumn. The two complete volumes are published at the beginning of each year. The books, and the website, also include summaries in useful form, with listings by ranking, show date, deadline and location. AFSB offers other products, such as calendars, that may or may not be useful, depending on how you keep records and plans.

If I were to use only one source for festival information it would be AFSB. For newbies, in particular, it is extremely informative, as long as you do not let it cloud your own experience and realize that many thousands of festivals do not make the AFSB listings.

The other major industry source, *Sunshine Artist* Magazine, takes a different approach. In addition to articles about the festival business, Sunshine Artist con-

tains listings, somewhat brief, of art festivals, with enough information to contact the shows. The listings are in date order, by month. However, each festival must pay for its listing, so those shows who choose not to pay the annual fee are simply not listed. The magazine has its own rating system for festivals, and publishes an annual book of its "Top 200" shows. These shows are emphasized in the listing section of the magazine with a star system, much like those used for hotels and restaurants.

In addition, *Sunshine Artist* publishes reviews of festivals, written by correspondents they employ, that appear a few months after the show takes place. The reviews are subjective, for the most part, although the writers often ask artists how they did, on a 1-to-10 rating, in different categories, such as sales, parking, weather, etc. The reviews can be interesting to read and offer a viewpoint on a festival, but generally contain little in the way of overall facts. As it is the only magazine devoted to the art festival business, it is worth the price of a subscription, but should be used carefully when choosing festivals to which you will apply.

Many other sources for festival information can be found on the World Wide Web, at sites posted by arts organizations, state cultural divisions and chambers of commerce. Many allow you to find festivals in specific locations or of specific types, such as traditional craft shows. One or two membership-type websites have recently begun, with a monthly or annual fee that includes geographic-location search capability. Today, most festivals have their own websites. A Google search usually turns them up.

Throughout the remainder of the Handbook you will find principles and strategies you can use to help decide which shows are best for you, since many show characteristics—location, cost, time of year, duration, demo-

graphics—affect your decision to apply. There is no single or certain path to building a festival schedule that will automatically produce excellent sales at venues you enjoy, with acceptable costs and travel requirements.

One line of thinking can help, however, and lend some relief to the anguish of uncertainty. You will apply to many more festivals than you can possibly exhibit in over the course of years, in order to insure that you have enough shows on your calendar to reach your income goals. You will find that even when a festival produces excellent sales, this will change over time. Your own requirements and preferences will also shift. Your viewpoint toward the entire art festival business and what you want to get out of it, both monetarily and emotionally (see Chapter 16 for more on this) will evolve. You will constantly reevaluate your art festival life, adding and subtracting elements and considerations.

View your application practice this way, too, as a fluid, not static, environment and you will reach a certain equanimity knowing that the art festival business is an evolving, ever-changing industry, through which you, too, can evolve and grow.

When you receive rejections from art festivals, as almost all of us do regularly, simply move on, in the knowledge that your artwork and you have not been turned down, but that your artwork did not fit a particular show's offerings to the public. There are thousands of other festivals where you will be accepted and at which you will prosper.

CHAPTER SIX

What You Will Need to Exhibit

AN ART FESTIVAL ARTIST I know, wonderful painter, veteran of a decade on the circuit, in his forties, married, with two young budding painterlets and three dogs at home, arrives at art festivals in a battered station wagon (pre-SUV era).

The tailpipe on his old Fordrolet drags the ground. His tent is tied to the roof. His paintings occupy the rear cargo space, along with a few water-stained cardboard boxes, a moldy folding table, a K-Mart canvas beach chair and assorted other paraphernalia. Inside thirty minutes his tent is up, his paintings hung on dingy fabric walls and his single bin of prints is full. He calmly unfolds his camp chair, pulls out a Tupperware container of macrobiotic rice, opens his latest library book and settles into a weekend of reading.

Occasionally, he sells a painting. Usually, he goes home broke. Often, his work garners a prize—at those shows that give out awards. He is one of the nicest, most misguided artists out there, way out there actually. But he is happy, or so he proclaims, and that's the name of the game.

Most artists, however, left the sixties behind at least by the nineties, and have come to understand that the "me" decade, the "women's lib" decade and all the other decades at the end of the twentieth century have given way to the "got to survive" decade, which is less fun,

perhaps, but more challenging and potentially more re-munerative. To get to the more remunerative part re-quires attention to more than the price of trail mix; you must see the outdoor art festival business as requiring substantial consideration of the tools, fixtures, furnish-ings and other accoutrements of a small, portable art or craft gallery erected and dismantled as often as once a week.

Your booth must be flexible and stable, inviting and enfolding, sophisticated and simple, and a great deal more all at the same time. It must display your work beautifully and elegantly and still have the common touch. It should contain not only display space, but also a work area, seating area, storage, writing surface and various other areas depending on your medium. Jewel-ers, for example, need a mirror for the customer to use while contemplating the necklace she may purchase. Clothing crafters need hanging racks. Sculptors often need pedestals. And so forth.

I have never seen two identical booths. Similar, per-haps, but not the same. As many artists as are out there, so are there that many ways to address how a booth should look and of what materials it should be con-structed.

But there are some rules or, perhaps better, guide-lines to follow.

First, consider the space. Usually ten feet by ten feet, with a wall height of seven to eight feet (some art-ists extend the height; we'll consider that in a bit). So, ten by ten, one hundred square feet. If your work de-mands it and you are so inclined, you can buy two spaces, but that doesn't change your needs, just makes them larger.

For the moment, assume your work hangs on walls. In your booth space, if you don't have outside or back walls to hang on, you will find up to thirty linear feet of

wall space on the walls. You can increase the hanging space, if you're a painter or other wall-needy artist, by running walls perpendicular to the outside walls, or at angles. These choices are design functions, and important to consider. If available, you may be able to buy a corner space, adding another ten feet to your display area. And, should you be willing to shoot for the moon, you can use a single booth in two spaces, usually at twice the 10x10 booth space cost, thus adding another outside wall. Corner and double spaces are effective strategies for increasing exposure of your work. I employ one or another whenever they are available; doing so can pay off immensely.

Let's consider why. If you have the three inside walls in a booth and thirty linear feet plus, say, seven more feet on perpendicular walls jutting into the space, you can increase your display by nearly one-quarter with one outside wall, and by nearly two thirds with two outside walls. If the space costs, for the sake of example, $400 for the weekend for a single space, and you add another $100 for the corner space—a typical increase—your space cost is $500. For only $100 you add twenty-five percent to your display capability, at no other added festival expenses. If you take a double space, expect to pay $400 more than for the single booth and increase your display by another twenty-five percent What could that amount to in sales?

Again, for the sake of example, if your average weekend sales are $4,000 at art festivals, you might add $1,000 with one outside wall and $2,000 with two. In either case, the sales and profit potential are high. Certainly, you risk more, but, if you consider the cost of travel, lodging, meals, gas or diesel fuel and other show-related expenses, the incremental cost of a booth with better display exposure is small.

Most art festivals will require you to use a white canopy for your tent. The single color backdrop shows off almost all mediums better than a mixture of canopy colors would. The show looks uniform, and creates a clean ambience. It's a good rule.

Most festivals also require that you weight your booth for safety. This is another good rule, since wind can move booths like sails on a boat, taking you and your display and your artwork aloft and down the street or park, damaging not only your work, but that of others and even endangering visitors An anecdote from my own experience may be instructive.

One year in Aspen, Colorado, at a festival that produces excellent sales for many artists, the weather was glorious Saturday and most of Sunday. At about three p.m., the skies clouded into dark swirls of biblical proportions. Gusts tossed booths that, like mine, were weighted down with two hundred pounds of cement as though they were twigs. Rain fell so hard it seemed icicles were descending from the sky.

Then the weather got bad! A mountain downdraft started with the noise of a locomotive. The wind burst downward, filled tents and, in the case of my trusty Finale by Creative Energies, started to lift it straight up off the ground. It so happened that four festival attendees were in the booth. Each person grabbed a corner pole and hung on. I grasped the center of the front of the booth; my wife took the rear. We were all lifted off the ground: walls, weights, people, artwork—everything. Fortunately, the wind gods set us straight down, gently. No harm to people or property. The bronze sculptor next to me was not so lucky; bronzes weighing as much as two hundred pounds went aloft like leaves in a hurricane. She escaped unhurt; damage to her work ran into the thousands of dollars.

The lesson? Weight, more weight and then more weight. Design your booth so the walls tie into the poles that hold your canopy and sides. When possible, stake into the ground. It is by far the best way to secure your booth. Four stakes at a distance of eighteen or so inches from the corners of the booth will suffice for nearly all conditions. So will a single stake in the center of a wall tied to both ends at the top of the corner poles. Most booths have provisions for this type of setup. Many festivals prohibit staking, concerned that underground sprinkler systems will be damaged. The best festivals mark the ground so you can avoid the sprinklers.

Two types of tents are in general use at art festivals: those designed for the outdoor festival business, and what many artists derisively call "EZ-Downs." The former are made by a few companies (see www.theartfestivalhandbook.com for names) as are the latter. EZ-Downs are just that: in any real weather scenario, they will come down. They are inexpensive, comparatively, and one or two of them offer some resilience and defense against wind and rain. One person can, with some effort, erect the tent in less than thirty minutes. However, their design allows water to pool in the four quadrants of the canopy top. Enough water and the vertical pole holding up the center of the tent can break through the canopy. That will ruin your show. One or two brands of EZ-Downs can be fitted with side curtains; most cannot. They are light in weight compared to other tent designs, but can be weighted to compensate somewhat. At times, the weights used may not resist the wind and the tent can actually become airborne, landing on neighboring artists—or patrons.

My best advice: don't buy one, don't rent one. If you are serious about participating in art festivals, invest in a quality tent. And sleep well knowing that the rain and wind you hear outside your hotel room window won't de-

stroy your artwork. With practice, you will find yourself erecting a high-quality tent in little more time than one of the EZ-Downs.

Now, the quality tents have a skeletal structure made of steel or aluminum. Steel is probably stronger, but it weighs much more than aluminum. My aluminum tent poles weigh less than forty pounds, all in, and the skeleton consists of just fourteen pieces that interlock and, when not in use, fit in a bag about a foot around and six feet long. The skeleton goes up in about fifteen minutes, when two people work together. My canopy and side curtains weigh in at about thirty pounds, and attach in about twenty minutes, again with a bit of assistance, or thirty minutes when I do it alone. My tent poles are a decade old and other than one having been run over by a fellow artist in a hurry to leave the show, have never failed me. The parts of a tent structure are replaceable one by one, so the cost was about thirty dollars to buy a new pole. My tent is manufactured by Creative Energies of Ocala, Florida. I highly recommend it and the company, although quality tents are made by other companies, too. Investigate them all before you buy.

Tent canopies are more individual than the poles. You can have a top with sides that attach by Velcro, button straps, snaps or zippers. Many canopies can be customized with flaps that open for airflow and translucent panels that act as skylights. Be aware that, over time, any fasteners for vent openings and stitching for skylights can weaken, allowing rain to come inside your tent. You can purchase awnings in various widths from two to four feet and more; you can even add a "back room" that extends your booth out the rear of your space, if the show layout allows. Awnings are great; they provide shade for you and your customers, keep the sun off your work and let you stay open in a light rain. A back

room might be nice, but it generally requires more walls and walls are cumbersome and usually heavy.

Speaking of walls, if you exhibit two-dimensional art, you will need them. If you make three-dimensional art designed to hang on a customer's walls, you will need them. If you are a jeweler, sculptor, fiber artist or work in some other mediums, you may want them. You will see sculptors who do not use a tent or walls, but place their work on pedestals or, if large enough, on the ground. Envy the lack of time and labor they spend putting up and taking down a tent, but do not think their grass is greener when they sit or stand in driving rain or blistering sun.

One of the more elaborate wall systems I have seen, built to exhibit the artist's turned wood vessels, was custom manufactured of hardwood that had been sanded and lacquered to a beautiful sheen. A dozen cubbyholes, complete with halogen lights, were painted white. Trim, also of hardwood, was added. The entire structure fit together with hidden hinges. When you entered the booth, you felt transported to an elegant museum gallery. The artist's work, priced at $1,000 to $5,000, gleamed and looked worth the price, and more.

The walls, not including the tent and other items, weighed in at about 1,000 pounds, required a large customized trailer to transport and took three hours, at least, to erect and disassemble.

Was the effort worth the result? The artist has two types of shows; excellent and zilch. He either sells numerous pieces or none. At some shows, his wonderful display pays off; at others, it makes no difference to his sales. He has honed his list of shows—his excellent work enables him to enter any show he applies to—to eliminate those where even his custom display does not motivate buyers. It is an ongoing effort, as it is for all festival artists.

The walls of your display are like the walls of any retail environment. They should hold your work in a way that does not compete with the art, while contributing to your overall show image. You will on occasion see an artist's booth draped with fabric. Recently I saw one where the artist had wrapped her tent poles with paisley cloth. Cute, yes, but overkill and distracting. Another artist, who makes glass chandeliers, first erects walls, then covers the entire inside of his booth in black fabric, believing the dark background shows off his work best.

Most artists avail themselves of walls that are manufactured for art display purposes. These come in panels, with three or four stretching the standard ten-foot booth wall length. They are available in numerous colors and either full- or half-height. You can also purchase extenders that add a foot to two feet to the height of your walls. You will need a booth that extends upward to accommodate them.

The most common booth walls are made of either a wire mesh, over which fabric can be stretched, or carpet-like material that is hook-and-loop friendly. These systems include "feet" to raise the panels a few inches and a system to fasten the panels together at the top. The walls are then attached to the tent poles themselves, often with electric cable ties or Velcro. Another wall system consists of fabric panels fastened at top, bottom and sides. This requires an additional set of poles at the bottom of your booth and, while easy to erect, can make some booth designs difficult to construct.

Your display walls are intended to fit inside your tent, with side, back and front curtains closing over them before and after show hours. Side curtains are made of the same material as the tent canopy and generally zip on and off. A few artists try to clamp their curtains to their canopies as a makeshift approximation of an integrated top and curtain system. It's a poor idea;

rain and dirt enter freely. Sculptors can do this more successfully than other artists, if their work is relatively immune to the elements. Sculptors who do not use walls or tents will often string steel cable through their work, if possible, to prevent theft at night and cover their art with tarps to keep out rain.

Your choice of walls is integral to your overall booth design. Booth design is as individual as each artist's work. A few principals bear remembering.

Your booth will most likely be 100 square feet, in all, unless you choose and can obtain a double space and erect a double-sized display. When you and more than two visitors are inside, it can seem very crowded, with showgoers jockeying for position to see the work on your walls or shelves or in your racks and bins. For artists with only hanging work, space seems larger, but of course is not. More people fit comfortably inside, but sight lines are equally disrupted.

If you have bins or racks, you have two choices: place them along walls or in the center—or near the center—of your booth. You can do both, but you must do so carefully, trying not to cut down visitor space to the point of discomfort for potential buyers. Often, visitors to your booth arrive in pairs, or threesomes or foursomes. They may look at work together, or look at different work or in different racks or bins. Very often, you will see couples where one will stand just outside your booth while the other looks at your work, asking his or her partner to join in if a potential purchase is seen. If you have more than one bin or rack, this encourages couples to look separately at your work and find pieces to point out to their partners. The tradeoff is that more bins or racks take up valuable customer space. These are choices you will need to make as you design your space and gauge the feedback from the public.

Potters, glassmakers and others who craft small 3-D artwork often need shelving. Two options exist: free-standing or attached to your booth's walls. Few manufactured walls permit attachment of shelves that can hold much weight. Standalone shelving makes the most sense, and offers great flexibility in design and construction—and placement under your tent. Shelving can be made of wood, metal, plastic or even glass. Any artist whose work is fragile—especially glassmakers and some potters—must concern themselves with potential breakage. Most ask visitors not to handle the work, but to let the artist show it to them. Fragile items can be attached with removable sticky substances, such as those used in museums to anchor pieces.

All 2-D artists, and many creators of 3-D work intended to hang, need a way to hang their work in their booths. Here, again, choices abound: drapery hooks, Velcro fasteners, wire attached to tent poles or wall tops, fishing line, rods made for hanging artwork, metal strips with holes in them. Large or heavy pieces require more care in hanging them. Multiple small pieces hung on a single wall can become busy-looking if hangers are obvious. I used drapery hooks for years, until I tired of puncturing my fingers with them and waiting days for my sore hands to heal. Then I moved to a rod system made of fiberglass, custom modified to fit over my wall tops. I've never regretted the change and my hanging rods are the same color as my walls, making them unobtrusive.

As you choose your walls, make certain they will fit in your vehicle easily and can be taken out and replaced in the order you need them for setup and teardown. Also, be sure you have enough room—and enough wall panels—to allow for extra widths you use to jut into your booth from the exterior walls. Many artists include partial walls that come off the outside walls, as extra hang-

ing surfaces or to divide up their booths for storage or work space.

Back to that 100 square feet inside your booth. Every square foot you use for storage, work space or seating space diminishes your available display space. To most jewelers, this is a minor inconvenience, since they can display a lot of their work in rather compact display cases or on small wall panels and need relatively little room for visitors. To the rest of us, it should be a major consideration.

When a festival layout offers no room behind your booth for storage or seating, you have little choice but to find other storage—or eliminate as much of it as possible, the better answer. If you cannot sit behind or even beside your booth at its front, you will either sit inside it or outside in an aisle, usually at some distance, facing your booth. Sitting inside your booth is rarely optimal, since you are taking up customer space and your customers are standing, making communication awkward. At some shows, you will see nearly all the artists seated in front of their booths, ten or twenty feet away, from which spots they will jump up to greet customers throughout the show. It works, but it is tiring and can be frustrating when crowds are large and your view of your booth obstructed by them.

Artists can also opt to stand rather than sit, either inside or at the corner of their booths. This works, but over the hours becomes as tiring as jumping up to greet the public. Again, the choice is yours and depends both on the festival's booth layout and your personal preferences.

Most artists want to display more work than their walls permit. We do this because our wall space is limited, or we hang original paintings and want to offer prints to the public, too (if show rules permit reproductions). We use racks or bins to increase the number of

images we offer (shows can and do limit the number of bins allowed; you should always check a show's prospectus for its rules). Like walls, these come in many sizes and shapes, from homemade wooden bins to folding steel racks manufactured for galleries. A favorite among many painters and printmakers is made of metal tubing with canvas stretched to create a flexible space for matted pieces. For my own matted pieces, I use black metal racks that either fold or come apart for easy storage and transporting. My largest rack can hold sixty pieces up to 40" wide. My smallest takes about 30 pieces up to 14" wide. The racks I use are somewhat heavy, but very durable; mine have lasted almost a decade and can be touched up if they get scuffed. They are also much more stable than the metal tube design.

Homemade wooden bins are different in that they can be designed with storage shelves or drawers under the bins that also act as pedestals to bring the artwork up to a comfortable viewing height. Their major drawback is bulk and weight, often requiring wheels to make them portable.

So, we have a tent, walls or display fixtures, hangers, racks and bins. They have been chosen or built to create a pleasing, unobtrusive backdrop for our artwork. The boring, mundane details of our displays are over, right?

Wrong. As the song says, we have only just begun!

The public will wander into your booth, look at your work and, if they are considering making a purchase, want to know the price. How do you communicate this to them? You have two options: display the price or wait for the customer to ask, then tell them. Both options have supporters.

Artists whose work is relatively inexpensive tend to always put out price cards, either on the walls or, if their work is displayed on shelves, near the work on small

stands. Price, while the customer wants to know what it is, does not constitute a major consideration. More expensive work leads to a different environment; the price may encourage or discourage a purchase. Painters will often place hand written cards at the edge of their pictures, tucked into the corner of the frames, a traditional way of communicating the price. Sculptors whose work rests on pedestals may place small price cards next to the work on the pedestals, as will glass artists and potters.

Yet some artists do not put up price cards. They believe that when a potential buyer asks the price, the purchase is under strong consideration and the interaction with the customer about price can encourage it. Painters and sculptors of extremely expensive work also may think that price is an unimportant factor to wealthy collectors and can even dissuade the very rich as seeming a bit tacky. My own preference is to display my prices as galleries do, on printed cards placed near the piece. I believe that if the potential buyer is discouraged by the posted price, the sale would be difficult at best. If after seeing the price a customer remains interested, then cost is a relatively modest consideration in the purchase decision. I also believe that acting as a gallery does increases the customer's confidence in making a purchase at an outdoor festival. Every artist develops his or her view of the subject, hopefully guided by what works best for him or her.

Outdoor festivals are held on all kinds of surfaces, from grass to gravel, from concrete to asphalt. You will see artists unrolling a rug to place inside their booths or laying down rubber matting (the kind made in 2x2 squares that interlock seems to be popular). Artists who do this believe the flooring adds a certain ambiance to their display and may increase customer—and their own—comfort. The downside is that rain and dirt can

turn a rug and even rubber mats into large puddles of slippery mess. After a bad weather or dirty show, you will do your best to clean and dry your flooring, but you will find yourself loading at least some of the moisture and dirt into your vehicle. At a particularly rainy show, you will see one or two abandoned rugs in trash containers, money and effort wasted. I have never used flooring in my booth and have not felt my presentation wanting because customers must walk on bare ground; they are, after all, attending an outdoor festival.

Large booth signs, with the artist's name or that of his studio, appear on a few booths at every festival. They do increase the public's ability to recognize a particular artist's booth by name, but if hung inside the booth, may also reduce display space. They can also be affixed with snaps or Velcro to the front of your canopy. You will even find booth signs hung from poles affixed to booths at their fronts, extending out into the aisle. Some festivals permit this, others do not. Early on in my festival career, I used a large sign, snapped onto the front of my canopy. After a few shows, I came to feel it was an unnecessary extra bit of work and another item to unpack, affix and repack. Other methods, which we will discuss later on, can inform the public about your location and name. There is some logic to this. If a customer knows you from earlier shows, he or she will find you. If the customer does not know you, a large sign only serves to assist them in returning to your booth if they are interested in a purchase. Rarely, and only at a few national festivals, will a potential buyer not be able to return to your booth. Many shows—most, in fact—publish programs with your name, medium and booth number, and usually a map, included. At a few of the top rated festivals, such as the Winter Park Sidewalk Art Festival located in a suburb of Orlando, Florida, you will find at least three programs: a pocket-sized edition, a magazine-sized edition and a

newspaper insert. There may even be a separate map of the festival layout.

Most festivals also print their own booth signs, letter-sized, with the artist's name, booth number, medium and sometimes home city. Judges use these to mark booths they have visited, to avoid duplication, but also to reassure artists that they have been considered for awards. A few shows deviate from the format. The Boardwalk Art Festival in Virginia makes large plastic signs with stick-on letter for every artist, then gathers them at the end of the festival, removes the lettering and reuses the plastic. While this may seem odd, if it saves the festival money and keeps booth fees down, artists are all for it.

Okay, here is where we have arrived. Your tent, walls, display cases, racks, bins, flooring, storage containers, price cards and signage are all in place—or you have decided against one or more of them. Somehow, stuff still sits inside your van or on the ground. What is it and what do you do with it?

The stuff is, and this list contains many but not all the possibilities: business needs, such as pens, pencils, business cards, postcards with show schedules, artist's biographies, artist's statements, wrapping materials, bags for purchased items, tape, sales slips, envelopes, stapler, credit card machine, cleaning materials and utensils, guestbook, paper or cloth towels, lights, electric cables, power pack or batteries, tools, fasteners, clamps, tiedown straps and stakes, bungee cords, rope, flashlight, first-aid kit; personal items including, but not limited to, hats, jackets, spare shirts and overshirts, medicines, facial tissue, hand cleaner, suntan lotion, moisturizing lotion, cosmetics, bug spray, combs, brushes, spare eyeglasses, food, beverages, reading material, art materials, radio, sound system and cellular phone. You may find other items you need or want at your booth and

some of the above may not be for you. You will, however, need places to hold all those small bits and pieces of your show life that, sooner or later, you will find useful.

Every artist has his or her own solution for storing these items. Over time, I have attempted to limit them by keeping many in my van, other than those which obviously will be required to deal with customers and consummate sales. You will see many, many different ways of storing and keeping these items. Credit card machines may be left on a work table, inside or behind a booth, for example, or in a "desk" or even under the seat of some chairs. After a few shows, you will find your own methods.

What some artists bring to their booths, and many shows now prohibit, are materials and tools used to create or alter their work during the show. For example, photographers have long brought framing materials and tools and, if a buyer wanted to add or change a frame, did the work on a table behind their booths. I am not in favor of this practice; it takes an art festival, in my opinion, down a notch in overall presentation and quality. Creating art at your booth is another matter, and more complex. Festivals may have demonstration booths or areas, where artists can create work while the public watches. These are very popular with showgoers, whose curiosity about the techniques of our trades adds to their enjoyment when they make a purchase. At our own booths, a painter can draw interest by working on a piece while someone watches. Yet our job at art festivals is to sell, not to create art. If our attention is diverted from this primary task, we may miss sales opportunities. Some mediums do not lend themselves to working at an art festival; these artists may consider themselves at a disadvantage if the rules permit working behind a booth.

What, if anything, have we left out?

You, the artist.

The second most important element in selling your art, after the art itself, is the artist. We will discuss how to approach and communicate with buyers in a later chapter. Here, we are dealing with how you fit into your booth and display.

Sounds simple: you show up. There is more to it than that. First, where will you position yourself? Will you sit or stand? Other parts of this book take many elements of your presentation into account; for the moment, consider how you, well, look. This is a delicate subject, as we are artists and do not wear uniforms or suits and ties, at least most of us do not, in our work or at festivals. But how we look is indeed a choice, and one that reflects on our art.

A dear friend of mine, an experienced, successful, talented photographer who has been in the art festival business for more than three decades, wears only clothes by Armani at festivals. He may opt for other brands during setup and teardown, but never during show hours. I once asked him why. His answer: "It works for me." He meant that his customers respond well to him when he dresses in clothes from a name designer. He may be correct, since his photographs are mainly of European locales.

Another artist, a female painter, wears flowing dresses of flower printed fabric and broad hats with flowers and feathers affixed to their brims. The style reflects her work, which is flowery, complex and many-colored, but without the feathers! She, too, believes customers associate her style with her work.

These are extreme examples. Most artists dress, first, for the weather and, second, for comfort. Shorts, jeans, work-style pants, t-shirts and printed Tommy Bahama-style Hawaiian shirts are most often seen. Climate and regional styles, such as jeans out West versus shorts in the South, offer clues to an artist's home area.

Usually, an artist will not wear the same clothes during show hours as during setup and teardown. Every artist I know bathes regularly. Most shave often.

I do not believe the public wants us to look like starving artists in torn shorts and dirty t-shirts. On the other hand, I do believe serious showgoers want the artists they buy from to look well-kept and groomed, casual yet purposefully ready to serve the buyer's needs. Buyers of expensive art may be most comfortable when they believe the artist is successful, one key to which is how the artist dresses. Bear this in mind, whatever your clothing style, and wear clothing that expresses—as does your art—who you are.

In time, you will develop dozens, if not hundreds, of practices and elements small and large for your own booth. You will decide on design, layout, manufacture, color, display systems and what to bring with you or leave at home. This individual approach makes as much difference to an art festival as does the variety of the work the show includes. And after your work in itself, it will do more than almost anything to determine your sales success.

CHAPTER SEVEN

Building the Perfect Vehicle for Art Festivals

AH, THE PLEASURES OF the road! Wide expanses of highway; distant vistas of glorious mountain peaks; alabaster clouds against azure skies; the stereo playing your favorite music; or, clogged interstates with construction zones, congested cities and road rage; sixteen-wheelers spewing fumes and noise; torrential rain and wind.

Take your pick: each is true at one time or another on the way to and from art festivals. You can minimize the bad times, maximize the good times and leave room for Mr. InBetween, as an old ballad says. It's all in how you understand and prepare for the road. Your vehicle will serve as your traveling art warehouse. Inside it, you will keep and transport everything you need to exhibit and earn a living at art festivals.

First, your vehicle. Most art festival artists use cargo vans, the kind made by Ford and Chevy and Dodge, including the latest and greatest Dodge Sprinter, aka Freightliner Sprinter, who used to make it but doesn't now. My traveling art warehouse is a Ford E350 Extended Heavy Duty model, vintage 2001, with nearly 200,000 miles on it. No signs adorn the side or back. I would rather not broadcast to potential thieves that I am a photographer, as in their somewhat under-IQ'd world, that equates to expensive, easily fenced equipment in-

side. My van is factory white, which came standard from Ford. So many of them are on the roads of America that it draws little attention. Other colors are available, but artists prefer white, or, at least, most vans are painted white at the factory. White reflects heat better than darker colors, keeping your van cooler on overheated highways and in parking lots.

Inside, and under the hood, plenty of options abound: heavy-duty transmission, dual air conditioners, heavy-duty suspension, towing package (which includes a bunch of extra sturdy components for the van itself). I ordered the interior with carpet on the floor, the ceiling panels from a passenger van configuration and top-of-the-line seats and passenger compartment, for both comfort and noise reduction. I let Ford install their usual junk radio, and bought a better system after delivery of the van to keep my ears in tune. The engine is Ford's strongest V-8. I carry a lot of paper, in mats and prints, and a lot of heavy wood in frames, plus my booth, weights, steel print bins, clothing, and all the other necessities (we'll expand on that in a bit).

My tires are the best I could find, Michelins specified for ambulance use. They are, in my opinion, the most reliable, safest and longest lasting on the market. While the Michelins are rated for 50,000 miles, with the heavy load they carry, I replace them about every 40,000, much to the consternation of the tire dealer. My thinking on this is safety first; coming down a mountain in a rainstorm in Colorado is no time to wonder how much tread is left where the rubber meets the road. A set of the Michelins can run $800, but can be bought on sale for less. You may find that other tire brands are better for your needs. If so, buy them, keep them inflated and replace them at the first sign of deterioration.

One problem that vans can have is weight distribution. With heavy loads in the rear, as most of us have,

the tires can "cup", or take on an upside-down smile shape. You are then riding on the edges of your tires, not a good thing. This, and too much weight in general, can cause tires to bulge in spots on their sidewalls. This happened to me until I discovered that keeping the front tires inflated by about fifteen PSI less than the rear tires, which I inflate to their maximum rating, stops the problem. Both symptoms never came again. Your need might be different, more or less pressure, but this does work.

Speaking of nasty weather, keep your windshield wipers clean and soft, and carry a spare set, since you may not be able to find them right when you need them, usually a hundred miles from the nearest dealer. Practice replacing them, in a rain if you can, since windshield wipers are notoriously odd in how they come off and go back on the arms that support them.

You may not need a cargo van. Many jewelers do not, nor do artists whose work is small enough to fit in an SUV or station wagon, or even a car. My favorite is an oil painter who travels in a BMW station wagon, somehow packing everything including tent and framed work in the back seat and trunk. I have watched him unload and load; there is no way he can do it, but he does. Another option is a so-called "box truck", which looks like its name and comes in numerous sizes. These offer tall headroom, wide beds and large cubic space. They are, however, gas or diesel guzzlers, a serious consideration in our times. If you need the room, they are the answer. In fact, as one metal artist I know has done, you can turn part of the truck into an RV, sleep in it and still have room for your artwork. This fellow even has a motorcycle in his big box, which he regularly rides between shows in some of the most scenic places in America.

Two other types of vehicles exist: the RV and the non-motorized trailer that you tow behind another vehi-

cle. RVs offer advantages and disadvantages. They certainly allow you to avoid hotel costs, but they must be maintained and stocked, with food and water and other niceties. Most show sites don't permit parking RVs nearby overnight. So, you may have to tow another vehicle, a van usually, or at least a car. Now you have to find a place to overnight, usually an RV park, and pay for space. One painter and his wife, a jeweler, travel in an RV without a towed car or van, and actually limit the shows they book to those where they can get into the site, or very nearby, in the RV and park overnight within walking distance.

When you consider the cost of the RV and the low mileage (5 mpg is fairly normal for the largest of them), the economics can come out nearly equal to traveling in a van and renting hotel or motel rooms. As fuel prices rise, the cost benefit tips in favor of hotels. You do, however, have the comforts of home in your RV and—as does an acrylic sculptor I know—might bring along two dogs, one cat and a bird. For him and his wife, it is about the lifestyle they choose.

Trailers are another matter. Many artists use them, packing their artwork and paraphernalia inside, with room for personal stuff in the towing car or truck. Utility trailers have some of the drawbacks of RVs, such as size and available parking. At a show site, a trailer will be more difficult to pull to your booth and can endanger relations with your neighbors if your trailer is in the way of their unloading and setup. They remain popular since they are less expensive than a second vehicle, such as a van, experience few mechanical difficulties and act as stationary warehouses when you're at home. They vary in size greatly and can be easily built in for good traveling and storage. Pulling a trailer takes much skill and practice, but can be learned. Popping into your favorite restaurant for dinner with one attached to your pickup is

at times difficult; most parking lots don't accommodate them. Neither do many hotels and motels, garages and parking spaces on city streets. They do provide a useful alternative to the van or box truck or RV.

Licensing requirements for vehicles used in business vary from state to state and your vehicle may also be subject to federal laws administered by the US Department of Transportation. You will want to investigate these and, of course, comply with the ones that apply to your vehicle.

For our purposes, I will use the word van, but most of what you find below applies to other vehicles.

Whatever vehicle you choose, plan ahead. You will want to keep it for years, until it is paid for entirely and you experience the joy of not sending out a monthly payment to your financing company. My plan was for a ten-year life for the van. So far, so good.

I purchased my van new, but you can do well with a used van, truck, trailer, SUV or car, if you shop wisely. One source for used vans and box trucks are dealers that specialize in selling vehicles that were leased as fleets to large companies. These are usually very well maintained and have excellent maintenance records. They may have been outfitted for a specific use, but these modifications can be changed or undone. A Carfax report will provide the vehicle's history and a complete engine diagnosis— before you buy—can alert you to current and potential problems. Many dealers will pay for these, if you request them, but they are worth the money even if you foot the bill.

The more you drive, the more you need to be extremely attentive to components that wear out and to scheduled maintenance. Driving my van most often on interstates between shows, I did not need to replace the original brakes until well past 100,000 miles. Each time I had the oil changed (do this when or before the manu-

facturer recommends), I had the brakes checked. They just seemed never to wear out. If a drive belt should be replaced every fifty thousand miles, do that. Gas filter? Change it when recommended. You do not want to be in Colorado on a mountain road and break down due to lack of preventive maintenance. It will ruin your day and possibly your next show. Towing is expensive; join AAA, or have road service with another reliable company. Road service may even come with your automobile insurance. Carry a small store of spares, such as the drive belt. Your particular vehicle brand dealer can recommend what is best for your van. A few maintenance items tend to be overlooked, such as windshield wipers, which, in the hot sun, dry up and need frequent replacement. Preventive maintenance saves time and money—and prevents surprises that can hurt your income from shows.

Now to the interior of your traveling art warehouse. Here you can personalize your ride (nice modern term, huh?) in a way that will maximize space, comfort, ease of loading unloading and, believe it or not, service to your customers.

First, space. Each artist has his or her own needs. You may have lots of small boxed items, such as pottery, or very large paintings, or just a few sculptures.

My own experience creating the best space inside my van was a three-month process that worked out extremely well. I began by drawing a basic layout of the interior cargo space, from above. I measured the framed pieces, unframed pieces, chairs, tent poles and canvas and everything else I carry. I drew these configurations on my basic layout. Careful to note the heights of these areas I was assigning, I then bought large cardboard boxes and cut and taped them into the shapes and sizes I needed. For example, I carry sixteen framed pieces measuring 32" x 38", each taking up 11/2" in width, thus

creating a need for a space a bit larger than 32"x38"x24"; the extra space is there to allow easy loading and unloading. The box then went into the van, where I had placed it on the drawing. On to the next cardboard box, and so on. Finally, when the van was fully configured with cardboard, I packed my things and took it to a show. Unloading and reloading taught me what modifications were necessary.

Several weeks and lot of cardboard boxes later, I was ready for the final step: building-out the interior of the van with wood. Using 3-/4 and 1/2-inch plywood, I replaced the cardboard with wood lagged not into the sides of the van (which is possible, but not easy to change) but into each other, creating a single, sturdy interior, with modules I could remove, recut—as my work changed, which everyone's does—and still have a very workable interior. Before assembly, I sealed the wood with varnish. After assembly, I installed indoor-outdoor carpet on the floors of the modules and, where framed art would be held, the walls. This helps prevent damage from rubbing.

Sounds like a lot of work; it is. When it is finished, you will stand back and behold your labors with a smile. And you will reduce your packing, unloading and reloading time by many, many hours over the years.

A favorite of art festival artists are plastic bins, available from Office Depot, Home Depot, the Container Store and a cornucopia of other merchants both off and on the internet. Early on, I carried eight of them; one ceramic artist I know holds the prize at 45! They are inexpensive, protect your work and dozens of other necessities and come in hundreds of sizes, designs and colors. Extra inventory stays dry inside them. Bags for customer purchases nestle within. So does your lunch, if you choose to carry rather than buy it. They are useful, comfortable and lasting.

They are also ugly. I carry just four plastic bins and keep none, not one, at my booth during a show. I want my booth to be a clean-lined, spare space, including behind my back wall, where my work stands out, not my particular storage solution. For years, I kept extra inventory at my booth, in bins and cardboard boxes. Now, I keep only what is available for the customer to see and replenish my booth from my van, where extra inventory is accessible, thanks to my arduous design and buildout process. For some artists, especially those who travel alone, this entails too much time away from their booths. A well-planned van interior that allows you to quickly and easily retrieve artwork you need helps minimize time away from your display. You can almost always obtain a booth sitter for a few minutes, or ask the well-staffed artist next door to watch your booth while you visit your van. You will be happy to walk to your van to retrieve a new piece that will replace the $5,000 painting you just sold. So, for travel purposes, plastic bins and cardboard boxes are great; for the aesthetics of your display, not so good. You might find a middle course, as few ugly containers as possible, the best answer. You can also design your booth so that your extra stock bins are hidden, or at worst, unobtrusive. Some festivals require that boxes and bins be covered; white cloth or vinyl generally works best.

Artists who work in different media have varying requirements for outfitting their vehicles. Ceramic and glass artists often have breakable wares. Protect them, box them, bin them and put them on shelves or in cabinets created just as I did my permanent inside spaces, but firmly attached to the van walls. Bronze sculptors may or may not need containers for their work, but usually will at least strap their sculptures to the van's sides. Basketry can be delicate and require a lot of bubble-wrap (the stuff kids love to jump on to pop). As I noted

earlier, every artist has individual needs. Think yours through and then build your eighth wonder of the art world!

When you are planning your traveling warehouse, take into consideration your personal needs: space for clothes, food, magazines, even your guitar or mandolin. Don't forget your maps and guidebooks, CD collection and emergency road kit, which may consist of battery charging cables, spare parts, a can of tire inflator, oil if your van burns oil, which it should not. A cooler for food and beverages is nice. Hats and sunglasses are necessary, at least for me. A warm jacket or sweater you can easily reach helps in cooler climates. One of those orange hammer and knife combinations for exiting in a true emergency can save your life.

Another wonderful item to have: a GPS navigation system. Portable units that work anywhere in the United States can be bought for about $300 (less, too, but with fewer features). In places you are not familiar with, when you need to find a hotel (some units list them) or a restaurant (same thing), or on the way to a customer's house to deliver a purchase, or even a hospital, auto repair shop, supermarket or pharmacy, a GPS system can't be beat. Enter the destination, push a few buttons, follow the mechanical voice. One caveat: these units need periodic software updating, as new roads and subdivisions and whole cities are built. So once a year, buy the manufacturer's newest software and install it.

Long road trips between shows can be very boring, especially if your travel alone. Music and talk radio help break up the monotony. I installed an XM radio system in my van a few years ago. It is wonderful, with dozens of music, news, talk and even weather and traffic stations for major cities. XM and Sirius are, pardon the expression, serious competitors. The systems are not expensive and worth the money and installation time.

A few more vehicular tips. There is a book that I never leave home without. It's called The Next Exit, and you can buy it at a few of the bigger gasoline station chains, such as TA, but for some reason, only west of the Mississippi. You can also order it online. The Next Exit includes every exit on every interstate in the US. For all those exits, it lists every gas station, restaurant, motel, store and mall nearby. The book is updated annually. When you are riding down the road, hungry and thirsty (or your van is), you simply flip to the state and then the highway you are on, look for a nearby exit, listed by mile marker, and check the list. I've used The Next Exit for several years and have consulted it many hundreds of times. In all, I recall less than five errors, those due to businesses that have closed. By the way, auto repair shops are also listed, as are Wal-Mart, Sears, optometrists, doctors' offices, hospitals and many, many more. Buy one. Send me a thank you note.

Your van contains your art; secure it as well as possible from vandalism and thievery. A popular solution is a cut-off switch, hidden where thieves won't easily find it, that must be activated for the vehicle to start. Alarms help, but noise is not as strong a deterrent as in years past. People tend to ignore car alarms these days. Consider another solution, too: insurance. Your homeowner's policy will likely not cover your artwork if it is stolen or vandalized in your van and, if coverage is in force, only to the extent of the cost of the materials, not your time or retail price of the work. You can, however, purchase a business policy that covers theft, damage and even adds liability protection, should someone be harmed by you or your van. Even with these policies, your artwork will likely be covered only for the cost of materials. Your auto policy may help, too, but not necessarily while you are traveling on business. So, evaluate your current insurance and consider a business policy, which many compa-

nies, possibly even the one that insures your home, offer. I have one; the premium is a few hundred dollars a year and worth my peace of mind.

Maintain an inventory of what is in your van, artwork, booth components and personal items included and stow it at home or in your studio. Update it periodically, but not obsessively, for use in planning what you need for the next few shows and in the event you need to make an insurance claim.

The cost to buy, maintain and operate your art festival vehicle will differ with your needs and desires. A huge RV can run $200,000 or more. To a jeweler I know, that is fine, since the RV is her primary home as well as her workspace and warehouse and travel vehicle. Her $2,000 per month payments for financing and insurance are spread over both living and working costs. A friend with a car and trailer, who paints in watercolor, spent $2,000 for his used cargo trailer. A photographer drives a box truck, with enough inventory for eight to ten shows, depending on his sales. The truck cost $40,000; he paid cash. I financed my van, paid it off in five years at about $500 per month. Numerous other scenarios exist.

You can and should calculate the cost of the vehicle you are considering. I will set up a hypothetical situation to give you a framework for your own cost projection.

We will start with a new van, at a delivered price of $34,000. That is typical, in 2008 dollars, for a fairly well equipped extended van. We will assume payments of $500 per month for the van. Next, consider repairs and maintenance. During the van's warranty period, repairs should be zero, but maintenance—oil changes, for instance—and a new set of tires (about $800), will set you back another $100 per month, on average.

Now, spend a little time on Mapquest or Google Maps and add up the miles from show to show or home

to show, using your planned schedule for a year. Divide this by your vehicle's MPG, or the one in the dealer's literature or the vehicle's window sticker. Use the lower number; it will be more accurate overall. Multiply your projected annual MPG by the cost of gas or diesel today. Add ten percent for what will certainly be increases in fuel prices. Divide by twelve. For 20,000 miles per year, at 15 miles per gallon, with fuel at $3 per gallon, you will spend $388 each month, on average.

Insurance is the last expense we will include. We will estimate it at $1800 per year, or $150 each month. Insurance premiums will vary based on your location and driving record, of course, as well as the coverage you select.

These are the basic numbers you need to calculate your vehicular cost. Here is an example:

Vehicle: $500
Fuel Costs: 388
Repair and Maintenance Costs: 100
Insurance: 150
Total: $1,138

In our example, this would be your average cost every month. The annual total of these expenses is $13,656. A lot of money. Fewer shows and less miles will alleviate some expenses, but not all.

To truly understand the impact on your business, divide the annual cost by the number of shows you do. Twenty shows equal $682.80 per show. Five shows equal $2,731.20, a hefty amount. In either case, and your own, make the cost per show a clear factor in your thinking about your festival schedule and your expenses. If you plan on exhibiting at only a few shows, your vehicle costs may prohibit making much of a profit. Consider renting a van if you need one. I have done this and it is far from optimum for loading and unloading or personal comfort, but it does keep costs down. Renting does not allow you

to use your van as a warehouse between shows, either. If you plan on doing many shows each year for a number of years, buying a vehicle would be the right choice.

As you work up your costs, do not become dismayed. Successful business owners find ways to keep costs down and sales up. A used van, or a trailer, cheaper insurance, proper maintenance and shopping for less expensive fuel will help.

You will spend many hours riding in your travelling art warehouse, and many days unloading, loading and working from it. Making it the best it can be for your needs will return many times over the dollars, planning and effort you will invest designing and creating it.

CHAPTER EIGHT

Staying and Paying on the Road

ONE EARLY SATURDAY MORNING in Augusta, Georgia, my wife and I arrived at that weekend's show site about 7 a.m. We parked our van next to another much like it and as we walked away, noticed the soles of someone's feet pressed against the van's rear window.

Assuming no carnal knowledge was being gained at that moment, the someone was fast asleep, and had been there all night.

"Great," I thought. "No hotel bill for that artist last night."

"Awful," I countered in my mind. "No air conditioning, no shower, no toilet, no hot water at all, no electricity."

And then it occurred to me that the artist sleeping in the van probably could not afford a hotel or motel room. I became saddened at the thought. And in awe of an artist who so loved the art festival business that he or she would brave a hot night in a small van in order to exhibit and possibly sell.

Some artists, hopefully very few, sleep in their vans when times are tough, which they can be. The same artist will spend what is needed on accommodations when the money is available. I know of no artist who would rather sleep in his or her van than snuggle between clean sheets with reruns of CSI on the tube.

Not all hotels and motels are created equal, nor are all hotel and motel chains. Across the country, the amenities of Hampton Inns or Holiday Inns or Comfort Inns, while approximately the same in each chain's case, will vary, in ways small and large. Newer hotels and motels in chain operations tend to be much alike, as the buildings are designed for standardization. Older facilities will be different. For example, I have stayed in a Hampton Inn with a three-floor walkup and another with a dozen floors accessed by elevators. Some motels, and most hotels, have restaurants, but even this is not a given. Many chain operations offer a hot breakfast; others what passes for a "continental" buffet. Coffee makers may be standard in one chain and not in another. Televisions are everywhere, of course, but not always with more than local channels available. The list of variations is nearly endless.

And then there are the independent hotels, bed-and-breakfasts, YMCAs, hostels, campgrounds and—wonder of wonders—friends with spare bedrooms who live near the show you are in.

Two elements will influence where you stay en route to an art festival. These are cost and personal preference. An added element, proximity to the show venue, will weigh on where you stay during the show. Let's look at them.

Hotel and motel chains, and some independent hotels, love ratings and generally use the "star system" with one star being the lowest and five stars at the top. The rule of thumb is: more stars, higher rates. But the star system has flaws, for example a two star hotel in the center of Chicago may be a lot nicer, and more costly, than a two star motel out near the Iowa border. And even when the facilities are equal, location can play havoc with rates. I once stayed in a Homewood Suites in downtown Chicago that was pegged at $240 a night. On

the way out to California from there, I slept in an equivalent room in Nebraska for under $100.

The reasons for the large difference are fairly clear: running a hotel in a major metropolitan area costs more than on the prairie and, unfortunately, demand in a downtown area will usually be much higher than out in the fields of wheat. But there is a loophole here that you can use to your advantage. Many big city hotels and motels, as well as those in smaller towns, are busiest during the week, with business travelers who really don't look at room costs that closely. On weekends, they may have special rates to attract customers. More importantly, they may be willing to lower their rates if you ask them to do so.

Lower their rates just for the asking? Yes, because an empty room is worse than a cheaply rented one to the motel or hotel. Here's how to approach the subject.

First, reserve the room you want. Ask if the motel has a weekend rate. Get that rate. Second, ask for the AAA or AARP rate, generally a reduction of 10%, off that rate. Third, on the day of your arrival (assuming you can cancel on that day if you choose) call early in the day and ask for the manager, not the desk clerk. Ask the manager about that night's projected occupancy. You may not get a specific answer, but you will plant the subject in the manager's mind. Then explain that you have a reservation and that the rate is fair, but that, in case the motel isn't full, you would appreciate a lower rate. Hint that other hotels are often cooperative, including the competition just across the highway from the one you have reserved.

Does this work? Surprisingly often. I've used the ploy dozens of times, with success perhaps half the time I ask. You can also make your plea at check-in, but often the desk clerk has no power over rates, except at large hotels where a desk manager oversees making a quota of

rented rooms for the night. As an aside, be aware that if you book on the internet, your rate may be fixed and not within the local manager's power to change. On more than one occasion, I have stood next to a weary traveler trying to negotiate a room rate with a desk clerk, only to be told the rate is the rate is the rate. I then checked in at a much lower rate, using a reservation I made and negotiated downward earlier.

Many artists use Priceline or another online booking service. While you can lower your costs, especially with Priceline, you cannot specify which hotel you will book; on the Priceline website, there is an area of specific hotels offered, but the rates are not necessarily better than on other websites, including the hotel's own. One large chain even advertises that the rate you find on its website is the lowest available—as long as you prepay with a credit card at the time of booking, with no cancellation or refund privileges. Personally, I reserve rooms only with cancellation privileges, even at higher costs, since driving conditions and other events can alter your schedule at the last minute.

Okay, lets hit the road. A wonderful mythical trip from Atlanta, where our artist lives, to Miami, Florida, for the prestigious Coconut Grove Art Festival, what artists all refer to, with a hint of reverence, as The Grove. Imagine you are the artist. You have created wonderful new work. It is beautifully framed (you're a painter, for this example) and ready for display. Your booth is pristine—a mini-gallery. Your vehicle has been fitted out perfectly. You have paid your nearly $900 booth fee. You are, as the NRA says, locked and loaded.

The Grove (hear those angels sing?) is a three day show, Saturday through Monday, over President's Day weekend every year. Setup is on Friday, teardown Monday evening. You need accommodations for at least three

nights, Friday, Saturday and Sunday, at the show. But wait! That's not the whole story.

Atlanta is a very long single day or easy two-day run from Miami, about 650 miles in all. And, it is two days back. If you leave Atlanta on Thursday, awaken early on Friday and head straight for the show site, you should be able to stay overnight only one day on the road. At the end of your journey to the show, you will need to shake off your road weariness and set up your booth and art (The Grove has a tradition of early opening on the first day of the show, when VIPs tour and hopefully spend without the general public around).

So, to save money, you arrive Friday afternoon, shake off the stiffness, set up your booth and go to your local hotel. You might, if you are so inclined—which I always am—have requested an early check-in at your hotel, thus dislodging your personal suitcases and other items from your vehicle before setting up your booth. Hotels and motels try to accommodate this request; if your room is vacant and has been cleaned, you will be able to check in early at no extra charge.

On Monday, you check out of your hotel, tear down your booth after the show ends and go—where? If you decide to leave Miami, you must travel some distance to leave the metropolitan area in your rear view mirror and find a lower priced hotel.

Now it is Tuesday, and you hightail it to Atlanta, arriving late at night, tired but happy with your sales at The Grove.

Let's assume you travel with your wife. She likes the amenities of life, including showers, hair dryers in hotel rooms and other niceties. So you reserve a 2-plus star motel for Thursday and the show's hotel partner in Coconut Grove for three nights and another motel on Monday. The hotel in The Grove will cost you about $225, including taxes, each night, which is far less than their

usual rate, which would add another hundred or more. That adds up to $675. Two nights at 2-star motels: $200.

How about meals? Two people, six days, eating reasonably, three squares a day, adds another $600. You can eat for less, but you may not survive the experience, unless fast food fills your needs.

We're up to $1,475. Add another $100 for gas or diesel, we've reached $1,575. Add in the booth fee, and the show has already cost neaeerly $2,500. We will not note the potential extras, which can include sunscreen, show memorabilia and a bottle of wine to celebrate your excellent sales.

Okay, you ask, is there any way to lower these costs? Yes, and no. You can't pay less for a booth at The Grove. You can pay less for motels on the road, at some risk that your room will be inhabited by a large population of bugs who don't buy art, but eat it. You can eat for less, although $100 per day for two people on the road is not very much when you eat well. You might try to stay far away from the festival, but you may regret it; traffic on show days to and from the show site can seem like driving in a slow motion water ballet. Actually, South Florida traffic rivals that in Atlanta, which is perhaps the nation's worst.

So the approximate travel cost is a reasonable benchmark. Until you look around a bit. Not too far from The Grove is a barely two-star motel that can save you $50 a night. It is old, but clean. In Coconut Grove exist one or two reasonably priced good restaurants. Save another $100 or so over three days. Visit a supermarket and buy lunch meats for sandwiches, fruit for snacks. Your costs drop another $50 to $60. Try not to buy gas or diesel at a highway exit. It is less expensive a mile or two off the beaten path, nearly all the time.

Work at it and you can indeed save 20 percent of your travel cost in our scenario. Many other shows will

be the same. How do you find these cost-saving places? Ask other artists, in fact get in touch with them as soon as you are accepted into a show you have not done before. While the Atlanta to Miami example will not extend to every artist in every show, the message is clear: travel costs are high; you can lower them with work and diligence.

The example does not always apply. I know a few very successful artists for whom anything less than a four star hotel with room service and on call massage therapists is unacceptable. I know a few very marginally successful artists for whom a hot shower is a luxury. Most of us are in between. And all of us have different needs. Let yours be your guide, but remember to reward yourself once in a while with a great place to stay and a round of brie from room service.

If you schedule a series of shows away from home, you will be faced with where to stay between weekends. This necessity adds to your travel costs, and should be allocated to the shows on your tour. Suppose you are exhibiting in four shows over the course of three weeks (four weekends equals three weeks), plus two days travel time each way. That adds up to 25 days on the road, divided by four shows, or 6-plus days per show. For convenience, assign six days' cost to each of three shows and seven days to the fourth.

You can use the time between shows any way you like: stay near a show site and explore the area, travel to a place you have always wanted to visit, or to paint, for example. In Chapter 15, we look at how this and other festival requirements affect artists emotionally. Whatever you choose, you may find costs will go down, or up, near the show sites. In cities, as noted above, hotels charge more during the week, when business travelers are plentiful and on expense accounts, than on weekends. Near tourist destinations, the opposite tends to be

true. Some hotel chains, and independent hotels and mo-
tels, offer multi-night discounts. Extended-stay chains
often give multi-night discounts and provide kitchens
and sitting rooms in their suites, further creating sav-
ings opportunities and increasing comfort. Once in a
while, you can talk a hotel manager into applying a
lower rate than advertised, for example, maintaining a
weekend rate during the week or vice versa. It never
hurts to ask.

As you gather experience and friends on the show
circuit, you will find artists who are willing to share ac-
commodations to lower costs. Some artists will offer
their homes to other artists, especially between shows
and if the offer is reciprocated. I often offer a fellow art-
ist a guest room in our home, since we live in Florida
and many artists travel to the south for winter shows.
They are always ready to return the favor. Savings can
be significant this way. You should not, however, rely on
or predict when this will occur.

Don't forget that most hotel chains offer "rewards"
points for staying at their establishments. Each year, I
stay without charge for about three weeks—21 nights—
using rewards points. The savings can add up to thou-
sands of dollars. I have rarely encountered blackout
dates, although some hotels and motels limit the number
of free stays they offer in peak seasons or during heavily
attended events. The trick is to book these stays early.

Over the years, I have come up with a personal rat-
ing system for hotels, not with points or stars, but less
precise and perhaps more important. Here's my list,
from most important to least important:
1. Cleanliness
2. Security
3. Comfort, type and size of accommodations
4. Proximity to show site (during the show)
5. Cost (especially between shows)

6. Parking (always important when driving a van or towing a trailer)
7. Access to restaurants
8. Nearness of shopping (supermarkets, drugstores)
9. Other facilities (exercise room, business center)

I used to concern myself with computer links in the room, but now I carry my own wireless card, having given up on trying to predict the wireless signal strength in hotels and motels. We all have our little travel bugaboos, mine being rooms where, after turning out the lights for the night, I find the window drapes inadequate. One hotel, in of all places Naples, Florida, among the nation's richest towns, has a few rooms with two windows. The smaller windows have no drapes at all! Light streaming in at 2 a.m. can make for a poor night's sleep.

For the sake of those, who, like myself, sleep best in our homes, let me say that the hotel and motel rating services sorely fail in one important area of comfort: pillows. Pillows in hotels and motels are, generally, poor to awful. Okay, if you spend $200 and up a night, you can demand the best headrests in the land. But in average hotels, which lately have actually begun to compete on pillow quality to some effect on where I lay my head at night, pillows are—terrible. So, I carry my own, as does my wife. They are expensive, exotic foam pillows made by Tempurpedic, a brand name. They're great. At $100 or so each, we don't forget them at checkout. And I endure the looks of other travelers with great glee: they rub their sore necks; I do not!

The importance of the pillow example is this; you can carry with you items that enhance your hotel or motel stays in measurable ways, and ask your hotel or motel for other niceties. Every time I make a reservation, I ask for, and most often receive, a room with a refrigerator, or prod the establishment to place a small portable 'fridge

in my room. I get a refrigerator about 90% of the time, at no charge. Water, juice, fruit and other edibles stay chilled and fresh, and on show days, I can carry cold drinks to my booth in the morning. When a hotel or motel tells me there is a charge for a 'fridge, I offer the observation that their competition across the street or highway includes one without extra cost. This usually works.

The topic of when and how to make reservations at hotels and motels carries a few important implications for your comfort, cost—and sanity.

As soon as I receive acceptance into a festival, I make reservations for the show nights. Hotels and motels near festivals can become sold out very quickly, especially if the show has arranged for special artist rates, which many do. Festivals include hotel information with most acceptance packets, or on their websites. Rarely, they arrange for a limited number of lower priced rooms for artists. In most instances, you can cancel a reservation if you find more appealing and less expensive accommodations, which is better than finding yourself staying an hour from the show in a down-at-the-heels motel. Generally, I leave between-show reservations for about a month before the show, or at least until I have planned my travel itinerary. I do know one artist, a bronze sculptor, who makes no reservations, preferring to show up at the nearest hotel to the show when he arrives for setup. I would not take this chance; shows are uncertain enough without wondering where I will spend the nights.

How you make reservations depends on your personal preference. Mine is the internet, and occasionally by telephone. I like having an email confirmation I can print out and carry with me. Today, most hotels and motels will send you one. Check it over to make sure your reservation includes all the proper information—type of

room, room rate—and make any needed corrections early. One caveat: while computers have made centralized reservation systems possible, they do not always have the most up-to-date information on availability, room types or rates. More than once, I have been informed on a chain's website that a property was sold out, only to call the motel directly and easily make a reservation. The same has happened frequently with room types.

Each year, I spend about 180 nights away from home at, en route to, or between festivals. Attention to small details of accommodations, amenities and costs makes those many nights much more enjoyable. I try to stay in motels under the same national brand banner, preferring to know at least in general what I can expect. You can do the same for your travel enjoyment, or you can, as many artists do, book the least expensive accommodation possible.

When you arrive at a festival location the day before setup, or in the morning before an afternoon setup, you will often see other artists parked near the show venue, walking around, looking in shops, stopping for lunch or coffee. They are trying to obtain a sense of the show site, for one, and to locate their booth spaces, for another. Except for gated sites, where fences are either in place or erected to assure payment for tickets by the public, you can do the same. Booth numbers, which are almost always sent to artists weeks or months before a show takes place, are usually marked on the ground with tape, the number written in permanent marker. A few shows held on grass use spray-paint numbers on the ground. One or two shows place flag markers with booth numbers written on them. This pre-show visit offers advantages, including assessing how easily you can drive to your booth space, whether you must dolly in your display and work and what sort of storage you are likely to

have. Most important, you may be able to determine whether the layout will permit hanging work on the outside of your booth, or leave open side walls for a better view of 3-D work that rests on pedestals or shelves.

Previewing your location can be very helpful if setup is to take place early in the morning on the day a festival opens, more so in winter months when setup may start before dawn. You can also check on parking availability, its distance from the show site and find the easiest path to where you will park. Close-in parking spaces, if available, fill up early on the first day of a festival, since many artists choose to place their work then rather than the day before. They arrive hours before the show opens, empty their vehicles and claim the nearest parking spaces for the day. When I know that parking is sparse near my booth, I try to arrive early, even if my booth is completely ready to open.

Parking at your hotel or motel is rarely a problem, although one or two circumstance can make it difficult. Vans and some utility trailers often exceed the height available in metropolitan parking structures, hotel facilities included. The hotel may have open-air parking available nearby, or you may have to find a lot on your own. Many inner-city hotels charge for parking. I have had some, but not much, success asking the hotel to waive their parking fees. If the hotel owns the lot, this may be granted; if not, you have little choice but to pay the daily fee, which can be up to $40 per day in large cities. On weekends, open-air lots in downtown areas offer cut-rate daily fees, so a bit of investigation can save you a few dollars, although security can be a problem.

The diversity, in quality, cost and convenience of location, of hotels and motels add a dimension to our art festival businesses that we can treat with as much or as little intensity as we choose. A photographer I know dislikes staying in hotels that do not have restaurants at-

tached, but hotel restaurants tend to be expensive and rarely offer excellent cuisine. A painter of my acquaintance refuses to pay more than $50 a night for any room and shrugs off skimpy towels, noisy highways and creaking beds. Choosing your accommodations on the road and at festivals involves many tradeoffs and compromises. All that aside, I have found that a great night's sleep in a clean, well-lighted place makes for a wonderful start to participating in any art festival.

CHAPTER NINE

Creating a Workable Festival Schedule

CLOSE YOUR EYES; OPEN your mind. Empty your brain of thoughts.

Envision an art festival world where every show is within two hours of your home or studio, setup is either on the day before or the morning of the show with a noon starting time for the public to come in, teardown begins at four p.m. and takes only an hour. You arrive back home in time for dinner and reruns of Miami Vice.

Now open your eyes and put thoughts like those above in a safely locked drawer, somewhere between fantasies of having your first solo show at the Museum of Modern Art on your 25th birthday and winning the lottery.

Why? In order to succeed as an art festival artist, you must accept the time consuming, lengthy and at times burdensome aspects of your festival schedule. For those of us who earn all, or nearly all, of our incomes from art festivals, this is a seven-day-a- week career, with only an occasional day off and haphazard vacations, during which we, well, work—painting, photographing, drawing, creating our art.

I am not a workaholic. If anything, and I believe most artists are the same way, I alternate between periods of creative frenzy and semi-comatose lethargy. Unfortunately, the periods of lethargy are few and far be-

tween, since I have never won the lottery and make my entire living as an artist.

For those of us committed to art festivals, a third level of activity enters the mix: on the road. We have been called gypsies, or worse, vagabonds. We are not. I prefer to think of us as having moveable places of work to which we must commute up to thousands of miles...there and back.

Few artists want to spend their time traveling from show to show for weeks on end with no time at home. Most full-time art festival artists do, although a few painters and sculptors I know sell so well that they follow a schedule with several weeks off between shows in order to create more work. And, of course, many of us would rather be creating art than selling it, and, if we have the means to do so, limit our shows to only those that occur when and where we want them to be.

My own typical year consists of thirty shows, leaving twenty-two weekends off. I try to divide the shows into several groups, for example, doing eight shows in thirteen weeks in Florida from January to March, then a month in Texas (with perhaps a weekend off in between), then a few weeks off, then a long run in either the Midwest or Rocky Mountain states. When autumn arrives, I try to stay near my Florida home, but usually wind up in the Northeast during September and October. November and December are devoted solely to creating new work.

That's my rhythm, not yours, of course, but no matter how yours differs, the principles of planning and traveling will be pretty much the same.

If you have the inventory of your artwork that allows exhibiting at several shows in a row, you may be able to group the festivals to minimize both your away time and your travel costs. If not, you will likely plan a schedule that keeps you nearer your home base and able to create

your artwork between festivals. You can also build a hybrid schedule that allows you time at home for part of the year and periods when, having built up your inventory, you can stay on the road for a number of festivals.

So, to a more hypothetical artist's needs. Our artist wants to participate in twenty shows a year, and has a sort-of plan to bring in $100,000, or $5,000 per show, in sales. Not a bad plan, since many artists do average that high a sales figure. He or she lives in Illinois, making travel to many shows a must. Let's' assume that five shows are within a brief—less than one day—ride, with the rest requiring more than one full day's highway time.

For the sake of our example, all twenty shows are two-day events, although you may find a few longer festivals. So, for the five shows near home, each requires four days on the road, a total of sixty days. For the fifteen shows away from home, each requires three days (one day there, two days exhibiting), adding up to forty-five days. In between those fifteen festivals are fourteen four-day periods, devoted either to travel, if the away shows are a long way from each other, or layovers. Those add up to fifty-six days. You can do the math, but I will: it totals 161 days! You will be selling on only 40 of those days, but trying to pay for them all. And you will need the income to pay for the other 204 days in the year (we'll throw in leap year days).

The good news is that you still have more than 200 days a year to create your work.

The bad news is that you must cope with 161 days on the road.

There exist, it is true, some locations where outdoor festivals are held virtually every weekend within a half-day's drive, such as southwest Florida, where, from November to March (and even into April) you can find a show to participate in every weekend. The problem is

that the plethora of festivals dilutes buying power when customers believe they can put off purchases from you, since they can see you on any weekend they choose. A few artists pursue this sort of schedule, but few if any do well every weekend.

For the rest of us, time at nearby shows seems to always be less than time at distant shows. To make this sort of schedule work, you need to consider several elements when building your annual itinerary.

First, finding, applying and being accepted into shows that fit into your desired travel plan. This is a most difficult area, which all art festival artists confront.

Say, for example, you want to be in the Midwest during June and July, and to participate in seven shows over a period of eight or nine weeks, with a weekend or two off for rest, sightseeing and visiting relatives or friends.

You begin by looking in the festival directories, magazines, state cultural department websites and other places on the internet for show dates and locations. You find that, in the Midwest, you have an average of four shows a weekend that meet your schedule desires, perhaps 36 shows that you can see fitting your goal. After researching these shows, about a quarter of them, eight in all, do not appeal to you or have parameters that suit your work—a preponderance of craft booths if you are a painter or few crafters in a fine art festival—and you are down to 28 possibles.

That is a lot of applications for seven shows, correct? No, it is actually not enough. If, and it rarely will happen, each of your weekend dates has four possible shows in it, you must decide how many to apply to for the greatest chance that you will be accepted in at least one, and that the one you are accepted into fits into your travel plan.

You will find that show directors and committees, and show promoters, do not like to schedule shows on the same weekends as others, either in the same or nearby communities. Doing so has two drawbacks: it reduces the number of artists available to exhibit and it creates multiple acceptances for artists, who must choose only one festival, thus forcing the show to dip into its wait list or, worse yet, find themselves with empty booths. Public attendance can also suffer, lowering a festival's success for both the festival and the artists.

From the artist's viewpoint, the more desirable shows the better—unless you must send in your booth fee with the application and, having been accepted, cancel with no possibility of a refund.

Let's break this into manageable parts. When you apply to more than one show on the same weekend, you are, first of all, hoping to increase your chances for acceptance. This may or may not be true, since being accepted is not a random act based on mathematical odds. Your chances of acceptance into any given festival do not rise because you apply to others held on the same dates. The more subtle influences on show acceptance or rejection hold no matter how many shows you try to enter.

Applying to shows where you believe you have little chance of acceptance makes no sense, regardless of your travel and schedule wishes.

Often, you will find that the shows held on the same weekends are not of the same quality, or income generation potential. Artists who travel call lesser shows on their schedule "filler" shows, something to do on an off weekend rather than just sit around. This can make sense, if you have other reasons, such as the opportunity to try a new geography for your work, an excess of inventory, a need or desire for cash flow without regard to profit, or a logical stop en route from one good show to another. I do filler shows, not always with great results.

Once, in Colorado, I exhibited at a festival that did not pay expenses, between two great-selling shows. Had I not paid the booth and jury fees for the filler show, I would have been better off monetarily. This happens, with regularity, to any artist following that logic. It is important to make clear-headed decisions about filler shows, as you do about all festivals. First year festivals in out of the way places, or in locales where established, highly regarded festivals already exist, should bear the closest scrutiny. Promoters, with staffs in place and systems available to run a new festival, can more easily start a new show than community organizations, which must bring aboard people with festival operating skills. This is not always a recipe for success; many artists will not participate in first-year festivals under any circumstances, but most artists evaluate each show individually and make their decisions from there. Once in a while, a first-year festival will be an instant success, but this is the exception rather than the rule.

Back to our example: you have the opportunity to apply to four shows for each of seven weekends. Rare is the artist who will do this. It is costly, time consuming and not usually successful. So, the artist searches for more festivals, but there are none to be found. The wise artist looks at the problem from another viewpiont.

Instead of applying to four shows per weekend, he or she eliminates two shows on each weekend that either do not fit the artist's optimal festival profile or to which the artist has very little chance of acceptance. The latter group is the most difficult, since we all want to believe we will be accepted into every show to which we send an application. A clear and honest appraisal of our chances is needed. And all the qualifications and self-judgments we use to make application decisions must be considered.

You should always attempt to gain acceptance into the very best festivals that suit your work, your travel desires and your willingness to bear the show's costs, but you should also resolve not to waste time and money applying to—and even traveling to—shows where you have little chance to sell, if you happen to be accepted.

So you choose two shows per weekend for your planned summer journey. When the jurying is done, you receive acceptances for only four of your seven planned weekends. What do you do? If, initially, you had expanded your schedule planning to include more weekends than you needed—say, ten instead of seven—you might find yourself with the seven weekends you wanted filled by shows. Now, if application deadlines permit, you can apply to more shows. This rarely happens, since deadlines tend to come before acceptances to other festivals on the same weekend are sent out to artists. Or, you can look to make up the missing three weekends with others later in the year. For the most part, you can wait until the next year or show season and apply to more shows on more weekends.

After your show schedule is locked into your calendar, acceptances in hand or in the computer, you will find your bank balance diminishing rapidly. If your acceptance is from a show you applied to electronically, you will need to respond to the email from the show or the notice from ZAPP or JAS with a positive answer, if you are going to exhibit. You will be given a deadline by which to forward your booth space fee, usually by credit card over the internet, but occasionally with a check through the mail. This is a non-negotiable deadline; forget to do it and you will be stricken from the accepted artists list.

If your acceptance came by mail and you already sent in your booth fee with your application, your check will be deposited, usually very quickly. If the festival did

not require your fee at the time of application, you will need to respond by mail, check for the booth fee enclosed, again by a non-negotiable deadline. Shows set these deadlines so that they can get on with their work of planning booth locations, preparing printed materials and publicity campaigns and completing other tasks.

No matter which system is used, your money will be in the show's hands long before the festival takes place.

For the artist struggling to make ends meet, this can become onerous. Top festivals, and some promoters, want you to pay for your booth spaces as much as six months—and in a few cases more—before the festival. Their reasoning goes like this: given the opportunity to do so, many artists would simply not show up at the festival, leaving the show with empty spaces and short of funds. Even if the festival were able to fill the empty space, materials such as show programs contain wrong information. I consider this an insult to most artists, who are professionals in their field and mature in their pursuit of their art festival businesses. Should an artist accepted into a festival fail to show up after accepting a booth, and leave the show without a replacement or payment for the booth, the festival simply can refuse to let the artist exhibit in the future.

The festivals' reasoning leaves out another way to handle the potential problem: make payment due not months, but weeks, before the show date. Since most festivals maintain waitlists of artists for their shows, finding replacements should not present a problem.

Artists dislike acting as the source of funding for art festivals, especially those run by promoters who, in a business intended to make a profit, should be able to find their own sources of money. Businesses rarely ask their customers to pay for what they buy until they fulfill the customer's order, unless what they buy is a unique, special order product. Most artists would not ob-

ject to paying for their booth spaces at some reasonable
point before a festival, but this rarely happens.

The monetary effect of paying in advance for festival
spaces can be enormous, and create hardship for many
artists. You may find yourself paying out thousands of
dollars before you have an opportunity to begin earning
a return on your money. You will do it every year and it
is unlikely that this will change. Festivals show little in-
clination to take the responsibility for financing their
operations on themselves.

Even more frustrating to festival artists are "no re-
fund" policies for cancellation by artists before a festival
begins. Some shows do have refund policies, with a few
of these using a tiered system that returns more of your
money to you the earlier you cancel. A few more offer to
refund your money in case of illness, on a case-by-case
basis, but you cannot count on this happening. Artists
believe that, if they cancel their participation and a fes-
tival succeeds in filling their booth space with another
artist, their money should be refunded in full. One or
two shows may do this, but only one or two. The rest
simply fill the space the canceling artist leaves open, ac-
cept double payment for it, and issue no refund. It is an
unfair, inequitable practice—and also not likely to
change.

So, in your planning, you should take into account
that your booth fees will be payable as much as three to
six months in advance of the shows you do. You can con-
struct a calendar, with show dates and payment due
dates on it, to assist in making booth payments on time.
You should also be careful about checks you write that
will not be cashed until months later; it is too easy to
forget these until the checks are cashed and your bank
sends you an overdraft notice, complete with fees you
must pay. The show that deposits your check and finds
it, to be blunt, made of rubber rather than paper, will

likely also want an extra fee. My own method is to consider the money spent the day I write the check, deducting it from my checking account. I receive no nasty surprises, or overdraft notices.

Now that you have received your acceptances, paid your booth fees and committed to exhibit, you will need to prepare for the shows. This means your artwork, your tent and display, your vehicle, your dogsitter and your hair stylist. No, really, you will have many, many small tasks to perform and, as you exhibit at more shows, these will become second nature. Until then, a checklist or a calendar with items that need to be done noted can prevent mishaps.

Festival participation has a certain rhythm to it, which is generally the same for all festival artists and different for each of us in its details.

The common elements are:

-Prepare your art;

-Pack your vehicle;

-Travel to the show;

-Set up your booth;

-Do the show;

-Tear down your booth;

-Travel home, or to the next show.

The differences in how artists accomplish this add up to hundreds of little nuances. You may want to pack your vehicle early, days before you leave, or hours beforehand. You may wish to leave as late as possible before setup, thus minimizing time away from home, or much earlier, to give yourself time to acclimate to the show's location or simply rest after a long ride. You might plan side trips between show weekends. The list goes on and on.

One thing is certain: all the steps you take, including making hotel reservations, packing beverages and snacks, checking weather en route to the show and so

on, are necessary. After you have a few shows under
your belt (or, rather, under your canopy), you will de-
velop a rhythm of your own and many tasks become sec-
ond nature. Still, because shows vary, as do travel re-
quirements, it makes good sense to pay attention to each
show on your itinerary as though it is your first—and
the first time you have participated in that festival.

Every show you are accepted into will send you,
more and more of the time over the internet, a show
package, the information you need to participate. Setup
schedules and particulars are included, as is information
about parking, your booth assignment, festival hours,
hotel and motel accommodations, nearby restaurants
and stores, local sales tax percentages, regulations con-
cerning your booth itself (such as staking into the
ground, weight requirements, etc.), show hours, tear-
down procedures and much more. After a while, these
packages seem to be mostly alike. They are not. Festi-
vals develop their own characteristics and these change
as time passes. Reading these packages can become bor-
ing, but you should do so, no matter how many times you
have participated in a show. You may find that the
show's hours have changed—or the show's location.
Setup times and dates may also have been altered; you
need to know the new information. You will also want to
bring the show package with you for reference. Some fes-
tivals hand out packages at registration, too, but many
do not, relying on the material they issued to you on ac-
ceptance. Reviewing and carrying with you the artist's
package will, sooner or later, save you time and frustra-
tion. Many times at shows I have been asked by a
neighboring artist what time the show opens or closes.
Not knowing your hours of business is, well, not the
hallmark of an astute businessperson. During setup, I
have been approached by many artists asking where art-
ist parking is located. Another difficult-to-believe lack of

knowledge. These and other questions whose answers are included in the artist's package—either prior to the show or at registration—are basic items you must know. Of course, we are all subject to moments of forgetfulness; your fellow artists will always help, but it is an error to rely upon their information all the time—their memories may be faulty, too.

You will encounter a show where the information in the artist's package is incomplete. When this happens, I call the festival director and ask. I have always been greeted with patience and courtesy. In the rare instances when the festival does not send out an artist's package, you will receive the information you need at registration (also called check-in). Show staff or volunteers are usually on hand to answer any questions not covered in the registration materials. At some shows, staff or volunteers circulate during setup—and during show hours—and will either have, or find out, the information you request. Smaller, community run festivals sometimes leave out, or do not have, a pertinent bit of information, such as whether staking your booth into the ground is permitted. When this occurs, make certain the festival director also does not know the answer, then do as you choose.

When you are ready to leave, take a moment and consider what you have forgotten. One year, preparing for several shows on the road, I noticed that the suitcase with my clothes in it seemed lighter than usual. Something distracted me and I forgot to open the bag and check that I had remembered to pack everything I would need.

Three days and 1,500 miles later, I discovered that I had failed to pack my shirts. An expensive trip to a department store remedied the problem, and ensured that my profits from the trip dwindled. Perhaps it was my aging memory, perhaps just the dozens of details—such as

my artwork—that needed tending to before I left home. Don't leave home without it can refer to more than just a credit card, although you want to remember that, too.

Remember to prepare you vehicle, also. I was ready to leave on a trip after a two-week stay at home when, all packed and with my house's alarm system duly switched on, I turned the key in my van to hear— nothing. A half-day and lots of frustration later, I discovered that I had inadvertently left an inside light on in the van, draining my battery and rendering it useless. It made for a long day and a diagnostic bill for over $150 from my local dealership, not to mention a new battery.

You, of course, are smarter than this and keep your traveling art warehouse in tiptop shape and ready to go. You also make your hotel reservations well in advance, since hotels fill up rather quickly in certain places. You confirm your reservations a day or two in before arrival, guarding against a mistake by your travel agent, the hotel or motel chain reservation department or—once in a great while—yourself.

When you travel a large part of the year, you learn to expect the unexpected on the nation's highways: construction, accidents, heavy traffic congestion and detours. These add time to your travel day. I have developed a keen awareness of when travel becomes less than prudent due to tiredness or boredom. My wife and I travel together, so we keep each other company. We never schedule our high-speed hours before or after sunset, leaving a margin for error that permits us to stay off the highways in darkness. Even though speed limits on the interstates can reach 70 mph in rural areas, we plan on averaging 50 miles per hour for an entire travel day. We look to average 500 miles, no more, in a single day, unless we are in the plains states, where you can up the average somewhat. The 50 mile per hour average includes time for rest stops—we try to leave the road every

two hours to stretch and refresh ourselves—and adequate time for meals. I believe this has kept us accident-free for over 200,000 miles going to and from art festivals.

CHAPTER TEN

Setting Up Your Display at a Festival

NO ARTIST I KNOW enjoys setting up a booth at an outdoor art festival.

A few, I admit, put on the proverbial happy face, turn on their boom boxes, let the dusky tones of Sarah Vaughn waft above them and enter a transcendental state.

And, just maybe, somewhere out there in art show land, an artist sees the blood, sweat and tears of setting up a booth display as cathartic: you leave the creator self and enter the selling self. Our hopes for sales rest in this physical portion of our business. We do it because we must.

Reality is simple: setting up your mini-gallery for the weekend is hard labor, perhaps even cruel and unusual punishment, but it must be done. You can minimize the trauma and even come to enjoy, if not the process at least the end result, with a few techniques and well thought out plans.

Art festivals differ greatly in how they implement the setup process. Some assign times to the artists, varying the hourly schedule to allow the most room for vans and other vehicles to enter the show site and pull up close to the assigned spaces. Others allot a block of time when artists may come as they choose, leaving jockeying for position to the artists. Many shows require setup the day before the festival opens; these are the most popular

among artists. And many others schedule setup the morning of opening day; one festival in Boca Raton, FL, permits setup starting at 3 a.m., which for me is blasphemy.

Crowded shows, in venues where two hundred vehicles will create a monumental mess and lead to shouting matches among artists (I've seen it happen too many times), will force you to "dolly in" your tent, walls, other display items and artwork. I advise owning the best hand cart you can buy, one with a big weight rating—three to five hundred pounds, pneumatic tires and multiple configurations, from flat to angled to straight up and down. Hand carts can be bought for as little as $50 and as much as $350 or more. The more expensive carts, or dollies as they are called, will last for years, have replaceable parts and wheels and won't rust or break. Mine is aluminum and I fondly call it my chiropractor; it saves my back from severe injury.

A few shows, which rarely are spoken of with admiration, want you to unload your vehicle at your space and then move your vehicle to a remote parking location. It's a fine idea, but does not account for the potential damage to your work from dust, wind, rain or sun. Often, you can circumvent the rule by showing up at the beginning of the unloading time, or at the end, allowing more time to do your work.

Whatever the show requires, your first consideration should be how you pack your vehicle. Almost all booths go up in the same order: tent, walls, display cases or pedestals and finally your artwork. You need to be able to follow this order at the show when you unload and set up. If you do not, you will risk damage to part or all your possessions, including your work, from weather and accidents and simple mistakes by other artists, like backing their vehicles over your paintings. Too often, I have seen precious artwork sitting on the ground or leaning

against a tree, exposed to all manner of possible hazards. Do not let this happen to you.

But let's look at the bright side. You arrive at a perfect show venue, a beautiful park with paved walkways, excellent but not overpowering landscaping, booth spaces that allow walkways or even hanging space outside your tent's footprint. Behind your space, more than adequate room has been allowed for storage or a place to sit.

Setup is the day before the show begins, from 9 a.m. to 5 p.m. Check-in is a breeze, with a tent staffed by enough festival people to make registration a five-minute process (unfortunately, you usually have to wait in line for up to a half-hour). You can drive right to your assigned space. Your van's side door opens two feet from the front of your space. Your van's rear door opens easily without banging into the van behind yours.

I try to arrive as early in the setup process as possible. Fewer artists will be at the show and, in summer, temperatures will be more moderate. The night before setup, I always check the weather on my laptop (if you haven't been there, visit www.wundergound.com; it is a great weather forecasting site). If bad weather threatens, I try to plan around it. If the weather is truly awful for the entire setup window, I arrive as early as I can and wait for periods of calm. When no respite from rain and wind come, I simply do not set up. Most shows are sensitive to this dilemma and will expand setup times, or find alternatives. One Maryland festival could not care less, insisting that you set up no matter how bad the weather. I no longer apply to this show. The amount of time you require for setup will vary by your medium, vehicle type, how you pack your vehicle, whether you are alone or have help, hour physical strength and energy and whether you have eaten a high-protein meal shortly before setup begins.

So, you are parked next to your booth space. First things first: say hi to your neighbors if they are there; the people on either side of you can make or break your enjoyment of a show. Shake hands, talk shop for a moment, offer any help they might need. Work around them if necessary. Even if your neighbors do not reciprocate, and almost all will, your weekend will be much more enjoyable knowing you have sent out some early good vibes. In fact, if you neighbor is, for example, a jeweler, you might not see or speak to them for the entire show, since many jewelers stay inside their booths with closed back and side walls (for jewelers, who have a high potential for being robbed, this is a practical security measure).

The niceties over, open your mental file of how your booth will look when complete. Even if you have done hundreds of shows, or have set up previously in the same space at the current show, follow this simple exercise, since it can reveal any flaws in your space, such as tree roots that will not permit your walls to go up properly. At one Pennsylvania festival, I discovered a sign and pole that would be inside my booth by about a foot. I appealed to the show staff before starting to unload and they sent a maintenance worker to remove the sign.

Check whether or not your space includes a slope rather than flat ground. This happens at street venues as well as in parks. You will need to compensate for the slope with shims; carry a few 1x4's, cut into six inch pieces; they work well. Without them, you may find yourself unable to properly erect your tent, print bins, pedestals, showcases or walls.

On grass, find any depressions in the ground. These need filling with straw or mulch, which the show will usually provide. Or you can visit the local building supply store and buy a bag of mulch for two or three dollars.

Now, take a deep breath, remove any excess clothing and let the sweating begin. Open your van, or other vehicle, door and remove your tent poles. Set them up. Push and pull and get your canopy in place over your poles. Attach your side walls, rolled up, just in case bad weather hits and you need to keep the inside dry. At this point, most tents are in a halfway up position. Don't put yours all the way up just yet. Now take out your weights, place one at each corner of your tent and attach them loosely to the top (most tops have places to hook into). Now put your tent all the way up. You are at least partially secured by your weights. In case of wind, you will have a way to keep your ten-foot kite on the ground.

Okay, the variables. Some tents require assembly that would make a toy company proud (batteries not included). Others are a snap (quite literally, they snap together). Give yourself enough time, do the tent assembly correctly and move on to the next step.

I will start with 2-D artists. They use walls. Walls vary in style, materials, color and other attributes. They can be fabric panels that attach to the poles at top and bottom, mesh screens over plastic or metal frames, masonite, wood, aluminum, flush doors hung on folding hardware, pre-made velcro-friendly panels with carpet coverings sold by one or two companies, and several other types. Bought off the rack or custom-made they are generaly cumbersome, heavy and take time to erect.

If your display uses a tent of any style, an important tip is to tie your walls to the tent's poles and cross-braces. I use wire ties sold at building supply and hardware stores and Velcro, as needed. This adds stability and weight to your booth at little in cost or effort.

It's time to put up your walls. You likely will have a configuration in mind, where the wall panels go, where they stick out into the booth, where you leave openings for going in and out at the back or sides, how much of

the front is open. I have sketches of several possible configurations, which I consult before beginning setup. They take into account what I will hang, where foot traffic will come from (left, right, straight ahead) and where I will sit during the show. My preference is to place myself behind the booth, if possible, with a clear view of customers coming and going. I use mesh panels that let air circulate and add to my vision of the inside. At times, however, no space exists behind the booth and you will find yourself sitting across the street from your display.

One important point: it is unwise to narrow access into your booth with a panel across part of the front. Those artists who do so may have a good reason, such as lighting or work that needs dark display areas. Otherwise, narrowing the entrance to your booth to increase hanging space is never wise.

Your walls are up. If your are a 3-D artist or jeweler with pedestals or display cases, set these where they will stay. Now stand back and look at your work, critically for a minute or five, and make any changes. Stand back again, nod in approval and take a break. Drink water or a soda, grab a pretzel or an apple to replenish some calories.

The purpose? An all-important decision is coming up, and you will want to be fully prepared. In fact, a bit of meditation might be in order. Breathe in and out; feel yourself relax as all thoughts leave your mind.

Ready? Will you put your work in your booth now, or the next morning before the show opens?

Not an easy question, but jewelers are immune to it, since no jeweler will risk theft by leaving finished pieces unattended. For the rest of us, the question has several dimensions. If you put your work in your booth now, you will avoid early-morning drudgery, be ready to open with possibly an extra hour's sleep and be able to spend time tuning up how your display looks. At some shows, you

will also find that potential customers wander the show site before the festival begins, even the day before. You will feel fresher at the start of the day—and at day's end. However, the theft potential is higher, weather can harm your artwork overnight and security may be lacking, thus encouraging possible vandalism.

If you wait until morning, aside from less sleep, you may find your booth inaccessible to your vehicle, especially if you work out of a utility trailer or large truck. Should bad weather move in early, you risk losing or damaging your artwork. And if something should be wrong, such as the need to fix a marred frame or repair a ceramic, you may not have time to do so.

My approach is to hang my photographs and put all my racks and matted pieces in at setup. I carry insurance against vandalism and theft. I like the sleep-in and easy breakfast potential. Most festivals open at 10 a.m. If I stay near the show site, I can arise at a leisurely 8 a.m., have breakfast, saunter to my booth carrying only my case with charge machine and other sales needs, plus a small cooler, and be open with time to spare.

Artists debate the pros and cons of the question endlessly. Each position has its benefits and detriments. Show staff always recommend not leaving your artwork in your booth overnight, either before or during the festival, to minimize the show's liability and as a cautionary note. All shows provide overnight security, but it is better and more effective at some shows than at others. In Virginia Beach, where the venerable and usually excellent selling Boardwalk Art Festival is held in June of each year, controlling the evening crowds that stroll along the boardwalk represents something of an impossibility. The police are diligent, but the show stretches more than a mile and the weekend throngs of teenagers would make up a good-sized professional football stadium crowd. Yet even here, I install my work the day be-

fore the festival, since parking is remote and the weather can be fickle.

The choice is yours.

When your booth is complete, once again take a breath and stand back. This time, face your vehicle. Check the inside to make sure whatever remains is safely tied down. Remove and place in your booth odds and ends you will want during the festival. Turn back to your booth, let down the front, back and side curtains (if they are not already down—side curtains should be let down and zipped up early on if no space exists between your booth and the one next door). Zip up your curtains. Make certain your weights are securely attached...wait! Weights? With all that heavy stuff you carried and put together, you still need weights?

Oh, yes. To paraphrase Gordon Gecko in the movie Wall Street, "Weight is good." Weights are another subject of ongoing artist conversation: amount, style, color, substance. Weights can make the difference between a windy, successful show and a windy, disastrous show.

Go reward your labors with a pleasant lunch or dinner. You have earned it.

Check your watch. How long did the setup take? My guess, and it is that, is about four hours for the average artist, perhaps three for the more experienced or those with simpler booth configurations. One glassblower I know requires five hours to set up. A painter friend does also. Yet a ceramic artist needs less than an hour, but she has an assistant. I always have a second pair of hands and need about two hours, including placing my work in the booth and making sure everything looks right. If you are new to the art festival business, give yourself fifty percent more time than you think you will need.

One more subject related to setup (and teardown) bears noting: assistance. Time was I thought nothing of

setting up and tearing down at thirty-five shows a year. But age and joint creaks, not to mention my lower back, have added their say and I no longer believe the process ennobles me somehow.

So, I hire help. At every show. For two hours, at setup and another two hours, at teardown, I have at least one and usually two assistants doing the heavy lifting. A very few shows actually have volunteers to assist you. Most do not. There are several sources for show helpers, all of which add cost and subtract pain.

My favorite source for helpers is Craig's List. This free internet service allows you to post job offerings, at no cost for the advertisement. Potential helpers who answer post their indications of interest to Craig's List, not to your email directly, allowing you to filter out any undesirable responses. You can then reply to the responses, which I do first by email asking for a telephone number. I then interview the most likely helpers and choose the ones I want to hire.

I have used this method many times, with excellent results. I try to hire college students who seem serious about earning a few extra dollars and I make clear that payment comes after teardown, so the helpers have an incentive to return for the second half of the job. At times, I have found couples who want the work and pay, and even out of work white collar types looking to pick up extra cash. Also, I pay well, usually $100 per person for the weekend. This encourages hard work and, frankly, draws a lot more ad responses from qualified individuals.

Here's the ad I run, which you will of course modify for your own needs.

"Photographer needs two assistants for setup and breakdown of booth at (Show Name) outdoor art festival. SetUp: Friday, September 14, 10 a.m.; Breakdown: Sunday, September 16, 4 p.m. Approximately two hours each

day. Empty van; dolly/carry to booth location, setup tent, walls; hang artwork, etc. Reverse for breakdown. Must be able to lift up to 40 lbs. Great gig for aspiring artist(s), college student(s), etc."

The ad has drawn excellent responses every time I have run it.

Another source for helpers is the show itself. Often, the festival director will know someone willing to work for a payday, and that person usually has a friend also in the market for a few dollars.

A third source is the local temporary labor office, either a for-profit company or a non-profit government organization. The for-profit temporary labor services tend to be expensive, with minimum hour requirements, but are generally reliable. The government agencies are less expensive, but also less reliable.

Finally, when I have on rare occasion not found helpers from those sources, I will ask at a hotel or restaurant. Hotel concierges and valet managers like to find odd jobs for their subordinates and, for a tip, are very helpful. Restaurant managers will help if they can and have access to their employees' schedules.

Directing helpers can become a bit frustrating, since most people have no experience setting up an artist's booth. Here, your organization of display and artwork comes in very handy. You can tell your helpers what to do in a repeatable order.

Many of you will not hire assistants, at least not when you begin your show life. Doing the work yourself has the benefit of understanding how well your planning and booth design are succeeding. My wife and I did the work ourselves for several years and the experience has proven invaluable. Not only do I appreciate the far fewer aches and pains, but hiring helpers has decreased set up and teardown time by nearly half. We can have our booth, display and artwork up and ready in an hour or

so; the same with teardown. When it is necessary to dolly in or out, one of us stays with the van and the other remains at the booth. Our helpers shuttle our things to and from our booth space. If you work alone, this system will not apply, of course. Then, the best method is to accompany your helper or helpers to and from your booth.

A few other matters relating to your hours at hard labor bear examination. Food during setup and teardown is almost never available, except at nearby restaurants, if any exist. The same with beverages. A drink and a snack during a brief break in the process really helps your energy and interrupts the tedium. In hot weather, hydration can be a problem; loading up on water before setup is a good idea, as it can be prior to teardown. During setups and teardowns that stretch into darkness, as they can in winter or when festivals schedule late hours, having portable lights will make you glad Thomas Edison lived and invented. I carry a light jacket and an extra shirt, for climates where sunset means the onset of chilly air, or for early mornings before the sun warms the land.

One of the most useful items to have for setup and teardown is a small ladder, two or three steps unless your booth is unusually high. It will save you time and pulled muscles. Another is a pocket knife or strong scissors, which comes in handy at about half the shows I do. You may need other tools, depending on your booth design and construction. A rolling toolbox will carry many items you need, from tiedown straps to clamps—these come in very handy when zippers on tent curtains break, as they do every so often. Velcro, cable ties, nails and screws will also find their way into your heart.

Screws? Yes, for something controversial: screwing your booth into asphalt. You will find that most booths have legs that allow for this, and most shows do not al-

low it. Small holes in concrete or asphalt, if they fill with water and then freeze in winter, turn into large cracks that municipalities hate to repair. Still, many artists ignore the rule; they believe the safety of their tent and work overrides the need to fix a few screw holes, since they have paid handsomely to rent the space. It is an ongoing battle, one that will not end as long as artists set up on streets and winter weather breaks up asphalt. I cannot advise that you break a show's rules, nor can I suggest you risk your possessions. I can say that I myself have, shall we say, bent this rule when heavy winds blow.

Setting up for a festival is a time of hard work, certainly, and for much thought and consideration of how you will look to the public. It is also a time for optimism and enthusiasm, since the show is ahead of you, with all its possibilities and potential for sales. You are among the relatively few who have been fortunate enough to gain acceptance into the festival. Opportunity awaits. Let's look at how to take advantage of it. But first, a topic all festival artists need to address: the weather.

CHAPTER ELEVEN

Weather or Not, the Art Show Must Go On

AT OUTDOOR ART FESTIVALS, raindrops have a way of falling on your head at the most inconvenient times: during setup, while the festival is open to the public and at teardown.

But rain is not the worst weather problem at art shows.

It is the wind, the chilly north, south, east and west winds, the winds of mountain, desert and plain. The breeze that refreshes us in summer's heat can turn, in an instant, into a destructive force that sets your show on a downward slide.

While rain is a secondary weather force in outdoor art festivals, it, too, can become an enemy of great strength. Driving rain drives away customers.

And, unlikely as it sounds, so can the sun. Warmth can become broiling heat in an hour or two. Direct sunlight will harm certain media, such as watercolors, faster than you can say "cadmium red." Sun mixed with humid air often breeds condensation inside framed hanging art; at its worst, this turns into rivulets of water inside the frame, ruining your artwork. We'll look at all three elements and their effects on our festival business.

But the elements are also our friends, giving light and cooling and, in chilly climates, welcome warmth. Let's examine weather's potential impact with a few examples.

In 2007, the finely run and highly patronized Austin Art Festival experienced a wind event of unprecedented proportions. Setup at the festival begins mid-afternoon on the day before the show opens. The artists have more than enough time and space to build their booths and install their work. Austin's location, which changed after this show, has a reputation as windswept. The 2007 setup day was something of an exception, being bright and sunny and only a bit breezy.

New high-rise buildings under construction edge the show site, at a grassy city square in downtown Austin that is being redeveloped. Tall cranes dot the sky. I registered, drove to my booth and began setting up at about 6 p.m. By eight, my booth was up, art hung, bins set. I make a habit of consulting the weather, on television or by computer, before every show. A cool front was forecast to make its way through Austin sometime over the weekend. No cause for alarm.

Austin's staff keeps a sharp weather eye, constantly monitoring the National Weather Service. At a few minutes past eight p.m., show staff came around to each booth, telling us that a storm was approaching. The staff suggested we close our booths and finish our setups in the morning. I was done anyway, so we finished securing our booth and left for dinner and our hotel.

Then the storm came, not immediately, but a few hours later, with all the wrath imaginable. I was fast asleep and did not hear it. But the show staff did and called every artist on the cell phone numbers the artists provided at registration, at about midnight. My cell phone was turned off. The show staff suggested that artists might want to come to the site, to protect their work if possible. Many did. By dawn, the storm had passed and its terrible impact visible. Booths were mangled and uprooted, thrown up to a block away from where they

were erected. Artwork lay in the street, on the grass, leaning against light poles.

It was a mess, and for some, a disaster. The overnight storm had been so brutal it tore a construction crane from its moorings, sending debris down on the site. The consensus was that a tornado of some small magnitude had whirled its way through the site. The straight-line winds had been far stronger than most booths could withstand.

On our block of booths, only four of perhaps thirty remained intact. Mine was one. The night before, I had anchored my booth into the street with drywall screws, which grip asphalt well. My weights were properly set on the ground and tied to the canopy. My walls were wire-tied to the booth structure. And I had roped both rear corners of the booth to a parking meter. Properly zipped closed, the wind had not been able to enter the booth and lift or move it. One print bin had fallen over, as the wind pushed one booth side into it.

I had sustained no damage.

Not so with my neighbors. So bad was the damage that the show brought in power saws to cut apart the mangled tent poles. A few artists' work was totally lost. Many more sustained some damage to their art.

The festival acted in a way that can only be termed magnificent. A tent company was called in and any artist whose tent was destroyed, but whose work still allowed him or her to exhibit, was given a booth to use for the weekend. Many staff and volunteers showed up to help any artist who needed assistance. The show opened two hours after its appointed start time, with all but a few artists ready to exhibit.

The Austin team, from the show director to the volunteers, acted in the most helpful, supportive and patient way possible. So did the public, who came out in throngs, including to an evening party on opening night.

And they bought. I recorded my best Austin show ever. Sales aside, I will consider exhibiting in this show a privilege, any time.

Another example: a recent festival in Ohio outside Cleveland, at a show named Boston Mills for the ski resort where it is held. The festival site is at the bottom of the resort's ski runs. Known as a quality festival with high sales returns, Boston Mills is actually two festivals held on two consecutive weekends in late June and early July. The weather tends to be hot, with the temperatures exacerbated by large tents holding fifty or more artists. While this is a pleasant change from setting up your own tent, the festival's large enclosures nestle directly against the mountain (a few tents owned by artists are set up also, farther from the mountain. Shortly after opening in a recent year, the rain began: hard, harder, deluge. Water flowed down into the site and, within minutes, reached a height of more than two feet. Every artist's belongings began to float away. Those whose work hung low on their walls frantically grabbed pieces and tried to move them higher. The water, running like a fast river, mixed with dirt to create a muddy mess.

Was the show over? No. The festival and resort staff leaped into action, assisting every artist. Those who could cleaned up and redid their booths. A few could not; they packed and left. By the next day, the show opened. And the festival granted automatic entry into the following year's show to all who wished to return.

A question often asked is whether the festival assumes any liability for weather-related events. The short answer is: no. For every festival, or for your whole schedule if you are applying to a large promoter's shows, you will sign a release saying, roughly, that all calamities and liability are yours. It would be difficult to blame the festival for bad weather, unless the festival knew it

was expected and failed to inform you; this might, and only might, be considered negligence. All festivals should have the availability of ongoing weather forecasts for the show site. Those that do not really are negligent and, if only by the number of applications to their shows, should be held accountable.

Most art festival exhibitors have stories like those above, and many more experience inclement weather from time to time. The less extreme weather situations still require planning and caution.

Whether on pavement or grass, rain of more than a sprinkle can ruin cardboard boxes, seep into cracks in plastic bins and do harm to your work or belongings. Plastic tarps, like those sold in home improvement and hardware stores, can be used not only over your boxes and bins, but as a barrier to wet—or even dewy— ground. Even moisture in the air can damage works on paper, whether framed or unframed. In frames, the glazing often traps moisture, which then overheats if the sun hits it, causing the art to look "cloudy". The moisture will dry out eventually, but the work may be damaged, turning wrinkled and unsaleable. No real solution to this problem has been found. Keep your framed works on paper out of the sun, if possible, even to the extent of draping a cover over a hanging piece while the sun bears down. Whenever I can, I put up awnings to assist in protecting the work.

If you show prints or originals on paper in bins, shrink-wrap or, better yet, use self-sealing plastic sleeves, available in dozens of sizes, with re-openable glue strips, that lock out moisture and dirt.

Oh yes, dirt. Try as you may, dirt at art shows will eventually cling to every surface of your booth, artwork and personal belongings. In parks, dirt can be ultra-fine dust that seems to seep into your very pores.

Every day of every show, including setup, I have to wipe down all my art, framed or unframed, my display rack, tables and chairs. It is a habit worth developing, since the customer really won't appreciate streaks of dust on the art they are viewing or on their hands.

About every sixth show, I take all my work from my van and clean it thoroughly. If necessary, I change bags on my matted pieces. I do the same after any particularly dirty show. And remember that wind stirs up the dirt, creating a need to clean more often. By the way, you can extend the life of these bags by clipping the ends of the foldover that has the glue strip at 45-degree angles, from outside toward the center. This eliminates one dust-catching spot.

Also remember to use only safe liquids for dusting. In fact, I prefer a micro fiber cloth, which lifts the dust off surfaces, or a duster impregnated with a cleaning agent, to liquids. The duster can work wonders on tent sides, furniture and other fixtures. Windex has its place, however, and I keep some handy.

After microdust, the worst kind of dirt is mud. You will inevitably be at a show on a beautiful park day when rain turns the ground into a sucking mass of brown slimy stuff only small children enjoy. You can do little about this and you may find, if the rain is coming down hard, that the mud splashes onto your booth sides and walls. Clean it after the rain stops, as best you can, and remember that other artists have the same problem.

So, dirt is in large part a function of weather at outdoor festivals. Which leads us to the question of rain.

Rain can be a boon to outdoor shows, if it is light, doesn't interfere with setup or teardown, and only falls overnight, rendering the festival pristine in the morning. Otherwise, it is a large pain.

I classify rain in four unscientific categories; light, medium, downpour and end-of-the-world. In each cate-

gory I add three characteristics: angle (straight down to sideways), temperature (warm to teeth-chattering) and consistency (sprinkle to large plops). I said my system was unscientific!

For each category, I have developed actions to take. These range from waiting out a light intermittent sprinkle to donning foul weather gear, closing my booth and finding the nearest source of wine. Show directors will do all they can not to close a festival during its announced hours, but not all show directors take into account every artist's needs. Sometimes, they are downright immune to what will happen to artwork in a horizontal, wind-driven, end-of-the-world downpour.

At a show I will never do again, the weather turned from ominous to ruinous at about 2 p.m. on Sunday, three hours before closing time. At 3 p.m., the chairwoman of the organization sponsoring the show walked around saying goodbye to the artists. I asked if consideration had been given to closing early. She said no, but she was leaving—she had made a last-minute appointment to have her hair styled before a dinner party later that evening. Rather than try to strangle her, a bunch of us returned to our booths and began to tear down our displays, myself included. I will not risk the source of my livelihood to stupidity; protecting my artwork comes before abiding by show rules that have no meaning, since, in this case, not a single showgoer remained. I must say that the show director closed the festival at 4 p.m. She had little choice; the artists had all left or were about to depart.

When you can, brave the weather and stay open. When you cannot, close quickly and stay dry yourself. Err on the side of staying open, especially if any possibility for sales remains. Show visitors can be surprisingly resilient when it comes to bad weather, somehow disap-

pearing (probably into taverns) and reappearing when
the sun peaks out.

Cloudy days can actually increase your sales. When
the sky is gray, visitors linger rather than moving on to
other weekend activities. The beach doesn't beckon, pic-
nics are dreary. Some of my best sale days have been
under a cover of clouds. And clouds lower the tempera-
ture, although humidity may increase.

Temperature. Hmmm. What's better, hot or cold?
Neither. Then what is better for sales: warm or cool?
Depends where you are. One year at the Sausalito Art
Festival, a heat wave drove the temperatures into the
low nineties, unheard of for the Bay Area. The mercury
soared, sales plummeted. One typically hot day in a Chi-
cago July, the thermometer fell twenty degrees below
average. Temperatures fell...and so did sales.

Perhaps the best, pardon the pun, barometer is this:
typical weather in any location is expected and assimi-
lated by the public. Great deviations in the norm keep
buyers away. You may experience exceptions to this, but
not many.

One year at the St. James Court Art Festival in Lou-
isville, KY, held the first weekend in October, the tem-
perature on the first of three show days dropped the up-
per forties, cold rain fell and I, being a Floridian, donned
two shirts, a sweater, leather jacket, hat and gloves.
Only earmuffs were missing, but my wool scarf covered
my face and ears. The public did not come in droves,
more like in a trickle. Sales were off, way off. The rain
stopped by the second show day, although the tempera-
ture did not moderate. To keep warm, I broke out my
trusty propane camp heater, which I rarely carry with
me, but have learned to bring to Louisville.

Across from my booth, in one of the neighborhood's
wonderful Victorian houses, lived a dear friend, who
gave me a key to her house and left microwave soups on

her kitchen counter. Saved the day, she did. We made up some of the loss in sales on the last two days of the show, but not all.

Another weather challenge is humidity. It is never good. Dry is better. Humid weather increases your perspiration quotient by not allowing evaporation from the skin to take place as well as it should. Hot or cold, humidity can even create a damp coating on your artwork and booth fixtures. I know of no way to stop it, short of having an air conditioner in your booth—one jeweler actually does this, fueled by an elaborate solar panel system on his booth's roof, for heat and humidity relief. Fans can help evaporate the moisture.

This is a good point to discuss electricity, which is not technically weather, but can add or detract from the climate in your booth. Few shows offer electricity; those that do often add a fee to your booth cost if you use their watts. Artists who need electricity, including most jewelers and others whose work shows best in gleaming artificial light, usually bring the power source with them. Deep-charge marine batteries make up the majority of power sources used by artists, although they are heavy and need daily recharging at a show. When permitted, a few artists will use generators. Both will power low-voltage lighting, small fans and even your computer, either directly or with proper cables that are usually custom-made. A few so-called "power packs" are on the market, but my experience with them has been mixed; their batteries tend to be small with short lives. A few shows have evening hours, or pre-show events at night, making lights a necessity. Often, these shows provide electricity. I carry three light strips and ten halogen light heads, which I wire tie to my roof beams. Works great, unless the weather is hot, since the lights give off a lot of heat.

Next to last on the weather radar is the question of canceling your participation when the forecast for a festival is dire. Hurricane coming? Stay home, of course, or evacuate, as the case may be. Severe thunderstorms? A tougher call, but one you must make. Excessive heat? Usually, grin and bear it, stay hydrated and keep a close watch on your body temperature. Overheating and heat stroke can occur with little warning and few early symptoms. Very cold? Add layers of clothing.

To be specific, the show must go on and if it does, you should participate, unless your inner voice tells you to beg off. Last minute or last-day cancellations cause show directors to scramble filling the empty space, but they happen in probably three-quarters of all art festivals, for one reason or another. If you cancel for good reason, you will rarely encounter vindictive show directors or committees. As I have noted before, it never makes sense to risk your artwork, or yourself.

The best time to deal with weather is before you must. Preparation is all. For your personal needs, while it will increase your load, it is wise to carry clothing for both warm and cool climates, especially in the seasons of change, autumn and spring, In summer, in the Rocky Mountains, temperatures can vary by forty degrees from noon to midnight. Bring your favorite jacket. In October, a popular Connecticut Show held at the Bruce Museum in Greenwich once in a while experiences a light snowfall!

Too often I have seen an artist shivering in the rain, no raincoat or poncho and without a change of clothes. I always carry a spare set of clothing in my van during shows. A dry shirt and pants can make a dreary day much sunnier.

We all react differently to weather. My thin Florida blood circulating under two shirts, a sweater, fleece vest and leather jacket makes me feel like the Michelin Tire

Man when I see a Minnesotan in shorts and t-shirt and flip-flops at a spring show in New York. Your body, your needs. You will know when you need a parka, or a sleeveless shirt—which, by the way, you should avoid. It sends the wrong message to potential customers.

The responses of showgoers to the weather vary widely, from none to popping open an umbrella to sprinting for their cars. At one Naples National Art Festival, the second day of the festival dawned gray and chilly, with a brisk wind off the Gulf of Mexico. The show opened at 10 a.m. By noon, almost no visitors had arrived. The director walked the show, asking artists what they believed should be done: close the show early or wait out the weather in case it turned better. Many artists voiced their desire to pack up and leave. Others, myself included, said the conditions were far from dire, with no storm on the horizon. The director decided to keep the festival open. The weather lightened, not completely, but enough so that, by 2 p.m., traffic had picked up. The people who came were serious art enthusiasts and the buying began. By five o'clock, I had accumulated near-record sales for a single show day. The sparse crowds allowed more time for interaction with customers; the cool air made browsing in the artists' booths pleasant.

A few artists, without the festival director's permission, closed early, packed and left. They were never again invited to exhibit.

At times, it seems that the expectation of bad weather has a greater effect on the public than the weather itself. They do not want to walk a show drenched or sloshing through small rivers of water. Heat tires them. Cold entices them to stay at home. Little can be done about weather forecasts that scare off potential buyers. All festival artists learn to accept weather—and weather forecasts—they cannot change.

The old advice to keep a sharp weather eye applies
to artists at outdoor festivals. This is a three-part proc-
ess: know the weather you are expecting, plan and pre-
pare for it, conduct your show in accordance with it.
Keep records of the weather at all your shows, so you
can decide over time to apply or refrain from doing the
show. It is important to know when the cause of a slow-
selling festival is an unusual weather event. Over time,
most of your shows will be held in fine conditions; the
others, whether we like it or not, are just about the
weather.

CHAPTER TWELVE

Evaluating Income and Costs at Festivals

IN THE DIM AND distant past of the mid-20th century, art festivals began as "clothesline" art shows, with paintings hung on fences and sometimes literally on clotheslines. A rickety table might hold sculptures and a few trays display jewelry. No tents existed. The local arts group might print up fliers and the local newspaper contribute a little space for advertisements and a junior reporter for Sunday feature coverage.

Then, malls were built and to attract customers and increase foot traffic, the malls allowed the arts groups to move indoors on a weekend, often at no charge. Soon, capitalism took over; malls saw the income potential and either produced the shows themselves, charging for space, or contracted outside promoters only too happy to pay a fee for the right to charge artists for display space.

It was a logical step from there to outdoor festivals. Many variations were seen, but the progression was usually the same: arts groups holding independent festivals, large venues such as malls adding art shows to their promotional efforts, promoters taking over and enlarging the business, municipalities entering the field to increase downtown consumer traffic.

The arts organizations did not cease producing festivals, but they were transformed into cooperative efforts with civic, local business or government bodies, since the

venues were usually on public land or on streets where permits, parking and traffic considerations are within the purview of these bureaucracies.

So today, you are likely to exhibit at a show under the auspices of the Rotary Club, hardly a bastion of arts thinking, or the Parks Department, or the Downtown Business Association, or the local chapter of the Daughters of the American Revolution. Fewer and fewer festivals are run by arts organizations or museums or even arts education institutions. Those that are seem to be guided in large measure by the capitalist or governmental interests in their cities and towns—with notable exceptions that rank among the best art festivals in the nation.

And where the arts groups have a large say in the local festivals, the costs to produce a show have become so high that the municipalities become de facto partners in the events.

How does this state of the arts influence you at a festival? In several ways, costs among them, and very importantly, as a key to understanding why your show fees are climbing and what your money buys.

While show fees vary from the rare festival that takes a percentage of your sales to the few shows that charge a small booth fee and a percentage, most charge a fixed price per booth space. Booth spaces come in many shapes and sizes, from a single, 10' x 10' space, to double, triple and even quadruple spaces, a few at corners where foot traffic is high and visibility excellent. You will even find a few festivals with smaller spaces, such as 4' x 10', but these rarely merit serious consideration, since you can display only a very limited amount of your work. Prices for booth spaces vary widely, too, from a low of perhaps $100 to a high of $1,000, for a single 10' x10' unit. National averages are difficult to obtain, but as a rule of thumb, you will find most highly rated festivals

charging $400 and up, regional festivals that rank well from $300 to $400 and local shows in the $100 to $300 range. There are exceptions, but these prices are a good gauge.

Average booth fees matter much less than the fees you are paying for your shows. Add up your show fees from all the shows you do or want to do and divide by the number of festivals to get your own average. This number is important, not just the average but the total as well. Festival sales vary, often by a large amount. How much you are paying at one show will not matter if, at that show, you sell a huge amount of your art and at the next show, where the cost is the same, you don't sell at all. You must spread your income to cover the costs of all your shows.

Looking at this on an annual basis allows a more "global" view of costs at any one show, allows you to relax about the ups and downs of the business and gives you an economic perspective on the value of a particular show versus others you do. Examining it on a per-show basis permits analysis of a show's income-to-cost ratio, which is nothing more than dividing a festival's income by its costs. And subtracting costs from income leaves you with your profits. You can build a fairly sophisticated model of income versus costs, assigning travel, lodging, vehicle, food, booth fee and other costs to each festival. Or, you can enter these items into a bookkeeping program—several exist for small businesses—and let the computer do the math. Still, it is instructive and useful to examine how these numbers work in the art festival business, not just to keep track of them.

Foremost, we should understand how variations in income from festival to festival impact profits. Let's plug in some numbers for the sake of example.

If you exhibit in ten shows and sell a total of $50,000 worth of your art during the year, you have an average

sale of $5,000 per show. However, what if one of your ten shows is a dud: only $1,000 in sales? Your annual income would then be $46,000. Somewhere and sometime during the year, you have to make up $4,000 to maintain your overall average.

How does this relate to building a show schedule?

Planning your show participation encompasses application, acceptance, travel, exhibiting and then traveling again, either to your home base or the next show. If you do not participate in a show that lowers your show average, you will benefit immensely.

Here's how it works. Suppose you did nine shows instead of ten, eliminating the $1,000 event. Your total sales would be $45,000 for the year, which, divided by nine instead of ten, yields $5,000. This is an average of $500 per festival *higher* than if you participated in the ten shows. You have just increased your *average* show sales by almost 10 percent ($5,000 per show versus $4,600), with a reduction in total annual income of only 2.1 percent ($46,000 less $45,000 equals $1,000, divided by $46,000 equals 2.1 percent). If your show costs exceed $1,000 for the show that yields only $1,000 in sales, which is likely, you have also put more money in your pocket—actual profits—by reducing the number of festivals you do.

The arithmetic may seem a bit daunting, but I urge you to go over it a few times until you have a firm grasp of the principle. It can be too easy to believe that a poor selling festival can be made up for with a show that sells well for you. While this might be true, you should also look at how much you need to recoup to make up for the $1,000 show. Using our example, your $1,000 festival left you with a need to bring in an extra $4,000 in your nine other shows to make up the difference. Divide $4,000 by nine, you must increase each festival by about $450. This may not sound like much, but it is an in-

crease of nine percent. Think of it another way. If you do not sell more pieces of your work, you will need to increase prices by almost ten percent to make up for the income lost in one poor show. Or, you will need to sell almost ten percent more pieces. Increasing prices to make up for lost sales rarely works and, if you can sell more pieces in each show, your overall average would rise, leading to a different scenario—more of a reason, actually, to eliminate the $1,000 festival.

Of course, factors such as weather, the economic character of a particular location (Detroit is not a great market when car sales are down and layoffs at auto factories climbing) and others can reduce a show's productivity one year and increase it the next. Still, at any particular festival, you can hone your understanding of the show's value to you by, first, assessing the show's contribution to your overall year's sales and, second, accumulating knowledge and instinct about the show and its public visitors. Over time, you will develop a quick sense of how a particular festival enhances—or detracts from—your overall business.

Whatever your target for an overall show average, if you fall short by any large amount, you should rethink your future participation. If, in the past, your customers have not shied away from buying due to your prices, but suddenly do, it may be the local or even national economy at fault. Should you decide it is the local economy, you can check local newspapers and demographic data (on the internet) and see if the area is experiencing hard times. For first-time shows, your fellow artists can tell you how this show compares with earlier events, and as long as you don't ask for specific sales numbers, they usually will answer truthfully. You can ask potential customers how things are going locally; people like to talk about their hometowns, although their views are tempered by their individual situations.

As a show progresses and after it ends, you can see if the items you are selling are higher or lower in average price than previously, at both this show and others. Many artists keep precise records of the average price of the pieces they sell. This points to trends, as well as to how the public receives your prices for various sizes and kinds of work. Average price per piece is different than average sale, since you may find you sell multiple pieces to an individual customer. Knowing both these numbers, especially over several appearances in the same festival, will provide you with a valuable dimension in analyzing your schedule.

One of the most puzzling elements of art festivals, to every artist I know, is the huge number of people who walk by your booth and simply do not stop in, or even give your exhibit a glance.

This occurs for more than one reason. Your work may be in a medium they have no interest in exploring; many people do not collect, or even like, pottery or baskets or weaving—every medium, in fact. The people passing by may have already purchased art at the show and are done shopping. The weather may be inhospitable, such as when it is already hot outside and the inside of your booth adds another ten degrees, or very chilly and people want to move around to keep warm.

And then this truism of outdoor art festivals; most of them charge no admission, offer free entertainment and children's activities and make for a wonderful day's entertainment and distraction. The majority of people visiting these art festivals have no interest in buying art. They do not feel compelled to enter any of the artists' booths. If they do, it is simply to view and enjoy the artwork.

I am going to leave the subject of festival income and costs, for a moment, to discuss another item your booth fee pays for: public attendance. This relates to show in-

come, since it is the public that buys art at festivals, and costs, since a portion of our space fee ostensibly pays for advertising to bring the public to the show.

You can and must take the published attendance figures for most shows with not a grain, but a mountain of salt: they are simply wrong. And the published attendance numbers make no difference to your sales, although they may influence your decision to apply to a given show.

Consider a festival with published attendance of 20,000 visitors. If it is a two-day show, that's ten thousand a day. Say the venue has parking nearby for 1,000 cars, which would be high for many places. If the average car arrives with two people, you have five thousand cars vying for just one thousand spaces. Once the parking lots and side streets are full, someone must leave for someone else to park. Thus, if the average showgoer stays for two hours, not unreasonable for parking, walking to the site, walking the show, stopping here or there, eating lunch at the food court and returning to their cars—and not including the time it takes to consummate a sale and enjoy the art—the site can only handle 2,000 people every two hours.

At that rate, 10,000 people would require 10 hours (2,000 in each of 5 two-hour periods) to visit the show, even if some people will leave before two hours elapses; others will stay longer.

If the show opens at 10 a.m. and closes at 6 p.m., which many do, that is only eight hours. Since the last group of showgoers should arrive at 4 p.m. to get their full two hours, you really have room for only 8,000 people.

Are these numbers accurate? They are close and, of course, many factors can influence them. The point is this: when a show says that 60,000 or 70,000 people attend, consider that a rather large exaggeration, unless

the figure comes from a truly reliable source. Even then, discard it from your thinking about what constitutes an acceptable attendance figure for your own purposes.

One of my favorite and bestselling shows, which no longer exists, attracted no more than 3,000 people all weekend. But those three thousand constituted an up-scale, art-savvy, high-spending group in an area with large population growth in the best demographic for my work. Rarely did more than fifty couples enter my booth each day. Yet my sales—both in number and dollars—reached satisfying levels every year. My average sale was a higher dollar number at that show than at most I do. Unfortunately, the venue, an upscale outdoor shopping mall, saw so few new visitors that the merchants decided they would rather not upset the public by closing off a large fraction of their parking lot.

So it goes.

Back in your booth, you watch people go by all day who do not even seem to realize you are exhibiting. Hundreds ignore you. A few stop in and leave quickly. Even fewer look at your work for any length of time. Psychologically, this is difficult to accept. But if all other factors are in line, you will sell to those few who are truly interested in buying. And the dollars will add up.

But, you say, how do you get more people to step inside your booth? You do this primarily in two ways: choose shows that will work for you; and present, price and offer your art as well as possible. When you read the chapter on marketing in this handbook, assimilate and implement those principles that will work for you.

In the meantime, consider what the space is costing you. If we use our $400 booth fee and accept for the moment that we are retailers just like any other when we are exhibiting in a festival, we can use a bit of retail arithmetic to understand the true cost of the booth space.

Shopkeepers use a term that describes what their stores cost them to rent. It is "cost per square foot". The amount describes the cost per square foot inside their store on an annual basis. Thus, "$20 per square foot per year" means that, if you rent 1,000 square feet, you arrive at $20,000 in annual rent. This may or may not include electricity or taxes or, in a mall, other fees. For our purposes, we will assume it does.

If your booth fee for a festival is $400, and your booth is 10 x 10 feet, or 100 square feet in area, then you have paid $4 per square foot, but only for two days (or three if the show runs three days, which can make a three-day festival more economical, all other factors being equal). The shopkeeper pays $20 per square foot for about 300 days per year (assuming the shop is closed one day a week; in modern times, stores stay open 360 days a year—or more). If you paid the same amount for 360 days as you are paying for two days, you would be writing rent checks each year for—ready?--$720 per square foot! Once again, that is $720 per square foot and it is not a typographical error.

Here's the math: $4 per square foot for two days equals $2 for one day, times 360 days, equals $720. Almost no retailer in the world pays that much for each square foot of their retail space. Artists do.

Fortunately, we pay that annualized rent only for the days we exhibit, which is a large consolation, since no artist I know could afford that huge rental. Yet the implication of this cost is stark: you must maximize sales enormously for that cost. Again, compare yourself to a retail shopkeeper. The retailer, paying what is a safe average of $20 per foot per year for 1,000 square feet, open 360 days, has a rental cost of a bit over $55 for each day his store is open ($20 per foot, multiplied by 1,000 feet, equals $20,000, divided by 360 selling days).

In a festival with a $400 booth space fee, we, on the other hand, are paying $200 per day!

This logic is important to festival artists: you must use the space very well to recoup what it is costing you on a per square foot basis, which is the way retailers evaluate rental costs. If you return only $18 per square foot per year in a store where your cost is $20, your store won't stay open for long. Second, booth space fees are much higher from the vantage point of traditional retailing than they might seem.

Take our crowd of showgoers who do not enter your booth and the published attendance numbers of any given show. The higher the attendance, the higher the fee a festival believes it can charge. A $600 booth space fee would run over $1,000 per square foot per year in a typical store. In a brick-and-mortar store, rents will increase with traffic. But since the shopkeeper is there on a somewhat permanent basis, the public can return at will. Not so at art festivals. Artists come and go in a few days, or less. Our opportunity to sell—at least for the most part—evaporates when the show closes. After-show sales do happen, as do sales at other festivals from customers you see at earlier events and even sales in later years. These tend to be a fraction of your annual sales, however.

Let us return to the artist whose sales equal $50,000 per year, an average of $5,000 in each of ten shows. He or she has rented a 100 square foot space for 20 days, if every show runs two days. That's $2,500 in sales per day on average. If one day's sales are only $500, the potential profit on the booth space fee nosedives. In effect, that $500 has cost the artist an exorbitant amount, per square foot, to earn.

Thus, this suggestion: look at your sales on a per day basis, not per show or per year, to decide if a show works for you. You have only so many days to sell and any of

them that do not perform are detracting from your income. It is kind of like being asked to work overtime, or on Saturday, at a day job without added compensation, or at half your usual pay.

You will hear artists say that a show is a "Sunday" show or a "Saturday" show, meaning that sales are slim on one day and good on another. This is true at many shows, but should not detract you from judging each day, since your costs are there each day.

I once did a show that, at the time, frustrated me enormously. On the first day of the festival, I sold nothing—which happens to us all at one time or another. The next day, I sold twice my usual daily average. This happened to be a three-day festival. My third and last day of the show was barely adequate, about 15 percent of my usual daily average. You might say I got my money out of the show. Still, when the application deadline came around for the next year, I decided not to apply. My inner voice was telling me that it was possible *not* to sell twice my daily average on the second day of the show. So I found another festival for that weekend, which has turned out well, meeting my daily average goal every year, in two days rather than three. The choice was difficult, since my other inner voice also wondered if I might be able to sell twice my daily average on all three days of the first show. To me, the risk was too high to find out which inner voice was correct.

This also has implications for festivals that last longer than two days. Festivals that last three or even four days would seem to be better for potential sales than two-day events. At times they are, but longer shows add cost and most of them are huge street events, with attractions other than art, for the public. Here is where average sales by day will give you valuable insight into a show's value to your overall festival business. Approach

festivals longer than two days with a clear eye to real profits, not just sales.

While you should consider all the above, you do not have the time, nor should you expend the effort, on thoughts such as those during a show; do so while you are deciding which shows you will apply to and which you should not consider. If you are new to the business, some guessing, especially about average daily or show sales, will be necessary. Once you have exhibited in a number of festivals, you can make more informed decisions.

Another way to look at the cost of your booth is to think about what, exactly, you are paying for with your booth—and to a lesser extent your application—fee.

You are, of course, paying for the patch of ground—grass, asphalt, concrete, gravel, dirt—where your display will be. You are also paying for: security guards to keep your work safe during the festival; trashcans and cleanup; fencing, if it is built only for the festival; artist amenities, such as a dinner or breakfast, snacks, water and parking, if it is provided at no charge; awards, if the show offers them; the festival staff, unless all are volunteers; advertising for the show; signage and banners, if they are used.

Yet there are still more festival expenses that the artists' booth fees need to cover, and they are less obvious: permits from municipalities, if the show is on city streets; compensation for lost parking meter revenues; extra police hours to control and direct traffic; repairs to park grounds, when the venue is in a public park; portable bathrooms, which are mandated at all outdoor public events; printing and postage for mailings to artists and the public; postcards for artists to send to their collectors (a few shows now charge for these); website maintenance for the festival's internet presence.

You might conclude that the more expensive a show's booth fee is for an artist, the better the show will be, since more money will be available for advertising, sprucing up the site and other niceties and necessities. Unfortunately, this is not always the case. Smaller shows, run on tighter budgets, can return much higher sales for the artist, when the festival is in a great venue, the work is wonderful and a small, but wealthy buying crowd attends. Bigger is better only when it *is* better, not by default.

Dozens, if not hundreds, of items large and small, can extend the list of a festival's monetary needs. With the possible exception of advertising, none is as important as something else you are paying for with your booth fee, which is not a cash outlay by the festival or you: the show's history. While no festival asks that exhibiting artists pay more for a booth space because of the show's history—at least not openly—a show's history does indeed influence space fees, as it should.

History at an outdoor art festival may be the most important determinant of whether your expensive per-square-foot booth fee is justified. A festival's history should be taken into account at the very top of your list of qualifications of shows you wish to do.

A long history can be important, but not nearly as much as the show's quality and sales level. Many artists believe first year shows are not worth attending. Yet early participation in a new festival can help you build a valuable list of collectors in a new geography. My own practice is to not exhibit in first year festivals, but, if I hear that the first year was good and that artists I trust believe the show has high potential for growth in sales, I may very well opt to exhibit in year two. Mindful of the principle of closely monitoring average show and day sales, I am loath to risk damaging those numbers.

Of the two types of shows—promoter and community—promoter backed and run festivals can be cancelled easily after the first year, if not enough artists sign up to meet the promoter's profit goals or those artists who do exhibit fail to sell enough to encourage them to return. While promoters bear some of the costs of a first-year festival that they may not be able to earn back in booth fees, the artists always bear the largest share of a festival's cost. Community festivals are not generally run with a profit motive, although many want to make a profit to support their organizations or others. Thus, community shows can take a more leisurely look at when a festival begins to earn its keep, allowing more time to decide if a show will continue to be presented. With all the art festivals available for the public to attend, new shows need time—years—to build a solid reputation, excellent participants and showgoer loyalty.

Yet there are also many long-running festivals whose history shows no good reason to expect high sales for artists. You will encounter festivals billed as the "15th" or the "20th" or even the "35th" in that particular show's history.

Do not pay for an expensive booth space for that reason alone. You will likely regret it. And do not be swayed by the prestige of being juried into a long-running festival. Community shows, especially, can linger for years as primarily ego-boosting social events run to give upscale supporters of the arts the belief, in part justified, that they are doing something good for their communities. They may be correct in believing their efforts add to a place's cultural texture and context, but the artists who exhibit receive no such benefit.

One other important component of a show's history is how its long tenure places it in the pantheon of other festivals in the same city or area. In many cities, a single show is known as the "best" show; often this is the oldest

festival, and the population tends to see it as the one where they will spend their art buying dollars.

In Naples, Florida, where there is a show, or two, every weekend of the winter season, two shows, based on their history—not just age, but what has happened over the years—are considered the "buying" shows. These are the Naples National Art Festival and Naples Invitational Art Festival. In 2008, Naples National will be held for the 29th year. On its website, Naples Invitational does not bother to list its age. Both are highly valued by participating artists; both produce excellent sales. Both are considered "signature" shows for the community. Many artists will tell you the booth fees are irrelevant at either show; sales are high enough so the space fee does not matter.

A bit north of Naples, the Art League of Bonita Springs sponsors two festivals each year, one in January, the other in March. In less than five years from their inception, they became signature shows themselves, targets for every artist who could apply and most difficult to jury into. They are linked to the community's superb art league and seemingly carry the backing of every area resident—and they are held in a rather small, although upscale, outdoor mall alongside a major traffic artery.

In both the Naples and Bonita instances, buyers have told me, on several occasions, that they buy art only at those festivals—even if the artist they buy from exhibits at other local shows! It is a matter of both history and context. I have never regretted the booth fees I pay at those festivals; I only hope that I am accepted into them every year.

You will pay handsomely for booth space at art festivals, more than you think you should. You will bear the brunt of most, if not all, of the shows' costs and profit for the promoter or community presenter. When you sell

well, you will welcome the opportunity; when you do not, you will rue writing the check. Is this a fair way to foster our artistic careers? Possibly not. But, then, it is the way of our modern society, in nearly all we do. As artists, we are not immune to the costs of the marketplace.

All this considered, you have applied, been accepted and traveled to this weekend's festival. You have jockeyed near your space, unloaded and set up your booth and display. In the vernacular of the art festival world, you are "in" the show.

It is an exciting moment, the morning of the first day of the festival, when you have unzipped your booth's side curtains, rolled and tied them up, dusted off your work, made last-minute adjustments to your display and unveiled your art. The angled morning sun holds the promise of a fine, fulfilling, remunerative day.

All that remains—and it is all—is to sell your artwork. The next three chapters will help you sell your art to the art festival customer and enjoy yourself in the process.

CHAPTER THIRTEEN

Selling Your Work at Art Festivals

DAWN SPILLS GOLDEN LIGHT onto a sea of white tents. The air at our perfect show glistens with possibilities. You have not been able to sleep, so excited are you about the weekend's festival. And so anxious. Today you must address that most awe-inspiring and terrifying element: selling.

Start by saying, over and over in your pre-caffeine stupor, I Can Sell, I Can Sell, I Can Sell. Inside your head, deeper even than your Zen-like pre-coffee blur, you hear: How?, How?, How?.

Never fear, Artman is here! Well, maybe not, but certainly many tools and techniques abound that you can use to sell your fine art! Pay close attention, fellow art travelers. Here is where we explore how to pay your mortgage, car payment, health insurance, taxes and...all your other bills and desires.

We begin at the beginning. Selling, in and of itself, is not the proper way to approach what you must do to create a transaction with a customer. We should hearken to one of those seemingly vague and esoteric terms companies from Cleveland use to sell everything from soup to insurance: marketing.

For our purposes, let's define marketing at outdoor art festivals as creating products (your artwork), securing distribution (outdoor art festivals), informing the market (participation in numerous communications pro-

grams, from websites to postcard mailings to festival programs), packaging your product (presentation in your booth and the booth itself—your storefront), relating to your potential buyers (talking with them at the show), consummating the sale (receiving a verbal desire to purchase the artwork from the specific buyer) and, finally, accepting cash, check or credit card (yippee!).

Sounds complicated, but it is not. The alternative is: toss up a raggedy booth, sit behind or opposite it reading all day, wait for someone to wake you and ask a price, say nothing after that, go home broke. Many artists choose this path; they do not, without a trust fund from Daddy, stay in the art festival business for long.

Successful art festival artists either learn the steps to making money in the business, or have them naturally ingrained. Most do the time and learn from days of nonexistent or mediocre sales. You can shorten the learning curve by following the steps above. We will look at each of them in depth.

A quote I keep tacked above my desk reads, "Art is never necessary, it is merely indispensable." Don't recall who said it, but I have found it very useful in marketing my work. It actually relates to our "product". As a 2-D artist, I despise nothing more than a blank wall. Blank walls cry out for my work to be hung on them. Blank walls are an insult to the fourth art commandment: thou shall not leave a hanging space unfilled. (I have no idea what the other commandments are; can't take it all that seriously). Empty wall space should be against the law, or at least require the wall's owner to wear a scarlet "A" on his or her chest (apologies to Hawthorne, for you reader/artists out there).

We need a bumper sticker: Blank Walls Are Blasphemy.

Windows and doors that consume wall space come in a close second to empty walls, but we artists must make certain concessions.

The message here is of two parts: one, many art buyers make purchases directly related to their empty wall quotients; and, two, your artwork must appeal to their desires more than their needs. A fine watercolorist I am privileged to call a friend painted barn scenes for years and sold them well in the Midwest. In Florida, he bombed, as he did in New York and California. He switched to closeup studies of farm implements and old farm doors. Same result. He has decided to stay with Midwestern art festivals. Smart decision.

Most of us are inner-directed. That is, we create what our hearts tell us to create. We should never forsake this principle. With 30,000 art festivals in the USA, we can certainly find enough outlets for the work we choose to do, rather than choosing to do work we feel will sell in, say, Indianapolis. Unlike the soap and soup companies, we do not deal in a needed commodity, but in—I believe when we are at our best—food for the soul. To us, it is as necessary as bread, of course. To the potential buyer, an expansion of their worlds, albeit a private, internal expansion, but one that, while not necessary, is indeed indispensable.

Art festival marketing's first step: create art that is indispensable to your potential customers and you will succeed. Make them think about which full wall they will empty to hang your painting.

Step two: secure distribution. Apply and be accepted into outdoor art festivals. As a corollary, follow the watercolorist's example above and do not exhibit in locales where there is no connection to the work you produce. Recently, I exhibited at a show in one of the nation's premier horse breeding areas. Sales were not great. My mistake, since I have never photographed an equine. A

nearby artist with paintings of horses—you guessed it—
sold every one she hung.

More than one strategy can be developed on exactly
which shows to apply to and which to avoid. Your travel
preferences, staying close to home or venturing cross-
country and many in-between plans, come first. Com-
munity versus promoter shows offer another clue. Na-
tional ranking of shows by a few organizations adds di-
mension, as does word-of-mouth from other artists. Ease
of setup and teardown factor into your decisions. Cost
can put a prospective festival in or out of your purview.

These are, believe it or not, rather minor considera-
tions. Securing distribution is the term I used above.
This involves application and acceptance, true, and show
characteristics. But above these ranks one item: match-
ing the people who visit a show to your work.

Think of it as round pegs going into round holes.
You're the hole, the public is the peg. If you offer $10,000
oil paintings and the show attracts a lower middle class
crowd, you may as well spend the weekend fishing. Vice-
versa, also. Low-priced goods, perhaps $10 ceramic cups,
aren't likely to sell to millionaires, at least not at outdoor
shows. True, some art festivals, many of them in fact,
draw a mixed crowd. It has been my experience that
these festivals, by appealing or attempting to appeal to
an extremely broad audience, can fail to serve many in-
dividual artists, especially those selling expensive work.
Wealthy people rarely enjoy buying alongside those of
lesser economic means. I don't like it, but it's true. That's
why we have WalMart and Neiman Marcus.

In many ways, we art festival artists practice a very
democratic sort of capitalism, asking only that our work
is included and accepted, going directly to the public
without middlemen. Many art festivals feel the same
way: their shows are for everyone to see and enjoy, ei-

ther free or with a token admission price. I applaud the principle; in practice, it can really limit my sales.

Securing distribution means, above all, participation in shows where your work matches the demographic, not just of the city where the show takes place, but of the attendees. A great example is the wonderful Longs' Park Art Festival, held in Lancaster, Pennsylvania Dutch Country. It reaches the pinnacle of the perfect show I've used as an example. Very, very few attendees live near the festival. They come from New York and Philadelphia and Washington and Baltimore every year to view and purchase artwork. The show includes some of best work created in the United States. The show committee carefully screens out anything beneath the highest standards in every category. Most experienced artists are happy to exhibit once in three years, so difficult is the competition. Prices at the show are universally high. Artists go home after the three-day event richer and happy. Crowds are not huge, but they are savvy, wealthy and they spend.

Would you take your $25 beaded jewelry to the show, if you were somehow accepted? Perhaps, for the experience, but, hopefully, not with plans to sell well. A local or regional show with tens of thousands of middle class attendees would be a better bet.

Secure distribution: apply to shows where the demographics and characteristics of the attending public match your product. No snow scenes in Florida, no cowboys in Philadelphia, no palm trees in Minnesota. No $50,000 life-size bronzes of buffalo in Harrisburg, or inner-city Chicago.

Interestingly, matching your work to the market at a given show will increase your chances of acceptance. Simply, show juries, committees and directors, as well as promoters, want to please their public.

Last under this marketing element is the question of taste. Bible belt America has, understandably, little love for paintings of nudes. We may disagree about whether nudes are art, but that won't help us with show acceptance or sales. Underestimate this principle at your peril.

Step three: informing the market. Communicate with your potential buyers. Not the sort of communication the festivals do when advertising their shows in newspapers and on television, but the kind of communication that invites, cajoles, tempts, embraces, attracts and creates desire.

One example is the pre-show postcard mailing. I do this faithfully, not for each show, but for blocks of shows, including my schedule on the message side of a beautifully printed card. If you have a mailing list, use it or don't bother keeping it. One pen-and-ink artist has a thirty percent return on her mailings; fully one-third of the people she mails to visit her booth as a result. Many buy, whether they have previously bought her work or not. This is known in the ad biz as targeted communication, with good reason.

Another example is the show directory, which will often contain paid advertising from artists. Look closely and you will find that most who advertise in a show's directory are very successful artists. It's a chicken and egg, of course, since you need money to advertise and should advertise to earn money. But which came first is not the point: don't advertise and you can't attract people from your advertisements. Do and you may. Try it. At some shows it will work well, at others not so well. You will soon know if it succeeds for you and at which shows.

A third example is email announcements, if you have your customers' email addresses. Not, in my opinion, as good as postcards, but useful and much less expensive. Today, it is possible to create attractive electronic "post-

cards" that look good, convey your message and images and let your clientele know where and when you will exhibit in their locales.

Public relations—news releases, mostly—are a fourth example, but not a great one in many ways. Creating news releases, printing and mailing or emailing them, can lead to publicity, but you have no control of final content, graphics or timing—if the media uses the news release at all. There is another approach.

After acceptance in a festival, call or email the show's director and say that you can be in their city a day or two early and available for public relations opportunities, on television and radio and in print. This has worked for me numerous times and led to visits by people who saw me or read about me. Sales usually follow.

It is important to recognize that no amount of publicity will counteract inclement weather, exhibiting in an inappropriate festival, or other difficulties. PR helps, but does not guarantee. The overall job of getting the right people to any show belongs to the show committee and staff. Communicating with your target customers takes time, effort and money. You should do it, but not be overwhelmed by it.

By the way, one opportunity for communication I shy away from is advertising in show inserts that appear in newspapers. The reproduction of your work will likely be less than optimal, since even in these days of digital printing, newsprint rarely allows colors in ads to match the originals.

Step four: packaging your product. This includes not just your booth space and how it looks, but also your method of displaying your work and your pricing. An excellent bronze artist from Denver, with whom I have been privileged to exchange work, shows sculptures that are beautifully conceived and made. Her work adorns homes throughout the Southwest. Her prices range from

about $800 to $25,000, and she sells in her own name-sake gallery as well as at art festivals. You will not find price cards next to her sculptures. She quotes a price only when asked. Her business cards are not set out for casual acquisition; she prefers to be asked for her cards, allowing her to engage in conversation with a potential buyer. She is both smart and successful, and a terrific person, to boot.

Without a doubt, the "p" word, pricing, sends more shivers up artists' spines than any other except the "r" word, rejection. Pricing is an art, governed by a few principles, and a set of skills. Sounds a lot like what we as artists do in our creative lives, doesn't it?

It is easy to say you should price your work to your market, in other words, charge what someone will pay. Well, few customers will turn down a magnificent vase pegged at $10. Fewer still will buy a small glass ball for $1,000. Thus, pricing to your market makes little sense in our business.

A better, yet still rather lame way to look at pricing is to ask whatever—the highest dollar whatever—a cus-tomer will pay. This encompasses two theorems: first, that you know what any given customer will spend and second, that you will not price so far outside what other artists' charge for similar work that the public perceives your art as flagrantly overpriced. I do know one painter who, over thirty years at outdoor festivals, has developed a nearly uncanny ability to judge what a particular cus-tomer will pay for a specific painting. He has never used price tags in his booth and quotes prices to each poten-tial buyer. The price will vary depending on what he be-lieves the customer can and will pay. The pitfalls here are large, from underpricing, that is, charging less than you can, to overpricing, thus losing the sale.

You can price at the other end of the spectrum, the lowest you believe will attract many customers to your

work. This happens very often, but not for the right reasons. Artists will see work similar to theirs selling for less than their own and lower their prices in an effort to compete. It is a failure-destined strategy, since a downward spiral of competitive pricing can easily occur, driving every artist involved directly to the poorhouse. And it can blur distinctions between your work and that of others, which serves only to decrease your identity among buyers, as well as your reputation for distinctive artwork. It is also motivated by a desire to increase the number of your sales, yet rarely does so. Leave this sort of thinking to Macy's and Gimbel's or, these days, to Target and Wal-Mart.

How, then, do you price your art? Not, I hope, by the square inch, which many painters and other 2-D artists do, as in $5 per square inch, an 8"x10" painting, therefore eighty square inches, times $5, equaling $400. So a small Picasso would be priced at--$400. I'll take three, please, here's my Visa card.

No, pricing by area is like buying a house only because it has x amount of square feet, and paying that way, too. Junky houses really should sell for less than beautiful abodes.

Since none of us is Picasso, $10 million or so for a painting is probably out of the ballpark. What is in the ballpark?

You might begin by evaluating yourself and your artwork. This is difficult, but an exercise that carries more than just pricing with it. Have you been painting and selling for a decade? Less? More? Experienced artists generally command higher prices. Is your work represented in public collections, such as museums, government buildings, or corporate art collections? If yes, your prices will be higher than those of artists not in those collections. Has your work won awards (not including high school or college competitions)? Score higher on the

price-o-meter. Has your work been reviewed and written about in magazines or books? The price goes up.

Now, choose a single piece of your work, your best effort at the moment. Visit other artists' booths and websites and look for art in comparable media (oils versus oils) and of similar size and style (abstract versus abstract, 16"x 20" versus 16" x 20"). What are other artists asking for comparable work? Don't choose artists who have a longer, more noteworthy career than yours, or vice-versa. If possible, view the artists' booths with a really objective eye; choose comparable displays to yours. Ascertain that the other artists are successfully selling at the prices they ask; many will talk candidly with you if they believe your interest is genuine.

Armed thus, after taking a deep breath, consider your own work. If it measures up to the standards and history of others, try this: price it 10% higher than the other artists' work. Yes, I said Higher! Why? You will immediately place yourself in the company of other quality artists in the public's mind. Show visitors can view your work and theirs and, if they like both, feel they are in the same value bracket and maybe, just maybe, will believe yours is priced higher because it is worth more.

Plus, you can always come down in price. I did just write that, and I stand by it. We will discuss discounting in a little while.

But if your work does not stack up, you have a dilemma. You want the highest price you can get, equivalent to those artists at the top of the game. Unfortunately, if you price alongside them, they will sell and you will not, at least not as much. What you can do is price your work 10-15% below the better artists, enough to encourage buyers to choose your art, but not so much that your work seems cheap. Many artists do this and are happy with the outcome.

Whatever price points you set, discounting is a fact of life on the art festival circuit. Some would say it is because the public expects lower prices at outdoor shows because the work is not as good as in galleries. I don't agree; they expect lower prices because they know that we have lower overhead costs and do not have to pay a dealer or gallery owner half our income. Most artists I know will discount their work.

In some locales, the public expects it. In other places, buyers are very tight with a buck and simply won't pay what you ask. Let me use myself as an example here. My priciest photographs sell for about $2000. Often, buyers ask if that is my best price. I reply that it is, but that I will aid their purchase by paying shipping, or tax, or both. The response is usually good; the customer sees the price on the wall card or print bin as their total cost.

Sometimes this does not work. The customer is looking for a bargain, seeing artists as different than retail stores, with the ability to reduce their prices at will. All the principled comments, such as, "You're paying for my years of education and training, not just the art" will rarely succeed.

At this point, the true nature of negotiation begins. If you are asked, "What is your best price?" you can respond with the lowest price you will accept. Don't. Sure as sand in the desert, the customer will want an even lower price. Instead, move the price down a small amount, in either percentage or dollar amounts, and wait for the customer to respond. If the answer to your offer is "that's still too much," then ask what the customer believes is a fair price—not a low price, not a best price, not an insulting price, but a fair price. It is important to make the buyer tell you what he or she believes is fair, at this point. Otherwise, you will find yourself negotiating with yourself!

Most customers will, at this moment, name a very low price; a few will be less greedy and more realistic. For the latter, simply say, okay, how would you like to pay for the piece? For the lowballers, you will need to counter and try to reach a compromise you can accept.

But why lower your prices at all? To make the sale, of course, but, more importantly, because you need the money.

Pricing is ultimately a very personal matter, to each artist, with as many different perspectives as there are paint brushes in this world. One principle I believe applies to all of us is not to lower your prices overall—or raise them—from show-to-show. Art buyers, like the rest of us, want to believe they have purchased something of value today and worth more tomorrow. If you exhibit at a show one year and your prices drop the following year, you will find your customers displeased at paying more than they might have had they waited to buy, but, equally, at purchasing artwork with a diminishing value. This can influence future purchases by them and their friends. On the other side of the canvas, increasing prices will often create recommendations from buyers to their acquaintances.

Once in a while, actually more than once in a while, customers will simply say "I'll take that," and not care about getting a discount. Put them on your "A" list, send them holiday greeting cards and consider adding them to your will. Change their status from "buyer" to "collector" in your data base of buyers and treat them tenderly. When you next see them at a festival, offer them a "collector's discount," perhaps five percent. They are buying because they love your work.

An anecdote will tell you why. At one show in Colorado, a woman arrived with a child and nanny and chose two pieces for her mountain retreat. She asked if buying two pieces would entitle her to a discount. I said yes, 10

percent. She agreed and I rang up the sale. I consider this a full-price sale, since not to ask for a discount on multiple pieces would be rare. She handed me her black and silver credit card. Turns out, her husband was chief executive officer of one of the nation's largest companies. When I delivered the artwork to her home, atop a mountain with a view of the lower portions of heaven, her collection of exceptional art—such as Warhols and Kandinskys—gleamed from the walls. I could imagine my work hanging in such exalted company—as the couple and their friends sipped vintage wine after a day on the slopes. Did she need the discount? No. Would I have taken more off the price? You bet. A part of marketing, and pricing, is to capture the market, not just one sale. When this couple redecorates their beach house in Florida, or their apartment in New York, or the villa in Italy, I want her to consider my work for the walls.

Let's look further into packaging your product. Packaging a product is much more than how you wrap, bag or box it after the sale, but it does include these concerns.

I will not tell you not to hand your buyer a painting inside a green garbage bag, or a ceramic wrapped in newsprint, or a necklace stuck inside a bag from the corner convenience store. I should, but I won't. I should because so many artists make these mistakes it is almost laughable. Nice-looking boxes and bags and wrapping paper are inexpensive. I won't because if you do not realize that you should never devalue your work with ugly containers, you may need to rethink exhibiting at outdoor festivals. A photographer who has, over the years, taught me many important lessons about the business has pre-printed bags in several sizes, and buyers walk the show displaying his name prominently. I use clear bags, even for my largest pieces, which are three by four feet or more and on several occasions have sold to other

customers who see the work being carried out of the show.

Many artists include a biography with each purchase, a good idea. Others add a show schedule card, also a good idea. One technique I use, but only with high-dollar sales, is to include my DVD catalog. This is a DVD of my current work, viewable on any television, and it can result in after-sale interest. The DVD costs me about $1.50 to have made, after I create the master, which I change every January. You can do this yourself, with an Apple or other high-end computer and a program such as Apple's iDVD, included in their iLife package. (I also mail the DVD to my top customers every year and have received as much as a 10 percent response to it.)

In corporate marketing terms, packaging your product involves all the elements that bring it to the potential buyer in a style, size and presentation that encourage purchase. Price plays into this, as well, but less so. For us artists, whose work is first created and only then considered as something to be sold, we create the "packaging" after the fact. Here, we encounter the context of our packaging: how we present our work.

You would not likely purchase a Rolls Royce from a car dealership housed in a dirty garage behind a convenience store. Nor would you by it without fenders or a steering wheel. As consumers, we see the products we buy in their sales environment and tend to judge value not just by the product, but also by its surroundings. A mansion set in a mobile home park won't bring the best price. We don't seek out Rolex watches in a discount store's jewelry aisle. For a painter of expensive oils, finely carved frames may be a necessity. A well-designed display signals value to the customer and should reflect the medium, style and price of your work. All the deci-

sions you make about presenting your artwork really fall under the concept of "packaging".

One income-raising element of packaging your product is to group similar work so the buyer can choose—yes!—more than one piece. Photographs, paintings, drawings, lithographs and other flat art that complement each other—in pairs or larger groups—can find their way into the homes and onto the walls of customers as a decorating solution for large spaces, for example in a hallway or both opposite and next to a bed. Many large homes have been built with "great rooms" in recent years. Wall spaces can be broad, lending themselves to multiple pieces that are related. If, for example, you paint Western landscapes, a grouping of them on your booth wall might just spur customers to consider them together on their own walls. I have used this technique many times and, when I find out a customer needs more than one piece, pulled related pieces from my print bins to suggest.

This can lead to one of the more subtle principles of packaging your product: the longer a potential customer spends in your booth, the greater the chance he or she or they will buy a piece of your work. Read that again, please. It is true. Short of hog-tying a potential customer, you must endeavor to keep them inside your booth. Lots of ways to do this can be developed. We will look closely at them a bit later in the chapter of the Handbook devoted to understanding the customer. For now, having more than one piece in a grouping can extend the customer's attention span significantly. Offering to show them other pieces in a print bin that are similar to the group they are viewing will also extend their time under your canopy.

This brings us to the next step in marketing: relating to your potential customer. Creating art is a rather solitary profession for most of us. We work alone most of

the time, even if we have some studio assistance, for at least a portion of the creative process takes place inside our heads. We may paint outdoors beside other painters, but each of us becomes absorbed in our own process.

Now comes the art festival, and we must suddenly transform into someone just short of a carnival barker in the old time American West.

Or so it can seem.

We would all like to sit in quiet repose behind our booths, rising from our magazines or books only to take the customer's money. We would like it, but it does not work. Festival-goers enjoy interacting with the artist whose work they may buy, learning about the artist and his or her art. They welcome both professional and personal insights into the artist; how you paint or photograph or cast pots, where you live, your history, your family. If they are from the Midwest and you were born in Chicago, you will see them visibly relax when they learn of your common geographic background. This type of communication is crucial to many sales and necessary to developing collectors from customers.

Hiding from your customers or, worse, staring at them without speaking, will assure their swift departure from your booth. Yet this is a delicate matter, with a delicate balance. You do not want to intervene in their thinking or enjoyment of your work.

My answer to this has developed over several years. Here's where I've arrived.

First, as soon as possible after a potential customer enters my booth, I say "Hello, my name is Marc." They always respond; it is difficult for anyone to remain aloof and be thought of as impolite. Then I say, "It's my work. Let me know if you have any questions." I then back away, Should the person or couple spend five minutes or so in the booth, I ask if they are looking to fill a particular spot on their walls. If they say yes, I ask more, about

decor, wall color, lighting. Then I offer to show them a few pieces I believe will fill their needs. Again, I'm playing for time. At this point, you will often hear, "I'm just looking." A good moment to ease away. Or, they may pull a fabric swatch or measurements out of their pocket or purse. Time to hone in on the possible sale. If you find a piece they are seriously considering, especially if it is a couple looking, give them time to converse without you overhearing. When they focus on the price of a piece, or flip a matted print over to find the price, offer to help, as in "the price is $500."

At this moment, your potential buyers will either cut and run, or stay and begin the buying dance. You can ask if the price meets their requirements, but this sometimes backfires, since it indicates you are willing to negotiate. Or, as one very successful painter does, you can ask what you can do to help them with their decision. You may hear, "Lower the price." Or you may hear, "We need to think about it." If they plan to wander the show and consider the purchase, you can ask if they would like you to hold the piece, for an hour, while they walk about. This can work, or not. In every case, hand them your business card and make certain it contains your cell phone number, telling them you always have the phone with you. More than once, I have received calls from customers asking me to deliver a piece to their homes, or ship it, and providing their credit card numbers.

Whatever your personal way of approaching potential buyers, do so with a smile. At times, they will not smile in return. Let it go. Keep smiling.

I have found it useful at times to distract the customer from focusing on the purchase, usually when I sense an intensity that can interfere with their pleasure, such as considering the price too much, or wondering whether their spouses will like the piece. At these moments, I ask about them, where they live, whether they

often visit art shows, even about their families. My interest is genuine; the more I know about them, the better able am I to relate to their tastes in art. And people like talking about themselves. One corollary: people who do not like you will rarely buy your art. Art is a pleasure giver to most of us, and we want the entire experience to be positive.

Now, the next step: making an offer of sale. Here, again, a delicate moment. Do it right, you will sell; do it wrong, you will wonder why your potential customer put on roller skates and fled your booth.

Timing, it is said, is everything. Here, that is correct. Ask for the sale prematurely, and your buyer will be taken aback. Wait too long, and your buyer may lose interest. When is the right moment? With a couple, when they have stopped talking and linger looking at the piece. With one person, when you feel their attention completely drawn to the artwork.

How do you phrase the question? Not: wanna buy that? Or anything that resembles it. Instead, ask if they have made their decision. Place the action in their hands, do not presume to take it into yours. Don't say, "May I write that up for you?" We are not selling shoes or paper towels. Your customer is making a commitment, sometimes a life-long commitment, to own and display your art in their homes or offices.

To put this another way, you are not selling, they are acquiring, not only buying, but adding to their lives. You are not in the midst of a transaction, even though a transaction must occur, but in the process of enriching their surroundings. This is their decision, in its entirety. Give it the respect it deserves.

The answer to, "Have your reached a decision?" can vary. "Yes, I'll take it." "No, it really won't work in my dining room." "I'm not sure." "It's outside my budget." The first answer has no need for further discussion, ex-

cept in the form of payment. The second answer is what it is: no. You can try to show them other pieces, if you have discerned the color, style, etc., they want. This often works. The third answer, "I'm not sure," has possibilities. You may say, "Tell me what your are thinking?" Whatever the answer, you are keeping the customer in your booth. If price is a problem, offer to negotiate. If color or style is the stumbling block, now is the time to trot out your trusty 30-day approval policy. Yes, give the customer thirty days to return or exchange the piece, no questions asked.

There are three reasons, perhaps more, to do this:

First, you may make a sale that would have otherwise not have happened.

Second, you truly want the buyer to be happy with your work and buy more.

Third, if the customer pays by credit card, they can undo the transaction simply by shipping the piece back to you and disputing the charge with their credit card company. We will go into this further in a moment.

Some buyers even say they don't want a return privilege, since they are sure about the purchase. Others welcome the option and visibly show their appreciation. Still others use it as a way to sort of, but not quite, make a decision.

None of this matters. Offer a return policy and your sales will increase. I do, and have never had more than one percent of my annual sales returned. The year I instituted the policy, my sales increased 20 percent. You do the math.

The credit card return and sale cancellation problem plagues not only artists, but merchants in every corner of retailing. Credit card companies found, a few years back, that conditions could exist where a consumer, for legitimate reasons, would return purchases and expect the credit card company to remove the purchases from

their monthly bills. Unable to exist in a vacuum, this led to rules, or at least practices, by the credit card companies that they could apply to all their customers.

I once had a buyer call me five months after a sale, saying that she wanted to return two large photographs, framed by me, for a refund. As politely as I could, I said no. She dropped the artwork off at my mailbox store—where I receive mail since I travel half the year—and proceeded to ask her credit card company for a refund. The credit card company agreed. My credit card processor removed the sale price from my bank account—they have the right to do this—and gave the buyer her money back. I was astounded, fought the reversal in letters and faxes and telephone calls, and lost. The credit card company's reasoning was that, since I have my merchandise back, the buyer was entitled to her money.

This was an extreme case, but people return purchases for credit back to their accounts by the millions. Artists are not immune to it, even if they post their return policies in their booths and on their sales tickets. It is not worth the ill will of a customer, or that customer's acquaintances, to dispute a return, unless the reason is damage to your work. Consider returns a part of doing your art festival business and implement a 30-day (or some time period) return policy. This clearly says you are willing to take a piece of art back, but only within certain parameters.

Returning to the topic of relating to the customer, if the potential buyer is still unsure, do not press the sale. Instead, offer to let her take the piece home, overnight, or offer to stop by after the show and let her see it in all its glory in her home. A few painters and sculptors do not even want to make the sale at their booths; they believe that presenting the work in the customer's home increases their chances of making a sale and can sometimes lead to multiple purchases.

The "It's outside my budget" answer is a bit more complex. You might ask what the budget allows, and begin negotiating from there. Or you can offer installment payments, which works only occasionally. Or, offer a lower-priced piece, a smaller painting, perhaps. This, too, will at times succeed. I have come to believe that few people actually have a pre-conceived budget for purchasing art at outdoor festivals. When they invoke their limited budgets, I tend to believe the price is simply too high, often much too high. The customer is engaging in a bit of fantasy. Once, I sold a piece to a young couple with a small child. Mom was finishing medical school. Dad worked to support the family. I sold the piece they wanted for half its listed price. Their happiness was palpable and they promised, when they reached full earning capability, to return for more photographs. They did. To be truthful, I did not expect them to return. My goal was to make their lives better, to enrich their environments and to support their struggle to succeed as much as I could. Engaging in acts of kindness and generosity is its own reward—and may lead to others!

So, we're done, right?

Hold on there, budding Dali! Whoa, Ansel, don't get your Adams apple in a knot. We have yet to offer a specific piece to a specific customer in a way that consummates the commitment by the customer to buy.

This I call "consummating the sale." It involves the mechanics of completing the transaction.

We've done the hard work of relating to the customer. Agreement has been reached. Never, ever say anything like, "paper or plastic', or, "cash or check". Instead, ask the customer to join you at your worktable; you need to get some information. Write out the sales slip, all the while chatting with your buyer. Name, address, email, etc. for your mailing list. Name of the piece, price, tax, shipping cost, total.

Now ask what form of payment your customer wishes to use. More and more, art buyers at shows do not bring cash. It is cumbersome and many people don't like to carry the green into public places. Checkbooks come out, perhaps ten percent of the time. Credit cards are the plastic coin of the realm. Usually, a cash buyer wants a further discount, check writers may, also, offering to make the check out to "cash", as though your first name is Johnny and you Walk The Line. My recommendation: that's one line you don't want to walk. The IRS and their minions constitute one of the few portions of life capable of instilling instant fear in my bones. A customer once offered me cash for a rather large purchase. I said it did not matter, since I would enter the transaction into my books and pay my taxes. He replied that he agreed, since he was a federal prosecutor in Miami and would rather see my art on his wall than a mug shot of my face.

Your attitude toward cash is between you and the IRS, of course. Most federal prisons do not have art supply stores in them. 'Nuff said.

Okay, the sale is done. You've accepted the credit card, run it through your wireless processing machine (get one; knuckle busters, those pesky manual credit impression units, offer no security that the card has enough available credit to accept the purchase) or taken the check, making certain you have all the information you need. Your customer has signed the charge slip—or not. Once in a great while, at this point a buyer will balk, saying her or she really needs to wait on the decision to buy. When this happens, let the buyer leave. Smile, say you hope he or she returns. Find an outlet for your frustration and be glad you have the self-control not to scream. Buyer's remorse is a known commodity, creating a major industry for sellers who need psychological counseling, where you will be told not to take it

personally. Yet it is, in some measure, personal, as is all rejection to an artist. We will discuss rejection, and other emotionally trying parts of the art festival business, in Chapter 15.

Your sale is complete. It is a moment of financial pleasure, emotional pleasure and an almost physical pleasure. It will happen over and over again and you will never tire of the sensation. And you have approached the art festival business with an eye to marketing, not just selling. Salesmanship, whatever that is, has become just one element in making sales, and a much less daunting one.

The effort to keep up with these marketing principles may, for a time, be tiring and tiresome. Keep at it, refine your marketing approach and you will soon practice good marketing techniques as second-nature. You can also ignore this chapter, but I would not: every successful artist I know uses most if not all of the principles we've explored. Over time, whether you are new to the art festival business or a veteran of many years, you will modify the principles of marketing at festivals to suit your shows, your display and your personality. Most art festival artists will tell you—all if they are forced to speak truthfully—that their marketing techniques run a close second to the quality of their work in fostering sales and financial success.

CHAPTER FOURTEEN

Understanding the Art Festival Customer

IT IS TIME, DEAR fellow artist, to address that most perplexing, important and at times frustrating element of the art festival business: the customer.

Or, the Customer. Or, even, The Customer.

Let's settle on the Customer. It looks good and sounds right and, since you hope to have many of them, implies a group of potential buyers, not just one.

Now, the Customer comes in all shapes and sizes, all ages and economic means, all tastes and desires. The Customer may be easily offended and just as easily pleased. The Customer may not always be right, but is always the Customer.

At a show in Boca Raton, Florida, which location probably yields more jokes about the Customer than any other, an overdessed, overperfumed, overloud, over-weight lady of indeterminate age and number of cosmetic surgical procedures entered my booth. She stood looking at a large piece on the booth wall for no less than fifteen minutes. Her amply fleshed arms were crossed, the look on her face—as best as I could tell under her plastic skin—was one of deep concentration, even pleasure. Her jewelry made me want to reach for my sunglasses, it glinted so.

Finally, I said, "May I answer any questions?"

"It's perfect," she replied.

"That's wonderful," I said, already counting the money she would spend.

"I've been looking for a picture to go over my sofa for six years," she said. "This is the one. It's perfect."

Smiling, I said, "May I write it up for you?"

She looked at me as though I had just landed from Mars.

"No," she said. "I hate my sofa."

Whereupon, she quickly exited my booth.

The story is not apocryphal; it is true. The lady had no intention of buying any picture to go over her sofa. She was not buying, but merely shopping.

The Customer has an absolute right do just that: shop instead of buy. Our job is to turn shoppers into buyers. Understanding the psychology of the buyer at an art festival and the steps in their decision-making process will help in that quest. Defining our response to shoppers and refining our method of meeting, greeting, wooing and winning them over will increase your sales. We have touched on this topic in earlier chapters of the Handbook, especially in our discussion of marketing; however, the psychology of the Customer makes so much difference to your sales that it bears much closer scrutiny.

People buy art for a myriad of reasons. Usually, it is intended to be decoration for their homes or places of work. The destination of a piece of art is less about motivation than about goals. Many paintings can be found to enhance, say, a living room wall. A few buyers become collectors, so much do they fall in love with a particular artist's work. Before they enter that rarified stratus, which all artists wish all buyers would do, we must perform a somewhat intricate dance with them. The steps become easier if we know them and the interior emotions and thoughts that accompany them.

Here's how the dance begins.

You are in your booth, all set up with nowhere to go but where you are, ready to greet and sell to the Customer.

The festival opens; people begin to walk by. A few stop, look, even linger. Most do not, but that is the way of the art festival. You look closely at the people. Many are well-dressed, a few qualify as fashion plates. Others are candidates for extreme makeovers. No matter, you do not discriminate. You employ your best charming smile, say hello to all who enter, offer to assist them if and when they need you. Discretely, you back away, giving them the space to look at your work.

At this stage, the Customer makes the first of several decisions: to stay and look more or to leave and find another artist's work to enjoy. So far, no sale, no indication of a sale, not a glimmer, not a hint. If you were playing poker, you would swear the Customer held a great hand and had a world-class poker face. At times, the Customer may even say, out loud, "these are beautiful," or some such compliment. You acknowledge this with a nod of gratitude and a soft "thank you".

If the Customer does not leave at this point, and many will, he or she—or both, since often the Customer is a couple, not a single person—will likely look at other hanging works or begin leafing through racks in your booth. If you have no racks, say you are a ceramic artist, the Customer may well fondle one or two pieces, move slowly around your booth looking intently at several pieces, or simply stare at the one that caught his or her or their eye. If you are a sculptor, the Customer likely will circle your work, stopping at some, bypassing others.

You might assume that, at this point, a sale is imminent. Nothing would be more wrong. At this moment, the Customer is deciding not whether he or she or they will buy, but whether your work is up for consideration.

Never assume anything more. Or less. It is early in the purchase process. The Customer is reacting emotionally, rather than in a logical thought process. You know only that something—most likely something the Customer does not even realize—has stopped him or her or them at your display.

What motivates the Customer to linger in your booth and not another's? The art, of course; your art. How you have "packaged" your product; your display, framing, the finish and colors of, say, a bronze sculpture. A connection to a part of their lives or emotional makeups; a scene that reminds them of a favorite vacation spot in Mexico. Form, color, abstraction or realism, texture, tone; all the elements you have used to create your work. Whatever has moved the Customer from the aisle, where hundreds walk in seeming somnambulism, into your booth, a connection, however tenuous and brief, has been made.

Several steps remain before the decision to consider buying is made. First, does the Customer like the work? Second, does the Customer want the work? Third, does the Customer need the work? Fourth, can the Customer afford the work or, somewhat perversely, is the work expensive enough? Fifth, does the Customer need their spouse's or significant other's approval—or even want it? Sixth, how do the answers to these questions compare to other artist's work in the show? Seventh, does the Customer like the artist?

The Customer may consider all these questions in the wink of an eye, or the span of a four-day show, with the Customer coming back many times. The process may even extend beyond the show, with the Customer visiting your booth at several shows over many years. My record is the Customer who bought a piece four years after first seeing my photographs (and complained that the price had risen).

Let us assume that, eventually, the Customer will purchase from you. Your job is not to convince the Customer to buy, but to buy now...or at least soon. Each step of the way, you and your work must overcome negative answers to the questions above. Once in a while, the Customer will enter your booth, look at a piece of your work and say, "I'll take it." Cherish the moment; it does not happen as often as any of us would like.

We can examine each of the Customer's steps in the buying process and find ways to move through them positively to consummate the sale.

Does the Customer like your work? Time spent in your booth helps answer that, and, done right, no harm comes from asking. Do so obliquely. If the Customer has been in your booth utters the word "Wonderful", or something like it, you can pretty well assume the work is well liked. If not, simply ask, "Does any image strike you?" You will get an answer, from "just looking," to "all of them," to a question, such as "How are they done?" Or, a favorite among artists, you can say, "What do you like about it?"

You are attempting to do two things at this stage: focus the customer's attention and move the Customer to the next question: Does the Customer want your work?

Again, use a bit of misdirection to find the answer. Ask, for example, "Would that look good in your home?" Once more, answers will vary, but you will know if your art has become an object of desire, or is on the way there.

Liking and wanting to own your art are two very different subjects for the Customer to consider. We may like, even love, Picasso's *Guernica,* but few of us would enjoy looking at it every day in our homes. I may truly enjoy the paintings of Jackson Pollack, but all those rivulets of paint, even in their emotional intensity and perhaps because of it, might just keep it off my wall. A

Turner landscape is a wondrous thing to behold, but not among my collection of abstract paintings. We may like many pieces of art, but we may not have any desire to own them. However, if the Customer does not like your work, it will rarely find its way into his, her or their homes.

Next, does the Customer need your work? My standard question here is, "Are you filling a particular space in your home?" The Customer enjoys talking about his, her or their homes and will generally answer forthrightly. If you hear something like, "Yes, over my bed," or "In the dining room," now is the time to extend the conversation, by asking what the Customer's decor is like. You will hear much about the room where the artwork is needed, and you can engage in more conversation, by asking questions. Then, without hesitation, offer to point out pieces in your booth you believe will work with their color schemes and furniture. You are extending the Customer's time in your booth and creating a sense of attachment to your artwork. The Customer will visualize your work in their personal environment, a major step toward making the sale. When the Customer's need matches a positive emotional response to your work, you have moved well along the sales curve.

At times, you will hear the Customer say no, she just loves the picture, or sculpture or pot or basket. The Customer may say that no space exists for it; you will have difficulty making this sale. Or, the Customer may wish the piece was smaller, or larger, or vertical rather than horizontal. When this happens, it is unlikely you will consummate the sale, unless you have a piece in your booth that fulfills those requirements. It is best to offer the Customer a business card and turn your attention elsewhere. If the Customer is truly interested, you will find them returning later, or visiting you at another show.

But if the indications are positive, as in "That will look great over my piano," you can move to the more difficult question: can the Customer afford the work? Or, is it priced too low for the Customer's exalted socioeconomic status?

We here enter a crucial, and very delicate, moment. You do not want to ask if the price is too high, or too low. Yet you must bring up price, at least in a general way. If your prices are posted, you may have moved beyond this stumbling block—although not completely. More points in the purchase process are available for price to become a barrier. Over time, you will develop a sense of when the Customer is unconcerned about price, but you will never be certain of this until the sale is completed. More times than I would like to remember, I have believed a sale was done when the Customer suddenly asks, "How much is it?" as though he or she or they had no concept of the price earlier. Moving through the price question in your own way can avoid these situations. Here's a technique that can work.

If your artwork is 2-D, and framed, begin talking about the frame, how well-made and put together it is, and how you do it at a fraction of retail price as a service to the Customer. Ask if the Customer likes the frame, and if it will work in the Customer's home. You will receive one of several responses, including "Yes, it's beautiful and reasonably priced," or, "I have a great framer. I always have my art custom framed," or, "Framing is so expensive, it's hard to afford to hang the art." You will hear variations on these answers, and they will often indicate whether the Customer can afford your work. Often, at this point, the Customer is thinking about affordability, and will either continue toward the purchase, or find a convenient reason to leave your booth. Sculptors can discuss pedestals and installation at this time; jewelers can focus on the Customer's other jewelry

and ask about it. Any indication of ability to afford the work will assist you in completing the sale.

When you have, in your own mind, established that the price will not derail the sale, you can move on to the next question: Does the Customer need, or want, their spouse's or significant other's approval?

Every art festival artist has found him- or herself in this generally miserable situation: one half of a couple loves, wants and needs a piece of your art. The other half does not respond well to your work—or at all. The wife, for example, lingers in your booth, while the husband stands twenty feet outside or just walks away. The wife in this instance may actually walk out of your booth, re-trieve her spouse and drag him back. She may say, "I think this would be perfect over our bed," or something equivalent. Most often, her loving significant other will not want to rain on her parade by saying, "I hate it." He may, in fact, stand stone-faced, arms crossed, providing his message to her without words. Or he may object to the color, size, price, subject matter or even medium. You will also encounter the Customer who buys without the other half's input or approval, but this is rare.

Then there is the Customer who loves and wants and needs a piece, but whose better half is out playing golf or fishing. You can respond in one of several ways: offer to send the piece out on approval, try to obtain a commitment that the Customer will return later or the next day with his or her significant other, make an ap-pointment to visit the Customer's home when both will be available. You can even offer to hold the piece while the Customer arranges for his or her other half to come to the festival; I have done this with success on several occasions. I have come to believe that the "spouse ex-cuse" is really a way of saying no to the purchase, at least much of the time. However, we can ill afford to ig-nore it, as maddening as it may be to believe you have

the makings of a sale when, in reality, you are only halfway there.

You will also encounter a different scenario: the Customer who spends time in your booth and seems to choose a piece for purchase, or at least a few from which to select. The Customer then, without another word, leaves. Later, or the next day, he or she shows up with a spouse in tow. It is rather nice when this happens, and you can engage the significant other in conversation about how much his or her spouse must really like your work.

Once spousal approval is obtained—or if it is unnecessary—we move to the next question, one none of us like, but all of us face: how well does the Customer believe your work compares to that of other artists in the festival?

When the Customer attends an art festival with the goal of purchasing a piece of work for a particular place in the home or office, you will compete with other artists for their money. Actually, you are competing based on all the questions above. You will rarely know that you are in competition, since except for the rare Customer who actually lets you know other artists' work is under consideration (this can happen when the Customer is looking for a discount, telling you that the price of the "other" work is lower), the Customer has no motivation to let you know. In fact, the Customer may even be a bit protective of your ego, letting you think your work is the only art under consideration.

They may have narrowed their purchase possibilities to two artists, and go back and forth between your booth and another several times. Competition at art festivals is inherent in the structure of the industry. We compete for acceptance into a festival, for what we consider excellent booth locations and for buyers. The Customer does not really care about this—except when trying to lower

the price they pay for a piece. Otherwise, the Customer considers competing artists as the natural diversity of the artistic offerings and a wonderful part of the festival environment. Yet, at any festival, only a certain amount of money will be spent and the Customer has limited needs.

Some artists will ask the Customer if another artist's work is under consideration. This is a tricky area, since calling attention to another artist in the Customer's mind may defuse enthusiasm for your work. We like to believe that our artwork surpasses that of other artists, and we carry this over to the Customer, asking that a potential buyer consider only our art. This, of course, is somewhat naive; people rarely purchase anything without looking at their options.

Yet competition can also increase the Customer's fondness for one artist's work by holding it up to comparison, thus spurring a sale. The very element of choice, rather than no choice, places the Customer in a buying mode. No artist is every likely to encounter a festival where one, and only one, artist's work meets at least some of the Customer's criteria for a purchase. If the Customer refers to another artist's work, you can suggest they discuss both your work and the competitor's, and sincerely try to help them make a choice, with as little prejudice toward your art as possible. The Customer will appreciate this, which leads us to the last question: Does the Customer like the artist?

The Customer need not like the artist to like the artist's work. Outside the art festival world, most buyers never meet the artist. This makes buying art at art festivals a much more pleasurable experience. Many times, I have been told by the Customer that knowing the creator of the piece they purchased greatly enhances their enjoyment of it. We live in a world where the producers of what we consume are nearly always unknown to us,

even including the houses we live in. Corporations care-
fully build an image they believe will increase sales, of-
ten obscuring the people behind their products on pur-
pose (although, cyclically, companies may inject a more
personal touch into their advertising, showing workers
and other employees, real or hired actors).

With our proximity to the Customer, and our inter-
action on virtually every purchase, the Customer's opin-
ions about us can make a huge difference in our sales.
While assuming a role never makes sense, opening our-
selves to the Customer's scrutiny does. We are more
than just facts and history; we have lives that the Cus-
tomer may find extremely interesting. Artists have al-
ways been subjects of curiosity, with our perceived, if not
actual, alternative lifestyles. When the Customer buys
from us, he or she or they may feel an association with
that supposed independence, self-motivation and crea-
tive freedom. This in no way diminishes the value of our
work. I have never sold a piece of art to anyone just be-
cause the Customer and I seemed to get along. However,
the perception that an artist is a nice person never
hurts.

Once, a couple stood in my booth debating between a
piece of mine and that of another photographer. The
Customer was sincere in being equally attracted to both
pieces. I offered to let them take mine home overnight on
approval, so that they could see it in their home. They
left to ask the other photographer if he would do the
same. The Customer returned, looking somewhat dis-
gruntled. The other photographer had rather gruffly said
no. The Customer left the show with my piece, the sale
done. Our actions toward the Customer count for much
more than our personalities.

Many times, you will not see or feel that the Cus-
tomer has gone through all these questions en route to a
purchase, but they are nonetheless there. Knowing this,

you can prepare for them, react sensitively and posi-
tively to them, and make *the* Customer *your* customer.

CHAPTER FIFTEEN

Art Festivals and Your Emotional Well Being

FROM THE OUTSET, LET me state unequivocally that this chapter is generally without facts.

What? Why am I reading it, you ask? Because it addresses the one area where artists are perhaps most vulnerable: feelings. And I will cheat a bit here, including matters about our emotions that do not all happen strictly at festivals, but also before and after them.

A well-dressed man walked into my booth one sunny Saturday, looked around and then approached me.

"May I ask you a question?" he said.

"Certainly, " I answered. I did not voice the point that he already had asked me a question.

"Can you really make a living at this?" he said.

Something about the man, his body language or vocal intonation or perhaps just his timing, irked me.

"Yes," I said. "And own a home, put my children through college, take vacations, buy food and give my grandchildren birthday presents."

I wasn't done.

"What," I asked, standing up as tall as I could and looking the fellow directly in the eyes, "Do you do for a living?'

"I'm a builder," he answered.

"Can you really make a living doing that?" I asked, my tone incredulous and more than a little sarcastic.

The gentleman turned abruptly and left my booth.

You will encounter many, many questions from visitors to your booth that you will find annoying, insulting, off-putting, invasive and just plain rude. Most of the time you will respond with patience and understanding, since that is part of your job as an art festival artist. There are moments, however, for good reason or not, when you will want to lash back at the visitor.

This is a case of do as I say, not as I do. I was wrong to trivialize the gentleman's question to me about earning a living. It might have—although I doubt it—cost me a sale, and it is not my usual practice, nor my way of responding to the outside world.

It did, in fact, demean not the showgoer, but me. My emotional balance was disturbed, not his.

I believe that most artists, if not all, have gentle souls, wrapped up in how they choose to translate the world as they see it, and the emotions that world evokes in them, into art. While much, too much perhaps, has been written and spoken about the artist's mental and emotional makeup, little has included the different and special elements exhibiting in outdoor art festivals brings to the artist's psyche.

Exploring those unique impacts on the art festival artist, and examining ways to understand, cope and respond to them, will, I believe, make us happier, better artists—and better at succeeding at outdoor festivals.

In the main, artists work alone, painting, drawing, sculpting, photographing—whatever their chosen medium. Then, quick as you can say, "I was accepted," they are required to prepare for an onslaught of humanity viewing, touching, examining, evaluating, accepting or rejecting their work. The transition happens fast and can be frightening. We are, after all, not chameleons who can or should change our mental skin colors to suit the selling world.

Or are we?

Most people who visit art festivals, most of the time, will either ignore you—another emotional area—or act wonderfully well when they are in your booth. If nearly all the people who come to a festival pass by your booth without giving it more than a glance, you may wonder what is wrong with your work, your display, or you. Usually, the answer is nothing. The passersby are simply not interested in what you do. Since most festivals charge no admission fee to the public, visitors feel under no compulsion to get something for their ticket price— they paid nothing. Your best emotional defense is to exclude them from any emotional equation: they do not matter, to your work, your sales or even your artist's ego.

Then there are the relatively few who do enter your booth. These folks do indeed enter your emotional sphere. You want them to like your work, and you, to seriously enjoy viewing what you have created and, hopefully, decide to acquire a piece. You watch their responses carefully, both for clues to their purchase inclinations and—to be honest—for their reactions to your art. Many artists care little for the world's opinion of them as people, but care immensely that their artwork gains public acceptance—and more. Interestingly, this need for acceptance—for, truly, validation of the time, toil and travails our art requires—is not a need for mass accolades. A single viewer of our work, responding with sensitivity and finding pleasure, or pain, or comfort, or distress in it, fills us as much as if a thousand souls lauded us. We re not rock stars, have no wish to be.

Conversely, a single case of disdain for our work, of dislike for it and, worse, of little or no response, can send us into paroxysms of self-doubt.

When an artist displays his or her work in, say, an art gallery, the artist has little interaction with the pub-

lic; beyond an artist's reception, that is the task of the gallery staff. So, while many may see our work in a gallery, their responses come outside our hearing and view.

Not so with outdoor art festivals. The public's response is immediate, brutally evident and rarely hidden: they pass us by, look fleetingly, move on. No buffer exists between us and them. It is one of the prices we pay—emotionally—for the opportunity to interact with and sell directly to the public.

How *should* we feel about this? There may be no should, but there are several possibilities. We can simply retreat to an inner place, not letting the public's reaction touch us. We can ride an emotional roller-coaster, our feelings rising with every "great work" and falling with each no comment. Or, we can see the public's response for what it is: someone else's opinion or reaction to our work, true, but limited in importance only to our task of selling our art.

This, you may say, is simply learning to live with rejection. Perhaps, but it is more: the art festival business cannot, by its very nature, be allowed to rob artists of our sometimes fragile inner emotional resources—that portion of our selves we protect and carefully husband—or we will surely cease to create and thus cease to be artists.

It is no easy task. In the course of a weekend, hundreds of people may enter your booth. After hours spent greeting them and watching most leave without even a comment, you may be excused for feeling a bit...rejected. This can affect you deeply, or not. If you can separate your artist's ego from the act of selling your work, you will find visitors to your booth are no more than potential customers—except for the very, very few whom you come to know well and whose opinions and responses to your work you believe, eventually, have value.

Becoming too detached from the public can be dangerous, both to sales and to your mental health. They are, after all, your source of income and deserve respect. Here's a technique I use: talk to your customers about more than sales. Ask about their responses to your work, in depth and in detail. If you can, through your sincerity and desire to know their thoughts, gain their trust, you will cross a line important to your mental health: they become a part of your artistic growth, valuable teachers, if you will, of how, in intimate contact with you, they express their own emotional responses to your art. Certainly, choose carefully whom you will engage this way. And remember that many buyers are looking only for a painting to match their sofa. Once in a while, you will make a connection that enlarges your understanding of how the public sees your work and, by that, how you see your own art.

So a balance can be struck. Dismiss that which means little to your artist-self; explore that which may add to it. A curious side product arises: the public senses that you are truly interested in them, when they are truly interested in your work. Potential buyers become actual buyers. Buyers become collectors. And the benefit is all yours.

The impact on an artist's emotions from the art festival business begins much earlier than at a show.

When you apply to an art festival, you are putting forward your work—and yourself—as worthy of participation. You may be rejected or accepted or waitlisted. Rejection has a way of telling your inner self that your work is not good enough, at least for that festival. Multiple rejections can reach deep inside you, make you doubt your work and whether you should exhibit at outdoor festivals. This is not always true.

So many reasons exist for rejection to festivals that any festival rejection you receive may have nothing to do

with your work. It is axiomatic that in order to create art we must believe in our work, that, whatever this means, it is good. The enormous subjectivity of that word aside, we are the first and, possibly, last judges of our art.

When we apply to art festivals and are rejected, how should we feel? Festivals rarely use the word "rejected" preferring to say "not accepted" or "could not find a place for you this year". Sugar dissolves easily; so does sugar-coating. The fact is that you will not participate in that festival in that year. It does not mean that your work is unworthy. We should try to be honest with ourselves, right?

To a point. Yes, other artists in the festival may be older, more experienced, even more talented. But not *better*. Take the yardstick out of the picture and you will find a different sort of reality, one more coincident with what we as artists must do: retain our belief in our work and ourselves so that we may continue to battle the empty canvas, the lump of clay, the blank page. Instead of seeing rejection to festivals as personal denials of the value of our work, simply do not live or think in that dimension. Rather, see the rejection as what it is: a business, which whether for or not for profit, an art festival is, has made a business decision. The decision, if it is a rejection of your desire to participate in the festival, ultimately says nothing about your art. Since only artists who want to sell their work apply to outdoor festivals, the artist is making a business determination by applying, not a decision about his or her art. Adopt this viewpoint—and I will not say it is easy to do, since I struggle with it myself—and you will not let business invade your feelings about your art.

What, then of acceptance? Also a business decision, if a more pleasing one. Acceptance into a festival is easier to assimilate but no less emotionally impacting. With acceptance to a festival comes commitment, cost, sacri-

fice of time, hard work and potential financial loss—as well as exposure to the emotions you will experience at the show. Until and only if you can place the emotional turmoil inherent in displaying your work directly to the public in a place that leaves your feelings intact, acceptance into a festival entails far more emotional risk than rejection.

As human beings, we are happier with acceptance than rejection, of course. But as art festival artists, we must learn to place these in a balanced perspective. Feel badly about rejection; get over it. Feel good about acceptance; get over it. Address the task at hand: becoming and remaining the best artist you can be, by your own lights. Art festivals tempt us to alter that, with all the forces that play on our emotions when the public arrives.

A friend of mine, another photographer, whose talent I believe outshines most artists' at festivals, recently said he was quitting the festival business. He has a small child and a wife who works and earns a good salary, but he rarely sees them and has grown tired of returning from festivals exhausted and with little money to show for the effort. I asked him if he really wanted to give up the show circuit. He said no, but he could not accept the lack of financial return for the effort and sacrifice. He is considering another career, in forestry, which he loves. I thought his reasoning was sound, since he had not mentioned anything about his work.

Yet something nagged at me. Later, I asked him if he had any other reasons for leaving the art festival business. He stood silent for a moment, then said, yes, he was tired of people rejecting his work by not buying it. He had equated sales with acceptance by the public, a risky proposition. He finished by saying that he would always make photographs, just not for sale. So much do I believe in his talent and skill that I think the world will

suffer for his inability to sell, or to reconcile not selling with his artist's self.

It is a classic case of how the art festival business can impact an artist's life.

On the other side, all of us who do numerous festivals know artists who have succeeded in striking an emotional balance while protecting their ability to create. We also see many, many examples of people to whom the art festival business is no more than a way to earn money, whose art matters little to them; they may even go from medium to medium searching for something to sell. I know one couple who went from crafting cutting boards in the shape of animals to painting abstract canvases to taking photographs. The art meant little. The money was all. Are they wrong to seek a way to earn a living at art festivals, if the lifestyle appeals to them? No, but artists who work at their craft for years, to whom selling is only a path to survival as artists, have little respect for the pure capitalists masquerading as artists. Art festivals, as I have pointed out, are a very democratic environment, requiring little in the way of education or training. We do like to think that, at their best, festivals are about art, not just money.

It is also possible to become so involved with the business of selling at art festivals that your art becomes secondary, where once it was your primary goal in life. Only you will know if this has happened, and only you can decide what, if anything, to do about it.

Let me tell you one of many success stories when it comes to striking an emotional balance while doing art festivals. Earlier, I mentioned an artist who always dresses in clothes designed by Armani, and who has been exhibiting in art festivals for more than thirty years.

He is Italian by birth, although he arrived in the USA many years ago and has long been a citizen. But

the call of his birth land is strong and every year for the last twenty-five he has traveled to Europe for a week or two. There, he visits family, catches up with old friends—and takes photographs. Recently, I called him to wish him pleasant travels in Europe. He was very excited about the trip, since, for the first time, he had nearly decided to forego it due to business being down and money scarce. He found a way to pay for the airplane ticket, with mileage points. A friend was loaning him his apartment, while the friend went skiing.

Photographers speak in reverent tones about light. It is our paint, our clay, our wood. Before we said goodbye, my friend said, "The light is perfect now in Venice. I must catch it. I'm so happy to be going. I have many pictures to make."

This photographer averages between thirty-five and forty shows a year, earns a good income, owns a gallery that shows only his work. Rather than take a vacation, he will spend most of his time in Italy searching for the perfect light in which to make his art. After a rather poor year in sales, his emotional balance is such that he knows where to seek rejuvenation. And no number of bad shows can stunt his desire to create.

Did I mention that he is well into his sixties? He has my respect, friendship and admiration. He is far from immune to the feelings artists have about festivals, and selling or not selling, rejection or acceptance. But he has settled into a place that will not—cannot—reduce his commitment to and joy in his work.

An always irksome and contentious part of selling artwork at outdoor festivals is the question of lowering the price of your work to make a sale. A painter whose opinion I value once commented to me that he could not blame an artist for lowering his or her prices when the mortgage payment was overdue. Neither can I. However, you will find artists who feel that when any exhibiting

artist lowers prices, the public believes that all artists will do the same. There is some justification for this, since the public rarely understands that, as business people, we all have costs to bear and that these costs do not necessarily—perhaps ever—go down. Some artists try to protect themselves from discounting their work by setting up what I call the labor defense: their hours and hours of work on a painting or sculpture must be paid for, not just their materials and show costs. It may be an admirable stance to take, but it is just an excuse for how they really feel. When they must reduce the price of their work to make a sale, they believe it demeans the work and themselves. Other artists believe that the price of their work reflects their expertise and experience, not just the cost of producing it.

One painter I know dislikes intensely having her work around for more than a show or two and begins discounting her pieces after they have not sold in a single showing. She continues lowering her prices until everything she paints is sold. Another painter of my acquaintance will never lower his prices, no matter how long the work remains in his booth. I have noticed certain paintings in his display for more than five years. Once he decides what one of his paintings is worth, he will never lower it. Every artist tackles discounting in his or her own way, from a financial viewpoint and, knowingly or not, from an emotional perspective.

When we lower our prices because we need money, our action is inner-directed, responding to our needs. When we lower our prices because our work is not selling as quickly as we would like, or when a customer requests a discount, the impetus is outer-directed. We want both to result in sales, but the motivation is very different.

Discounting to fulfill our emotional need for sales, and thus acceptance by the public, rarely works, since

we may suspect that the reason for the purchases is the lower price. This reduces the positive feedback from the sale. We have, at least emotionally, gained and lost and perhaps not satisfied our needs.

Buyers often ask for discounts, especially when economic times are difficult. They may not be able to afford your asking price, or they may simply want what to them is a bargain. Showgoers seem to believe that artists' prices are somewhat capricious, that the artist who puts a price on a piece is just trying to get the most he or she can. This may be true, but it is unimportant. As artists, we decide what we will accept for our artwork; there is no corporate directive. Some artists at outdoor festivals place higher prices on their work than they really want, to counter the public's tendency to ask for a discount. Other artists may rebel against agreeing to lower their prices under any circumstances.

We should remember that the buyer has decided to make a purchase—if the price is right. In that decision, we can take satisfaction on an emotional level and consider the price question no more than a business decision: do we want the money from the sale enough to accept a lower amount than we had asked?

The discount dilemma, as I have come to call it, occurs often. You may not be able to adopt a single rule to cover all the ways it can come up. You can separate the emotional from the monetary impact of discounting. If you do so, you will probably make better business decisions when you are confronted with one of the artists' least favorite questions: "Is that your best price?"

At times, the public can seem amazingly insensitive to you, or your needs, inside your booth. Photographers become so tired of being asked what camera they use that, in one case of a friend of mine, he actually posts a sign on his booth saying that he will not discuss equipment or techniques. Painters may be asked what time of

day they painted a certain picture, or what brushes they use, or what canvas. Every medium seems to evoke questions that have little to do with the art as art, and nothing to do with a possible sale. Most artists try their best to answer without anger, but, after a few hours of hearing this sort of question, many lose their patience and begin offering up snide remarks or monosyllabic snarls. Is it just weariness that turns us into sarcastic snobs?

No. It is having our art ignored, as art, for you are there presenting your best work and you would very much like it to be received as art and, if discussion comes up with a visitor, discussed as art. Painters of European scenes will hear many times how the visitors to their booth have been right where the artist stood when he or she painted. Every medium has an equivalent to this, even if it sounds different, as in the jeweler whose work is consistently compared to jewelry that can be found in certain stores, or by certain manufacturers.

Often, it seems that the public has entirely missed the point: we are artists, not factories, and our work reflects our selves, not the latest fashion. When this happens, you can protect yourself by realizing that the speaker has just drawn a parallel between your work and something familiar to them, thus drawing closer to your creative output. You can turn this to your sales advantage, by pointing out the differences in your work and its handmade, unique nature.

The public, we must remember, is under no obligation to buy. In the festival business, there are many ways to say no, and only one way to say yes. "No" can come in the form of any number of excuses, including the ubiquitous, "I'll be back," the oft-heard, "It won't fit in the space," the pleasant if unimportant, "I have no more walls," the rather dreary, "The color isn't quite right," the truly inane, "I don't really need more art," and my

personal favorite, the completely absurd, "What show will you be at next?"

I admit to really disliking this last way visitors say "No". If someone is not going to buy my work, what difference does it make what show I will exhibit at next? None, of course. If they have a real reason for asking, such as needing to consult with a spouse, why not simply say so (some people do)? In being honest, our customers permit us to respond with the best ideas we have for making their purchase decisions easier, such as offering to let them take a piece home on approval. When a customer says they really like a piece, but need their golfing spouse to see it, I do whatever I can to make that happen, from extending my hours at the show, to sending the piece out on approval, to visiting them at home after the show closes.

The many guises of the word "No" at art festivals are tiring and can be emotionally draining. The best way I have found to handle them without banging my head against my booth's end poles is to determine as quickly as possible if the customer's words mean "No" or hold the possibility for further discussion. How? By asking a question designed to elicit a firm response.

For example, if a customer says "The color isn't quite right," you might offer to show him or her other pieces with different color schemes. If they say "I have no more walls," you can ask whether they are tired of any work that hangs in their homes and might be ready for a change. By their responses, you will know immediately whether to pursue the conversation or find a quick, and polite, way to move on to the next visitor—or return to your chair while the customer leaves. This technique leaves you less emotionally drained, since you will usually have a final "No", rather than a muddled, inconclusive interaction with the visitor to your booth.

Whether we admit it or not, we all approach the shows we do with expectations. If we have exhibited at a festival before, we like to believe this year's show will be better, meaning our sales will be higher. We prepare ourselves—and our offerings—using this knowledge. If we are not careful, these expectations can turn into apprehensions, that the show will be worse, not better. Or course, we should use our history at a festival to plan our future participation in it. Planning is the operative mode to use; expectations can result in disappointment, plans can be altered or not work out exactly, but with much less emotional distress.

If we have not done a show before, we base our expectations on the experiences of others and the information about the festival we have gathered, filtered through our own perspectives. Here, our expectations are more nebulous and more a reflection of what we would like to have happen than what may happen. With new shows, it is best not to create expectations, but to convince yourself, as is true, that you have no basis for them. Another word comes into play: hope. Unless an artist is seriously mentally ill, such as Van Gogh, hope stems from the inner optimism artists must have, but rarely admit to, that makes it possible to create something from nothing.

We hope our work is good; we hope our sales at a festival are high. We attach one to the other and, in the process, may find that our sales diminish our hopes. This is extremely dangerous for an artist. You must be immune to the effect sales can have on your sense of worth in your work. Otherwise, paint or sculpt dollar bills. Part of the problem is the moving target syndrome: how high do your sales need to be to make you feel you have achieved what you "hoped" to accomplish, not in your sales planning, but in creating your art? There is no

answer that satisfies. Simply do not ask the question and your sales will not affect your work.

Another risk relates to sales not by you, but by other exhibitors. If you paint landscapes and an artist nearby paints figures, how do you feel if your work does not sell and hers does? While this may be limited only to the show you are doing, you may find yourself thinking you should paint images like those of your neighbor. All your knowledge about different shows attracting buyers with differing tastes can be forgotten in that instant of—dare we say—envy? Usually, this will pass and at another festival, when your landscapes sell and her figures falter, you will shake your head at your previous feeling and move on emotionally.

While, as a festival artist, you may sell to paint, that is, exhibit and offer your work for sale so you can continue painting, you should never paint only to sell. Too many artists have walked that path, only to find their art careers in a death spiral. Their psyches soon follow.

Emotional quicksand lurks in other areas of our work as art festival participants.

You may be accepted into a festival for several years in a row, only to find your work rejected in the most recent show. The immediate question is "why?" and the immediate concern is that your work has fallen in quality, not that the show has changed, the jury is different or that dozens of new artists have applied. Over the years, your work was chosen over that of hundreds, perhaps thousands, of other artists. It is too easy to forget this fact. You must remember it and look to the future building on your track record.

You leave a show that has been good in sales previously, but now has produced less than your costs. The public, you think, hates your work, even though they liked it only a year earlier. Many factors may have affected your sales, the least of them your artwork. Let the

show go. Try to understand the reasons for your drop in sales, but do not relate it to you or your work—unless your work has changed radically. Then reevaluate the show from the perspective of your new output.

The art festival life, if you choose to travel away from your home area, requires days of non-art activity, on the highway or waiting in a strange town or city for setup day to come. These days can, if you let them, wear away at your enjoyment of the festival business. You can see all the non-art days as a waste of time—or at least a waste of time you could be using to create art—or you can place them in another perspective. Days between shows offer a unique moment, one of complete freedom to apply our time as we see fit. Artists handle this in different ways. A few, whose media permit it, take along their paints and brushes and make art, in hotels or outdoors. Photographers seek out new vistas or city streets to photograph. Many of us visit museums and galleries. Others bring portfolios of their work and contact dealers and galleries for potential representation. One artist I know loves movies and uses the days between festivals to see films he has missed at home. Another reads books she has been hoarding while at home, where other chores make extended reading periods rare. And, as trite as it may seem, the byways of America are replete with interesting places and people.

You can effectively expand your life, enriching your experience, while on the road. No, not while traveling at 65 mph down an Interstate—unless you listen to audio books while driving. The trick is to avoid a rhythmic complacency that can easily take over: setup, exhibit, teardown, travel, wait. Substitute or add other endeavors to the "travel" and "wait" times and you will find yourself refreshed and invigorated when the "setup", "exhibit" and "teardown" days arrive.

After a festival ends and the work of teardown has been completed, your sales at the show can affect your mental state deeply. When sales are good, you will feel a bit of elation at completing your selling task well. When sales are poor, you may believe you are at fault—even if only for choosing to exhibit at that show—and feel gloomy, or even depressed. You will be physically tired, probably, and if you have another show to do the next weekend, somewhat dejected.

While it may be little immediate consolation, other artists at the festival are in the same frame of mind. Remarkably often, a bad show will have been bad for many or most of those exhibiting. Conversely, a good show will be good for many of the artists there. You are not alone in your sales or in your response to it. Allow this to assist you in shrugging off the festival and moving on to the next.

While it is important that we evaluate a show where we don't sell well, it is equally important that we evaluate a high-selling festival, to learn from both and carry the lessons forward. Rather than putting a bad—or good—show out of your mind, address and examine it. Fit it into your thinking about your festival business overall and you will find the emotional impact far less.

Artists tend to live internal lives, using their energy to transform their materials into expressions of their emotions. Art festivals present the opposite need, submerging our emotions to external stimuli. Exploring, finding and using ways to make these two worlds meet without damage to our emotional well-being allows us to enjoy and prosper in both.

CHAPTER SIXTEEN

Staying Healthy on the Art Festival Circuit

RARELY HAS ANYONE MISTAKEN food sold at art festivals for *haute cuisine*. Indeed, it often seems more like an advertisement, however subtle, for an enterprising heart specialist who has run out of patients.

Personally, I believe that instead of "Sausage and Pepper Sandwiches" signs on festival food booths should read "Cholesterol and Artery Clogs." Not that I am immune to the occasional steak dinner (very occasional, thank you), but art festival food, so to speak, takes the cake.

Early in the morning, should you walk past a food booth, you will be assaulted by the aromas of frying chicken, frying potatoes, frying beef, frying dough and just plain frying. The wonderful open-air smells of chicken on the barbie do not compare. These are your die hard (or die easy, if you eat the stuff) odors of mass cooking by purveyors of placque.

Yet we must eat at festivals, and on the road. The days of three-squares seem to have gone the way of homemade chicken wings, and if, like myself, you spend 180 days a year traveling, you develop a complete strategy for eating while away from home.

This involves several levels of thought, from caloric to gastric to economic.

Over the years, restaurant food has become more expensive than most artists are willing, or even able, to pay. Again, we must eat, often three times a day. Typical breakfasts at places like Perkins or Denny's run about $8, with coffee and juice. These places often offer combo specials. Lunch can set you back $10, or more, in an Applebee's, for example. Dinner, anywhere decent, is a $15-$20 tab, and often higher. Think Outback or Macaroni Grill at these prices, not country French with a nice bottle of Chardonnay.

So, let's say food, per person, per day will—on the road, not at a show—cost you about $50. If you can sustain this level of spending, you are doing well. Two people, as in my case, runs the per diem up to $100. For each show you do, calculate the number of days you will be on the road and multiply by your daily cost. For me, it's 180 times $100, or $18,000. That is a startling amount, mitigated somewhat by not purchasing food for home consumption, but often increased at festivals in upscale communities.

Can you beat these costs? Some, by staying at hotels that offer free breakfasts, which have even reached edible status in recent years. Hotels and motels that include hot breakfasts, eggs and bacon, toast, coffee, juice and muffins, have higher room rates than those where breakfast is a pre-packaged donut and coffee (possibly juice, too). A few motels, such as Homewood Suites, feature a "light" dinner four nights a week, catering to the business traveler. The meals are usually more than "light", such as the one I ate that featured salad, lasagna, garlic bread, desert, wine, beer, soft drinks, coffee and tea.

You can calculate what the difference in room rate versus restaurant meals means in dollars and then decide.

When lunchtime rolls around, you have a very few choices: eat the food court offerings, order takeout from a nearby restaurant or bring your own. Food vendors charge high prices, since their audience is fairly captive. My idea of a fair lunch deal is not an $8 hamburger and $2 soda. My preference is to order from a nearby restaurant, which you will find at many venues. Sometimes they will even deliver to your booth, first dropping off a menu and taking your order. You can visit a local supermarket, make sandwiches or salads, add chips or desert or both. My lunch, when possible, is a Subway Italian, 12-inch sub, which my wife and I split. We buy it on the way to the show, but don't try to keep it overnight. The cost is low and the dietary impact not nearly as bad as show vendor food.

When traveling between shows, the forced-march kind when you must be 1,000 miles away in three days or less, eating becomes more problematic—and costly. Your hotel or motel may not be adjacent to a decent restaurant. You may need to pull off the highway at an inconvenient time for a meal. So, instead of searching for your favorite chain, you wind up eating whatever is available next to the gas station where you buy fuel.

In dollars, this can mean an increase in food costs, if your budget says Arby's and only Friday's is nearby. Rushing from one show to another over long distances comes with deadlines that may become difficult to meet after you hit the highway, including time crunches from unexpected repair, weather or other stops. Most artists I know eat light meals while on the road, to maintain some sense of their body shape and stay alert and to limit costs.

A delicate subject, that: taking care of your tummy while traveling 500 miles per day. I've found (and so have others I have asked) that not eating in your vehicle helps. Whether it is a restaurant, fast food place or rest

area picnic table, the break from driving or riding and the time for a walk and a stretch aid in digestion. Conversely, so does not traveling on a completely empty stomach. When I have been forced to drive an hour to the nearest breakfast emporium, my system objects all day. I keep snacks nearby to alleviate the mid-afternoon griping down below. And I will admit, a bottle of antacids lurks inside my glove compartment.

All the standard recommendations for digestive health apply to art festival artists, of course, the high-fiber, low-animal fat dietary thinking of our era included. We artist gastronomes have a few added concerns, the biggest one being calories.

Yep, good old chocolate cake. What, you don't eat chocolate cake? You munch on trail mix from your favorite health food store? I did too, until I read the label and found out that a few ounces of a good-tasting trail mix held more calories than a McDonald's cheeseburger!

Not being an aficionado of sugar-free pastries, and being an addicted chocoholic, I switched back to the cacao of choice. There are good and bad calories, certainly, but the good ones tend to taste somewhat less, shall we say, chocolaty than the bad ones.

Seriously, none of us wants to expand our bulk on the road and at shows. So, again, the conventional wisdom about weight holds: take in fewer calories than you burn and you will lose weight, and vice versa.

The difficulty comes from the enforced inactivity we experience in our vehicles, for days at a time, and the fact that running laps inside your booth doesn't really equal true aerobic exercise. (Let me see: a mile is 5,280 feet. If your booth perimeter is 40 feet, then you must run around your booth 1,320 times to equal a mile long jog.)

So which is best, increased activity or deceased calorie intake? Practically, a bit of both. Many hotels and

motels have exercise facilities, some even give you a temporary membership in the gym nearby. Walking in the morning helps you awaken, walking in the evening leads to a good night's rest. At every rest or food stop, you can stretch, although other people may look at you slightly askance, and even walk about. Walking promotes circulation and helps avoid what can become serious problems, such as blood clots from too little movement. And limiting calories by substituting healthful foods for that Oreo Double-Stuff just plain makes sense.

Eating well does, of course, assist in maintaining good health. When you travel thousands of miles to and from art festivals, other health topics become equally important.

Full-time artists, those of us not married to people who work and thus have access to health insurance, find obtaining and affording health insurance difficult at best. We are a classic example of the nation's health care crisis, often earning too little to afford private insurance and too young for Medicare. Our health is crucial to our ability to exhibit in art festivals and we must guard it carefully. How do you do this if you cannot afford or qualify for private health insurance?

There is no easy answer. Mine has been to carry catastrophic insurance, should the worst happen to me or my wife, and to pay for everyday medical costs out of my pocket. On the road, illness plays havoc with both your bank account and your sales. You may be forced to cancel a show, if illness strikes suddenly. You may be faced with finding a doctor outside a hospital emergency room, since these are costly and often crowded. I have used urgent care centers to some advantage. They require no appointment, are usually open long hours seven days a week and, while not inexpensive, charge much less than emergency rooms at hospitals. Urgent care centers do not mind that you are a first- or one-time pa-

tient. The medical attention my wife and I have received at urgent care centers has always been the best I could desire.

Why, you might reasonably wonder, has no one offered a group plan to artists? This may be more a procedural problem than a financial one. Insurance regulations differ in every state and a company must meet them in each state in which it wishes to do business. Art festival artists—most artists, in fact—belong to no group that meets the criteria for group coverage. I have known many artists whose spouses hold jobs for the sole purpose of having health insurance, and other benefits. This is an area some enterprising insurance company should approach, a problem waiting to be solved that will produce excellent returns.

Artists at times face unusual health needs, due to the substances they work with creating their art. Metal sculptors, in particular, and photographers working in traditional darkrooms, often encounter toxic substances. Knowing how to handle them will keep these artists healthier on the road—and at home.

Most art festival artists I know take excellent care of themselves and are a hale and hearty lot. Perhaps the outdoors helps, as might the physical exertion of participating in festivals. Understanding that a certain amount of physical labor is necessary promotes maintaining our bodies to meet those needs. Artists traveling long distances in their vehicles listen to their bodies' requirements to stretch and exercise. As the population ages, and along with it the community of art festival artists, the needs of artists on the road and even at nearby shows, change. We art festival artists have no employers who offer paid days off, so we are mindful that missing a show due to illness places the lost income squarely on our shoulders. Even so, we should understand that our health must come first, our busy lives as art festival art-

ists second, in order for our good health to promote our good art festival businesses.

CHAPTER SEVENTEEN

Teardown and Creating Added Sales

IT IS FIVE P.M. The clock tower bell, were there one, would toll a mournful knell.

Restless, you glance around at your work, display, personal items, cashbox (which is brimming with credit card slips). Still, a languor overcomes you, or is it your jaw tired of saying "Can I help you?" and "Please, honey, don't drip ice cream on the art." You realize that the inevitable has happened: the festival is over.

Unless sales have been anemic, languor fades to a foggy, if satisfied, mental state. If sales have been sparse, the post-show stupor just seems to grow until it encompasses your very soul, and you wonder whether or not you will survive.

Welcome to the Teardown Zone. For all his inventiveness, Rod Serling would never have been caught alive doing what art festival artists do for an hour—or two, three or four—at the end of a weekend outdoor festival.

And yes, you will survive, to exhibit another day. Let's explore how to make your survival not just easier, but almost—only almost—fun.

First, consider the show rules about teardown. Rare is the show that closes at five or six p.m. and permits artists to drive immediately to their booths. Those that do earn a special place in the artists' esteem. The festi-

val director, charged with the safety of patrons and artists alike, will want all or nearly all the attendees out of the festival grounds before two hundred vans and trucks and trailers march in. When the site is fenced, this is easier to accomplish than in a public park or on a street. At the Coconut Grove Art Festival, police drive down the streets telling the public that the show is closed and to please leave as soon as possible by the nearest exit. A few open-grounds festivals will announce the closing over a public address system. The norm is simply to let the show wind down. Artists must often pack their work and break down their booths amid wandering latecomers, children on roller skates and mothers pushing strollers. The festival organizer has little option but to hope—as the artists do—that no one is injured in the process. True, once booths begin to disappear most showgoers notice and understand. People will linger at every festival, stumbling around boxes and bins and crates, even snaking through vehicles parked everywhere on the site. A few will be buyers, but most are either fascinated by the teardown process or do not realize the show is over. As the packing and teardown process progresses, I have many times had to ask politely that a showgoer stay out of my booth, to avoid possible injury.

One of the most stringent rules at all festivals is that, except for truly inclement weather and then only if told to do so by the show's staff, you must not begin teardown before the official end of the show. You will find this stated in almost all show applications and artist packages. You may even see a warning that any artist caught tearing down early will not be invited to return. The rule is in place for a reason: when one artists begins dismantling his or her booth or display, other artists are likely to follow. The public may think that the show is over, which can prevent sales by artists stilly fully open. Many artists at slow selling shows do begin

preparing for teardown before the show officially ends, but in unobtrusive ways that do not harm the festival's image.

Once in a great while you will notice that an artist's booth, which was fully open on the festival's first day, is simply gone the next morning. Serious illness aside, that artist decided not to stay for the whole show and packed up the night before. It is difficult to understand why an artist would do this, since the booth fee has been paid and most if not all the other costs have been incurred. Even if the first day produced little, or no, sales, there is still another day, or more, remaining. The empty space in the show looks forlorn, reducing the flow and interest for the public. Artists truly hate to see an empty space that was earlier filled. Artists who do this find themselves unwelcome at future events—both those they have abandoned and, by word of mouth among show directors, other festivals as well.

You may find patrons still in your booth at closing time. Unless they are interfering with your teardown, it is not a good idea to throw them out; you may lose a sale or more. In fact, I have made numerous very large sales at or just after the end of a show. But once the last attendee leaves my booth, I rapidly begin dismantling what, a few days earlier, I so lovingly built.

Many shows require that you pack up your art, dismantle your booth and only then retrieve your vehicle. A few festivals stage teardown and vehicle entry in groups, or by how far your teardown process has progressed. The excellent Bonita Springs National Art Festivals, provides a three-stage teardown process. Forty-five minutes after closing, those whose booths are completely dismantled may drive into the site. A half-hour later, those who are partially finished may enter. Everyone else is permitted to drive in after another half-hour has passed. This permits artists, like myself, who must load large

artwork directly into their vehicles, to do as much prepa-
ration as possible, then drive to their booths. Even
though spaces are tight between rows of booths, tear-
down at Bonita Springs rarely becomes frustrating or
overly time consuming. Once the show officially ends,
artists are also allowed to bring their vehicles into park-
ing lots near the grounds, to which they can dolly out
easily.

On the other side of the teardown coin, you will ex-
perience one of three categories of frustration: difficult,
impossible and why do I do this?

Difficult is when your vehicle is a half-mile from the
show and your packing boxes, bins, etc. are inside it, but
you are told to teardown before bringing in your vehicle.
If you are alone at the show, you must find a way to keep
your booth secure while you go to your vehicle, carry or
dolly in your packing materials, pack up and dismantle
your booth and then go back to the remote parking lot to
retrieve your vehicle. In all cases, you can choose to dolly
your possessions out of the site. You will see many art-
ists take this route, especially when bringing in their
vehicles looks difficult and involves a waiting line of art-
ists. Some venues do not permit driving up to your booth
space, so dollying out is the only alternative.

You can ease the pain of a difficult teardown by
bringing your packing materials into the site early on
the morning of the last day, assuming you have space
near your booth for them. This is a compromise, since
you will lessen the attractiveness of your booth space
with all those boxes and bins. Sometimes it is the only
good choice.

Impossible is the show teardown that includes three
elements: one, no entry to your van or other vehicle until
your booth is completely down; two, no way to drive up
to your booth, due, for example, to narrow aisles that be-
come parking lots once a few vehicles have entered them

or inside a park with no driving paths; and three, no space to store or place your booth and artwork while you tear everything down.

An example of this is the venerable Atlanta Dogwood Art Festival, where I have sold extremely well, but no longer choose to attend. The show is a major Atlanta event, difficult to gain acceptance into, and very well attended by the public. It takes place on a high earth berm, with a small road along it, above a park. At best, the road, really a path backing up to a fence, is wide enough for a booth and a single vehicle. To facilitate setup, artists are given specific times to drive the precarious road to their spaces and lined up in order of their space numbers. It is tedious, but it works.

Not so at teardown. You are supposed to dismantle and pack everything, then get your vehicle and drive to your booth. But, if there is a vehicle before your booth parked and loading, you simply cannot get by. One artist waited two hours to get to his booth at a recent show.

Once you are loaded, you will likely wait again until the artists in front of you drive out. This same artist waited another two hours before being able to leave. Total time: five hours, including loading his van, before he could consider going to dinner.

Why, you might ask, do not the show's committee members change the process? In short, they cannot do so given the show's location. So, how about a change of venue? Good question, for which no adequate answer exists, not only for this show but for many others.

It is fair to say that many artists who sell well have learned to grin and bear the difficult or impossible teardowns. It's the third category—*why do I do this?*—that baffles us all.

Imagine a show at one of the nation's—actually, the world's—most exclusive resorts. High atop a mountain in Colorado, this venue boasts the homes of several For-

tune 500 CEO's and even former Presidents of the United States. The resort is designed and built as a Swiss Alpine town, complete with ski lifts that run almost to the streets, outdoor cafes for sipping mulled wine and eating braised shank of buffalo (really) and an outdoor ice rink that is open all year, even when temperatures climb into the eighties. This is a wonderland called Beaver Creek, and the show is Howard Alan Events' Beaver Creek Art Festival.

To fully understand how bad teardown is, we must begin with setup.

A full day is allotted for artists to arrive and set up their exhibits. You are given a setup window of what should be enough time well before the show. When your turn arrives, you must check in at the bottom of the mountain, receive an entry pass and drive to the top. A small pulloff at the edge of the resort accommodates perhaps ten vehicles, maybe even fifteen. You must unload everything you need at your booth onto the sidewalk. Next, you drive down the mountain to park in a remote lot. A shuttle gives you a ride back to the unloading zone. There, you find a few resort employees with small garden tractors to take your booth and artwork to your space. You can choose to dolly your things to your space, but few do, since the resort is very steep in spots. Once at your space, you may set up your display.

Okay, your day is done. If you are like most artists at this show, you do well. My own sales here have always been excellent.

The show ends. How do you pack, load and leave? The question is, for a good bit of time, unimportant. You can pack your art, if it is packable, dismantle your tent and...do nothing. During setup, after all the other artists had unloaded, more booths were erected in the pulloff where you must bring your vehicle to load. Thus, until

those booths are gone, you are stuck. That can take two hours, depending on the artists and the weather.

So, you take down your art and booth and wait for one of the tractor carts to become available. You may need two or three trips to bring your things to the pulloff. Your possessions are now stacked on the sidewalk, while you take the shuttle down to the parking lot, retrieve your vehicle and drive back up. And, yes, you must acquire a pass from the show staff, ensuring that you are in compliance with the rules.

Once back up the mountain with your vehicle, you load up and drive away, usually in the dark, often too frustrated to say goodbye to any artist friends you see. By the way, you are not allowed to leave the festival until you pay, on the spot, the taxes due to the resort. You must write a check then and there, and obtain a receipt which you must show to the event staff. It is a poor and demeaning system, inherently implying that artists will lie on their sales tax returns.

This is truly a *Why Do I Do This?* teardown situation, yet artists by the hundreds vie for a space every year, and return as often as they are accepted into the show. The clientele is wealthy; the show is established. For many, it is the best festival of the year.

I do not believe all the difficulties at Beaver Creek—and other festivals with similar problems—can be solved, but some can and should be. Teardown would be far faster if the booths in the pulloff were eliminated, but that is unlikely, as it would cost the promoter many thousands of dollars. The show could be ended earlier than its 5 p.m. Sunday closing, to provide more time for artists to tear down and leave before dark. Additional teardown and loading alternatives could be found.

Beaver Creek offers an example of how show rules such as these can interfere with—and harm—artists' efforts and artwork.

In 2007, a severe thunderstorm struck the Beaver Creek resort at about 4 p.m. on the show's last day. The next day, I ran into three artists who were unable to finish teardown until after 1 a.m. Tempers flared, because the resort and promoter would not allow loadout via the resort's freight elevators and loading docks. Two physical fights were reported. Many artists sustained damage to their work and displays. At *Why Do I Do This?* shows, this sort of thing seems to happen. It is due to lack of preparation for the worst possible situations by the show and the venue. The suffering was at least uniform for most artists, a small consolation.

A few artists believe that at the end of a festival, the prudent teardown action is none. They leave their booths, go to dinner and return hours later for a leisurely dismantling of their tents and work. This may be possible, even desirable, at some shows, but far less than a majority. Most festivals, especially those held on public streets, require that you finish your packing and loading by a set time, normally three hours after the show closes to the public. Leaving for dinner, then returning to tear down, also means working in the dark. For seasoned art festival artists, this can be done somewhat easily, since they know their work, displays and vehicles well. For artists new to the business, it can be a disaster. You can carry portable worklights, if you have a source of electricity or battery powered units, something many artists do.

If you have planned and constructed your vehicle's interior well, you can reverse the setup process at teardown. This is not always possible when you have sold a lot of work and need to rearrange the remaining art for safety and security. The order of effort at teardown tends to be: pack your art; dismantle your display, shelves, racks, or pedestals; take down your walls or other hanging items; remove your tent sides and top;

dismantle and pack your tent poles. Teardown will usually be faster than setup, by about one-third. Most artists do not want to linger at a show that has ended, preferring to finish their work, go to dinner and either retire to their hotels or RV's or head for the highway.

Finally, consider the matter of security during setup and teardown. It is important.

At the end of the Port Clinton Art Festival a few years ago, a jeweler whose booth was near mine removed all her jewelry from her display cases at the close of the show. She put them into a rolling suitcase she uses, which is black and disguises what is inside well. She also put her charge receipts, checks from customers and cash in the suitcase. At the show, she had been assisted by a friend who often worked with her.

The jeweler then left her booth to visit the restroom, Her friend continued to take apart and pack up the display cases. The friend's back was turned when a robber quietly slipped into the booth space and took the suitcase to a waiting accomplice's car, about thirty feet away in the street.

The jeweler returned, found her suitcase with jewelry, money and receipts gone. She began yelling; a show staffer and a police officer arrived almost instantly, but the car with the thieves was gone.

The jeweler lost more than $10,000 in inventory, money and checks. Her sales receipts were gone, too, so she had no way of identifying customers to ask for replacement checks and inform that their checks—with name, address, telephone number and other information—had been stolen.

It was a teardown nightmare.

Could this have been avoided? Probably. Thieves have been known to case art festivals, looking for likely targets, even traveling from show to show identifying easy marks for their crimes. The jeweler should never

have left her valuables at her booth during teardown; her attention was elsewhere and even if she had not left her booth, she was an easy target for the thieves.

Jewelers have special needs to protect their precious products but all art festival artists must be mindful of security during setup and teardown. Never leave money or valuables in plain sight (this applies during the festival, too). Do not call attention to your valuables with easily identified cases or bags for them. And always be mindful of your surroundings, at the festival and going to and from the venue. It's the old ounce of prevention saying in action.

You will likely never encounter the problem the jeweler above had, especially if you view teardown as a time for extra vigilance when it comes to protecting your work and hard-earned money.

Some artists choose to hit the road as soon as possible after a festival, aiming for home, if it is close, or trying to get an evening's start on the highway if home is more than a few hours away. While this can be appealing, and cost effective if hotels near a festival are expensive, it can also be dangerous. A photographer whom I counted as a dear friend drove out of a Colorado show, which had been long and difficult due to inclement weather, hopped onto a major Interstate highway and, rounding a curve at high speed, did not see that an accident had stalled traffic in front of his pickup truck and trailer. He rear-ended a 53-footer and, unfortunately, died in the crash. No doubt his reaction time and awareness were blunted by a long weekend dealing with the public.

Of course, many more artists head for home after festivals without incident. You must be the judge of your mental and physical state at the end of a show, and decide on the prudent course for your own safety and comfort.

Your festival is finished. The money from your sales is in your pocket, or on the way to your bank account. Art festival artists universally feel a certain satisfaction at this time, having fulfilled their goals—if not their highest hopes for sales—and offered their creative product to the public. We can be forgiven a moment of quiet pride in our art, and ourselves. Perhaps not a long moment, since the next festival may be only a few days away and we have planning to do, preparations to make, new art to create.

What if the festival failed to meet your plan for sales? Now, while the show is fresh in your mind, is an excellent time to review what you have done and how to make the next festival better.

You can ask yourself several questions, the answers to which will offer a path to increasing your sales down the road.

1. Was the festival "right" for me and my work?
2. Was my art equal to that of other artists, in quality, style and price?
3. Did I have the inventory to meet my pote tial customers' needs?
4. Was my booth presentation good enough to entice showgoers to enter it?
5. Did I interact with the public in ways that promote sales?
6. Did outside factors—weather, the economy, large events—hamper my sales?

These are important questions, since they lead to the largest consideration of all: would I participate in this festival again? The answer comes in two parts: sales and enjoyment. They are the yin and yang of art festivals, although not necessarily in that order. When they interact in a way that creates a balance, you have found an art festival—and perhaps a way of life—that can be both satisfying and remunerative.

We have come a long way since the beginning of The Art Festival Handbook. We have considered whether the art festival life is for you, what it means to apply to and exhibit in outdoor art festivals and how to plan, construct and carry out your art festival participation. One of the most rewarding parts of the art festival lifestyle is that, when everything is considered, it allows you to follow your creative journey while earning a good—or excellent—income. Your travels will be made easier by the wonderful community of art festival artists you will meet and befriend. Should you choose to follow the art festival road, I sincerely hope we cross paths along the way.

CPSIA information can be obtained at www.ICGtesting.com
Printed in the USA
BVOW030710091111

275676BV00002B/124/P